C
Language,
World

Body, Community, Language, World

JAN PATOČKA

Translated by Erazim Kohák

Edited with an Introduction by James Dodd

OPEN COURT
Chicago and La Salle, Illinois

Open Court Publishing Company is a division of Carus Publishing Company.

Copyright © 1998 by Carus Publishing Company

First printing 1998

Printed and bound in the United States of America.

Translated from the original Czech. Translation based on the fourth volume of a typescript collection known as the *Archival Collection of the Works of Jan Patočka* and on the Czech edition prepared by Jiří Polívka, *Jan Patočka: Tělo, společenství, jazyk, svět* (Prague: Oikoumene, 1995).

Library of Congress Cataloging-in-Publication Data

Patočka, Jan, 1907–1977
 [Tělo, společenství, jazyk, svět. English]
 Body, community, language, world / Jan Patočka; translated by
Erazim Kohák ; edited with an introduction by James Dodd.
 p. cm.
 Includes bibliographical references and index.
 ISBN 0-8126-9358-2 (hardcover : alk. paper). — ISBN 0-8126-9359-0
(pbk. : alk. paper)
 1. Phenomenology. 2. Body, Human (Philosophy) I. Dodd. James,
1968– . II. Title.
B4805.P383T3713 1998
199' .437—dc21 97-26040
 CIP

Contents

science, Bergson, Aristotle).—The first movement (sinking roots, anchoring) and the affective harmony with the world.— The second movement: self-sustenance, reproduction.—The third movement: self-achievement, integration.

Editor's Introduction

These lectures document an attempt on the part of the Czech philosopher Jan Patočka to present phenomenology to his listeners as a living tradition—that is, as a philosophical heritage that carries with it an imperative to be rethought, its course and "program" redirected in light of possibilities that it has itself uncovered. As such they represent a double achievement: on the one hand, a profound appraisal of the work of Husserl and Heidegger, not only in terms of an assessment of texts and ideas, but also of the guiding philosophical insights that animate their writings, their respective paths of thinking. On the other hand, the "philosophy of movement" developed in the final lectures in this volume is Patočka at his most original, setting criticism and appraisal aside and offering his listeners an inspired description of the ontological structures of human life, of its dimensions of self-relation and worldliness. Here Patočka is showing us what he believed had been heretofore neglected in phenomenology, but which nevertheless remains an inherent potential for this type of reflection: the possibility of articulating a way of understanding ourselves, "theoretical" to be sure, but which nevertheless acknowledges the fundamental significance of our situatedness as finite beings, the rhythms of existence that permeate us even as creatures who re-create themselves, who reflect and who understand.

This double achievement at the same time poses a double challenge to the reader, as it must have to his listeners. The first challenge is to understand the complicated interweaving of reflections inspired here by Husserl, there by Heidegger, and to recognize that Patočka is not a straightforward proponent of the positions of either. The second challenge is to see in what way Patočka's assessment and appropriation of Husserl and Heidegger

is in fact an argument for why his own original phenomenological analyses, what he calls the "three movements" of human being, are something philosophically *compelling*. For the two achievements—the interpretation of Husserl and Heidegger, the philosophy of movement—are of a piece: it has always been a mistake in phenomenology to make a clean distinction between the "method" and the "investigations," as if in methodological considerations we were not exercising our ability to *see*, and in seeing or reflecting we were not at the same time learning *how* to see or reflect. And in fact it does not take long for the reader of these lectures to come to the conclusion that the discussions of Husserl and Heidegger found here are those of a mature thinker, one who is seeking to appropriate a tradition in order to present his own insights, his own philosophical reflection in the most compelling light; nor does it take long to come to the conclusion that Patočka's own insights owe everything to a long, careful consideration of these two figures and the tradition to which they in turn belong. There is no contradiction here, but rather an expression of something basic to philosophy: one always returns to a "tradition" when attempting to understand the significance of an insight, grasp the true extent of a new manner of description or the posing of a question.

An understanding of the philosophical problem of the "body" is the key to meeting this double challenge. In these lectures the body is not merely one phenomenological problem among others, but is a question that leads Patočka directly to the meaning of phenomenology as philosophy—this is something that occurs explicitly on the first page, and it accompanies the reflections throughout. Thus for the purposes of a useful introduction to Patočka's thinking in these lectures, I would like to take up the following question: Why is this the case? In what sense is the "body" of any interest to "philosophy" at all?

In a wholly preliminary fashion, we can answer this question by proposing the following thesis. The theme of the body is essential to a fundamental task of phenomenology, one definitive of phenomenology as a "philosophy": the task of articulating a self-understanding of humans, one that reveals what humans most truly "are" and thus achieves a reflective grasp of human "being."

Perhaps the fact that the meaningfulness of this self-understanding has to do with a mode of being, that *mode of being*

that "we are," is most clearly expressed by Heidegger. This is so because in Heidegger the *question itself* takes on a particular significance, revealing something basic. In *Being and Time*, Dasein (that being which each of us "is") becomes the guiding theme of an investigation that will uncover the "meaning of being," because Dasein is defined as that being which has itself as an issue, which is concerned with itself—the mode in which Dasein "is," is as this self-concern, which is at the same time interpreted by Heidegger as a self-understanding. This mode of self-understanding is not, however, a simple theoretical grasp of what we are, nor a natural drive we possess to care for our existence, but is rather a self-understanding as a *type of existence*, a type of "entity" *(Seiende)*. The "self-understanding" at issue in philosophy, then, is more than just a grasp of ourselves as a being-concerned with our being; it is more than having a thesis or definition of our being "in mind." *It is itself an expression of this concern.* We can perhaps paraphrase the situation thus: this description of a being, that of "Dasein," is what we arrive at when we ask the question: what is it that we most truly are? But in initiating this description in reflection we also arrive at the *significance* of this question, for we discover that it is the essential question of our existence, that the attempt of self-understanding itself is what we most authentically "are"—for it is as an "understanding" that we care for our being, that we are in relation to it and to the world as a whole.

Yet this is just as true with Husserl's philosophy of consciousness, insofar as it is a "philosophy." For Husserl, phenomenology is not merely a question of providing a ground for the sciences, for justifying claims to knowledge—phenomenology is not merely a response to an embarrassment with not being able to give a "full" or "systematic" account of scientific discovery. In Husserl, phenomenology as philosophy arises out of a radical will to self-clarity, to grasping the ultimate ground for what it is that I am—and what "I" am, the I who reflects on itself as a human being, is an understanding of the world, of things. Of course this "understanding" that I am is interpreted very differently by Husserl than it is by Heidegger, not only because of the different concepts they employ ("Dasein" vs. "transcendental subjectivity"; "being-in" vs. "intentionality"), but because they put forth two different conceptions about what "understanding" of things is, what it means. Yet for both we are beings who "understand" ourselves and the

world—more importantly, it is precisely *in this act of seeking to understand* that we discover something fundamental about ourselves.

There is something else that goes with this: for both Husserl and Heidegger (and, for that matter, Patočka as well), philosophy, as a questioning of and reflecting on our being, is no "mere" questioning and reflecting, if by that we mean the mere attempt to give an account of the phenomenon "human being" or "self." The initiation of the reflection, the "hold" that it has on us, has more to do with a transformative possibility latent in our life as such. This life of ours, or this life that we are, is a concrete, established understanding of self and the world; as such it is always already an achievement of existence, something that has already been formed. Thus to question it— whether to question its being or its legitimacy from the perspective of a will to radical clarity—is to ask that it be re-formed, that it reestablish itself on a different level, becoming something other than what it has "at first" taken itself to be. In the thought of both Husserl and Heidegger the "truth" of our life is being taken up again in reflection, not merely to be "reflected" in language or thought but to become something else, to reach a new level of self. Again, of course, what this entailed for both philosophers was respectively very much different, but they both fall into the tradition that saw in philosophy an achievement of a special type, one that involved not only an understanding of human being and its world but its *transformation,* an emergence of a new mode of life.

Paradoxically, it is with reference to these two aspects of the self-understanding of classical phenomenology, both of which Patočka took up and sought to develop, that the importance of the problem of the body can be understood. How so? The phenomenological theme of the "body" is that of the "situatedness" of our existence, of our being in the world as enmeshed in a multiplicity of relations in and with this world. The sense of paradox arises when it is asserted that philosophy, the fundamental possibility of human life to reflect on itself, is itself part of this "situatedness" of human being. Here one may well ask: does not the idea of philosophy depend on another sense of the "situation" of human life, one that is different in kind from what we could classify—thus separate out as—our

specifically *corporeal* situatedness? For one might suppose, quite reasonably, that in turning to the theme of bodily situatedness (to the structures of perception, to our bodily orientation in space, etc.), we are thereby leaving behind the theme of the philosophical, that is, of the transformative potential of human life, of the possibility of reestablishing in a reflective attitude our understanding of the world, thus of ourselves, on a "different level." For is not philosophy something we do principally as *thinking* beings, as mind or spirit, and most definitively *not* as bodies, as corporeal subjects?

Indeed, to set for myself the task of describing—phenomenologically, to be sure—my being as a body, this immediately brings to mind my everyday relations to things, to "myself" insofar as I am caught up in a net of physical relations to my environing world. The "world" here means the whole as physical plenum of things and structures in which my body, itself something physical, is submerged, determined by a causal and affective nexus that is more or less open to my own machinations, my own physical initiations. Does not such a perspective in fact raise the specter of the *impossibility* of philosophy as we began to define it above? Does it not rather suggest the possibility that in the end I am "actually" determined not by my being as an understanding, but by my unfree being as a part of nature? Is not my physicality the dark side of my spiritual self, "dark" in the sense that it is precisely what *cannot be changed,* that it is immune and immutable in the face of any "radical decision" I may make to reflect, to think through to the very ground of my being?

In the opening sentence of his lectures Patočka goes right to the point at issue, asking the fundamental question: "what body?" He then proceeds to discern in the history of philosophy the beginnings of a concept of the body that, rather than standing for all of that which lies between us and self-knowledge, denying us an immediate intuition of what is "true" (as it does in Plato's *Phaedo,* for example), instead holds the key to understanding the "self" for whom the possibility of philosophy is not only *present* but *its basic task.* In doing this Patočka makes an important contribution to the history of the concept of the body—not so much by providing a detailed account of this history, but by giving a conceptual framework in which to *interpret* this history, bringing out what is philosophically decisive.

More specifically, Patočka's procedure is to outline a pre-history of what in phenomenology will become a key distinction: the contrast between the body as (1) an object, a thing in relation to other things, whether this relation is something unique or simply another example of the type of relation that holds sway between things in general, and (2) a conception of the body as what Patočka calls a "personal situation," or better: a personal situatedness among things. Patočka's claim is that the former conception blocks the path to answering the question: what is it that I most truly am? It insists that this truth is no different from any other truth, that it requires no procedure that would be specific to the task of articulating human being. The alternative conception of the body, on the other hand, recognizes that we must approach the question of ourselves in a way fundamentally different from the manner in which we would tend to approach questions of the being of things; it thus opens the way to asking about the essence of our being not in terms of the characteristics of this or that "thing," but rather in accordance with the structures of the situation that we are, the being of the life that we are.

The history of the concept of the body is a history of the partial discovery of this personal situatedness, a glimpse here and there of its problematic; it is also a history of its being pushed further into the background, of the development of philosophical attitudes and points of view that in principle exclude the legitimacy of its thematic. It is a history that is not without its ambiguities and intriguing inner tensions. In Greek philosophy, for example, the personal, lived body is not explicit, but neither is it something that is wholly absent. Aristotle, in giving an account of the body in accordance with the principle of *psychē*, its essence, touches on the being of the personal, insofar as he has in view the situatedness of bodily existence. *Psychē* is not a mute, one-shot bestowal of form and structure, but is a dynamism, an ongoing development of a life; it is precisely the principle of a living, "animate" creature. The animate character of a body, even its physical organization (the body as *organikon*, a thing-organized-for-life), can be accounted for only with reference to a progressive development of a situation of commerce with other things, a situation that is always defined in advance with reference to the tasks of growth, the onset of need, the immediacies of desires and the

mediate character of their satisfactions. It is this growing, needing, thus *moving* creature continually forming and re-forming its connection with things around it, thereby bringing the environment around it "into" (its) life, that Aristotle means when he examines the being of an "animate organism," the essence of which is *psychē*.

Yet, as Patočka points out, in Aristotle the body is not thematized as a *personal* structure per se, for here there is no formulation of the concept of the "I," or what we could call a Greek equivalent to the concept of I-hood. Greek philosophy remains, as Patočka puts it, a philosophy in the "third person"—i.e., it is not an *impersonal* philosophy, one that would only recognize the body as an example of a complex organization of matter, and which would be blind to the reality of the body as an organization "for" or "for the sake of" life, for the actualization of a being in the mode of life. "Life" for a wholly impersonal philosophy could never refer to a mode of being that would be different in kind, a mode of existence that carries with it possibilities of a different order than any "thing." Still, even in Greek thought "life" is thematized within what we could call an "objectivistic" point of view, one which also overlooks the personal character of the situatedness of life, insofar as it puts a distance between itself and that which is being studied. In fact, it takes advantage of a possibility of self-distance basic to the personal field itself: I can always transpose my sense of self into a "third-person" description; I can develop an entire discourse about myself and my surrounding world in the third person, "as if" there was nothing but this third-person view of things, or "as if" things seen from out of this distance appear as what they "truly are."

Contrary to this, Patočka insists on the idea that the dynamic that I am cannot be fully grasped from a distance, as a movement we can observe from the outside, but must rather be grasped from within, as a situation that is always "mine." Greek thought overlooks the significance of this "mineness" even as it formulates a profound conception of life as a pursuit and development of possibilities inherent to it; even when it is clearly aware of the "person" as a being who develops within a community, and of philosophy as a possibility posed by *psychē* to this life, *psychē* in the form of thinking. It is only in Descartes that personhood as such becomes, for the first time, the explicit *basis* for philosophical reflection;

here the I is more than the hidden truth of philosophy, or something that it takes for granted. Here the I encounters itself in a more "fundamental" way—it does not simply become a theme for thinking, but rather philosophical reflection itself is revealed to be an expression of the mode of being that the I is. In Cartesian doubt the I discovers itself as having a special status in contrast to other things; but more than that, the "idea" that it has of itself, which is grounded in its unique grasp of the truth of its existence, becomes the basis of all further reflection on the being of that which lies beyond itself.

Yet, ironically enough, Patočka tells us, the Cartesian program does not lead to a more profound grasp of that situatedness that we are, for the manner in which Descartes conceives of the I established by reflection as indubitable being actually precludes fruitful consideration of the being of this I as situation. The I here is no longer life, no longer the soul of the ancients, but is a pure thinking conceived as substance. Pure thinking—that means an I defined as that which is set over and against the world, as something radically different in the sense of that which is separate from the world, alien in it. Here, where the uniqueness of the I is first made explicit, where the ipseity inherent to personhood is revealed as the basis of philosophical reflection, is also that point in the history of philosophy where the body becomes truly impersonal, for it is subsequently identified with the being of the world as *res extensa*, as that which is ontologically separate from the I, a different "substance." This depersonalization reaches its most thorough expression in thinkers such as Locke, Hume, and especially Condillac, for whom even thinking itself is emptied of personhood on the way towards a thoroughgoing objectivism of both spirit and body.

It is in this context that thinkers such as Maine de Biran become interesting in this history of the body. Biran conceives of our corporeity as the locus of effort, of an encounter with things that is neither merely mechanical or representational, but which can be described instead in terms of concepts of force, energy, power, resistance. Biran's descriptions of corporeity are important not only because they recapture the sense of the body as a situatedness of life from objectivistic trends in science and philosophy. They are also interesting from the point of view of the possibility of formulating an alternative conception of the I that would be

sensitive to the need not only to recapture a dynamic sense of "life," but to understand life as "my" life, not only accidentally but essentially. Biran is a step in this direction: here the I is neither a thinking substance, nor pure thought or apperception—it is not only an I that "is," or that conceives, but as the center of an effort it is something that has to do with the unfolding of a sphere of activity. This idea will come up again in Bergson, but most notably in Husserl in his concept of the I as an "I can"—and here, in setting these thinkers side by side, we begin to see the outlines of a distinct tradition of thinking about the relation of the I and experience, one that stresses the necessity of conceiving of the activity of life as something based on a mode of *self-having*. This "self-having," seen from the perspective of the situatedness of human life, cannot be that of Cartesian reflection. It is more akin to the sort of self-having that had been present in Aristotle's description of *psychē,* even if it was never thematized as such, the entire analysis taking place from a vantage point of the third person, at a distance from which the "act" of life can be observed without explicitly noting the "having" basic to it.

But what is this "self-having"? The "I can" of Husserl—the best text in this context is without a doubt the *Ideen II*[1]—is a mode of holding sway in a situation, but in such a way that the dynamic of this holding sway is not an epiphenomenon but the very opening up of the horizon of the situation as such. That a horizon needs to be opened, that it is something that must be acted on, is why we need to speak of this holding sway as having to do with the I; the dynamism of this opening up cannot be a mere principle *in actu,* as it were. This is what it means when Husserl—and Patočka—stress the fact that the situation of life is an *oriented situation.* Life itself is a multiplicity of activities, of a series of appropriations "in order to"; but this is no mere aggregate of functions, rather it is always something that arises from out of a center that defines the whole. Thus "self-having" here is not merely a fact of self-consciousness, or self-possession as a derivative phenomenon, but is something originary: it is the ever-present starting point of an activity that must arise from *some-*

1. Edmund Husserl, *Ideas Pertaining to a Phenomenology and to a Phenomenological Philosophy. Second Book: Studies in the Phenomenology of Constitution,* trans. Richard Rojcewicz and André Schuwer (Dordrecht: Kluwer, 1989).

XX *Editor's Introduction*

where, must be initiated by *someone.* That is only possible given an I.

Again, this I is no longer the subject of the Cartesian *ego cogito,* though it is true that in Descartes we have already the insight that a thesis is something that needs to be held by someone, that a question must be posed by a questioner, or that an idea is something that occurs within a sphere of the ego as "its own." Even in Descartes, as in Husserl, the theme of consciousness is a theme of "ownness," though the concepts that Descartes used to interpret this "sphere of ownness" are essentially different from those of Husserl (*ideae* and arguments about the nature of representation on the one hand; the concepts of phenomenon and lived experience on the other). In Husserl's analyses, for example in the *Cartesian Meditations,*[2] "ownness" is from the first conceived as a horizon within which the determination of things and our understanding of things takes place; the being of the I is a horizon for the presentation, for the appearing-showing of things. Thus when we say that the situatedness of life must be understood from out of a self-having, thus from the I, what this self-having represents is this horizonal character that marks the appearance of things, thus of the concerns of life. To be an I is to be the sense in which life is set against the horizon of its own becoming, its own development; it is as an I that the present is interspersed with these horizons, and that the life "in" this present is oriented towards its own inner possibilities. That a life is led by someone is an expression of the fact that these possibilities are, as possibilities, an active constituent in the overall character of life as it is "now." This "horizon of possibilities," though "objective," is not something mute, brought out only by our chance encounters with other beings or the world as a whole; we do not discover that they were "there" only when they are "by chance" realized. Rather, as an I, I am a being that actively lives in my possibilities; not only am I on the lookout for them but, as an I, I already am speaking for them, announcing their presence in my life. This is the sense in which all of my activities are defined precisely in terms of the horizon of "my" potential—life is always "on the way to," and is in this sense "egological," or, better, "personal."

2. Edmund Husserl, *Cartesian Meditations,* trans. Dorion Cairns (The Hague: Nijhoff, 1960); see especially the Fifth Meditation.

Husserl's analyses of lived corporeity, most notably those which are found in the *Ideen II*, are a major contribution towards a phenomenological grasp of the "personal" character of lived experience, of its "situatedness" in an oriented space founded on the "I can." Yet Husserl ultimately interprets this horizonal character of experience in a manner that, Patočka argues, is in the end unsatisfying. The reason for this lies in the fact that, for Husserl, the touchstone to understanding the nature of this horizon is *objectivity*. The argument here is not, to be sure, along the same lines of the above-mentioned attempts to take pure objectivity as the ground and origin of all meaning, all senses of being. Rather, Husserl's conception is that the horizon of subjective life is the horizon of the *determination* of objectivity, of the opening up of the world as an objective "reality"; thus even though the dynamism of this life is not identified with objective structures and movements, it is still oriented towards such structures and movements. The conviction expressed here is very similar to that of Kant: the "truth of things," that towards which our thinking or experiencing tends, is the world as a determinate, empirical totality of objects, of that which can ultimately be fully understood as a correlate of a judging, a thesis. Experience, for both Kant and Husserl, is in the end understood to be a type of *thinking,* and the "world" is a world for thought, for a conceiving of things in terms of their essence—and that means things presented by way of their objective determinations.

To be sure, Husserl is no "realist" in the sense of someone who would claim that what the world truly "is" is only a sum of physical things, or even that human being can be summed up as a complex physical system the being of which is no different than any other physical system described by modern mathematical science. Yet it is the case that in Husserl the self-realization of subjectivity—this idea of a life in horizons—takes place as a process of objectification, of fixing the identity of things for the sake of the project of understanding things; the claim here is that the "understanding" that we are is an objective or objectifying understanding.

We could, and this is by no means contrary to Patočka's own position, point out that this is by no means a simple weakness on the part of Husserl, but that in another respect it is a strength. For "objectification" in Husserl is set within a context of its self-development, its unfolding; objectivity here is not the "last term"

of our understanding of what knowledge is, but is rather an expression of something more originary, an act in which something other than mere "objects" realizes itself as something "real," something "actual." Because of all this Husserl's phenomenology poses in a more fundamental manner the question of the *meaning* of objective thinking, the meaningfulness of understanding, of science and knowledge—not as one activity among others but as something that defines us, that is basic to what we mean when we speak of existence that is specifically "human."

Nevertheless, Patočka rejects, or is at least suspicious of, the idea that the horizon of our life, the world that is opened up by the I that orients life towards its possibilities, is a process of understanding in the sense of objectification—he denies the assertion that thoughtful contemplation, and the world that is the correlate of this contemplation, is an expression of what we most "truly" are. Our situatedness, Patočka argues, can be fully understood for what it is only if we begin our reflections with the structures of our existence, as existence—not forsaking the I, but rather turning our attention to what is implicit in the being of the I, of its existence as a horizon.

To this end Patočka considers Heidegger's approach: in Heidegger, reflection begins with the mode in which personal being not only "is" or "exists," but the mode in which this personal being is "here." This "here" is implicit in the I, and we have already touched on it above when speaking of the I as a center of *effort*—for an effort is always bound to a "here," it is "against this" that I push, and in pushing everything is concentrated on this basic "being up against" a resistance. This manner of posing the question of the I—of the I not only as a mode of being, but as a *presence* of a certain type, a presence that is always "here"— sharpens the question of "what we most truly are," for it asks not for a definition but a description (an "analytic") of the way in which we are projected into things, the manner in which we come into our own, actualizing our being.

It is important to note that in following Heidegger's reflection, Patočka has not in fact left behind the I, nor for that matter has he left behind objectification. In Heidegger, too, the horizon of our life is the "objectification" of things, insofar as what things are in their being is realized in reference to our existence, to the opening up of a world that occurs as a totality of references to our

presence. This "objectification" is even grounded in an under-standing—for "Dasein," our "presence," is a type of understand-ing. But neither this "objectification" nor this "understanding" is "theoretical," that is, it is not something which takes place in terms of an explicit, thematic articulation of the world around us—even if it is a matter of understanding, it is not necessarily a matter of thinking, of holding a thesis about this or that entity in the world.

Thus in Heidegger's *Being and Time*, the "world" is analyzed not as a horizon within which a totality of objects is actualized in accordance with a totality of theses that is subjectivity; rather, there is an attempt here to think anew the relation between "personal being," the presence that is always entailed in this mode of being, and the "world" that is revealed with reference to it. What specifically attracts Patočka to Heidegger's project on this score is the primacy given to *practice,* to the idea that it is within the *practical horizon* of our life that the fundamental structures of personal being are most evident. The point is not, however, that the world is there merely as a store of tools for my own purposes; the idea is rather that our very being resembles the existence of a purpose, i.e., that the course of its actualization is analogous to the way a purpose assimilates things "to be used for . . ." Thus it is not that we merely "have" purposes and ends, which we then use to orga-nize a context around us; in a sense we *are* these purposes and ends, we are that practical activity which is referred to whenever a thing "has its place," is "used for . . ." The activities of our life are not just projects that we take up, but in an important sense these are projects we become—which means that being concerned with projects, living a life as a realization of what is possible in life, is simultaneously to be concerned with our being. And here again is the theme of a "self-having," of the I, but one that brings phe-nomenological description closer to the "concreteness" of life.

There is something else that goes with this "primacy of the practical." In Heidegger, this self-having, this being-concerned with our being as a projection, has nothing to do with a "self" that is prior and independent to the act of reaching it, of realizing it; the "self" is no idea that I then realize "in the world," as if the world were a ready fund of material, a supply-house of being. The "self" here is not a pure spiritual existence, but is fundamentally bound up with a "world" to be what it is: in our concern with our

being we are—and must be—an *openness to things,* open to their becoming involved with our self-concern, with the "project" that we are. "World" and this openness on our part are two elements of the same movement—our openness to things does not merely take note of things that we happen upon in an objective world about us; it is not as if we first have things, then somehow make "use" of them, these uses and purposes being something wholly "subjective." For our "self-having" to be an *actuality,* for an individuation to occur in which life initiates that multiplicity of activities "for the sake of" this or that Dasein, our life must have already come into being as a horizon of praxis, it must already be a "being-in-the world," a *living out* of what we are. It is because we are originally this acting out of possibilities that our presence is this openness to the horizon of the world; and it is because of this "worldhood" of Dasein that things are for us "pragmata," "some-things-for," "usables" *(Zeuge).*

There is much that Patočka appropriates from Heidegger, in particular the analyses that one finds in *Being and Time.* Patočka, too, emphasizes the finitude that characterizes the presence of personal being, of the mode in which personal being "is"—and not only in that our life is "finite," but that finitude is an *issue* for personal being. Patočka also adopts the Heideggerean conception of the temporal structure of Dasein as a futural projection from an "already there," a "from which"; further, the "world" as that "in which" *(Worin)* the concern with things unfolds as a system of references, of "places" defined in terms of the pragmatic, the "for the sake of" such and such. Yet Heidegger's phenomenology in the end proves to be inadequate to the problem of the body—not that the analyses in *Being and Time* are inimical to it, but that they fail to stress what is implicit in personal being as something corporeal, something "physical."

To be sure, Heidegger's pragmatic analysis of personal being had introduced a deeper meaning of the "concreteness" of life, one more genuine than the idea of the concrete as that which is objectively determinate. Yet the *corporeity* of personal being suggests an even more radical situatedness in things, a submersion into that which is not so much a reference to the *possibilities* of Dasein as its boundary, something out of which its being is individuated and into which it is dissipated. In this way the body, the corporeal character of any "becoming" that life is, highlights the

limits of the concept of Dasein in helping us to grasp fully the nature of the relation between personal being and world.

In pushing beyond Heidegger, Patočka follows the path of Merleau-Ponty, Levinas, and others in trying to grasp the sense of our corporeity, something we always carry with us in our experiencing, as indicative of a proximity we have to things, a nearness to the bodily, however much it is the case that our lives are the unfolding of possibility, an openness to the future of what "is" not yet. We are that part of the world that sees and "experiences," which always implies a distance or nonproximity to what it is we see, but nevertheless we are at the same time something "worldly"—not only in Heidegger's sense, but in the sense of creatures who are as much "of" the world as an "openness to" the world. The idea here is to radicalize the reflection on Dasein, to turn this reflecting towards the task of finally arriving at "my actual presence to myself" (Merleau-Ponty).[3]

But what is this "actual presence"? It can only be the presence of that which I am: an identity of self, a history I carry with myself and a future towards which I project myself, a thinking and an understanding—all the modes of human transcendence—but in the sense of something that is "happening" here and now as I sit and ponder and think. All of these transcendences are postures of a situation, which is "me," but there is also an inescapable sense in which they are postures of my body, that everything that I am is somehow bound up with this corporeal being-here. It is as if all the activities that I am, all of my taking things up and making them a part of my "projection" as a being of possibilities, has also taken up a part of the world, a part of "being" into itself—but in a fashion fundamentally different from the way that a being *(Seiende)* is assimilated into a context of activity as a pragma *(Zeug)*. "Being"— my own, that of things—is present differently in my corporeity; the body is more than what the practical-existential interpretation of the situatedness of personal being brings to light. Quite literally, situatedness as corporeal points to a "feel" that is something more than situatedness as a "context of activity"; there is an irremovable

3. Maurice Merleau-Ponty, *Phenomenology of Perception*, trans. Colin Smith (London: Routledge and Kegan Paul), p. xv. See also Emmanuel Levinas, *Totality and Infinity,* trans. Alphonso Lingus (Pittsburgh: Duquesne University Press, 1969), especially section 2: "Interiority and Economy."

proximity to things being expressed by corporeal being that needs to be acknowledged, an affectivity that is as "primordial" as the practical character of the personal field.

One could note here Husserl's solution to conceiving the nature of this proximity that we have to things, something Patočka does not explore here, though he was well aware that Husserl was anything but oblivious to these questions.[4] For Husserl, too, it is as a body that I become aware of my "actual presence to myself," it is the mode in which I am "here." But more important than that, it is the mode in which I am "real," and to be real, as we said above, is according to Husserl to be the "pole" of a process of objectification, to play the function of a correlate of a subjectivity that realizes itself as a grasping of things as determinate "objectivity." Everything that I experience, I experience "as" something; my experience itself is a manifestation of a conceiving activity. Thus when I grasp something "in" experience I am always preparing the ground for the possibility of contemplating it as an object.

That subjectivity comes to grasp *itself* as something real, that "transcendental experience" is at the same time preparing the ground for the conception of an empirical ego, is of twofold significance. First, this assertion of Husserl's contains the affirmation, crucial to transcendental phenomenology in general, that the being of the world and the being of subjectivity are radically different—that the former is a being *nulla "re" indigit ad existendum,* while the latter is on the contrary a horizon of dependent being, of being dependent on the experiential articulation of a "nature" precisely "to be" what it is. However—and this is the second significant point—this "difference" of subject and world is precisely why the particular type of "reality" that is the empirical subject must be understood in terms of a fundamental, originary *achievement.* The achievement lies in the fact that, in the existence of the empirical "I" (precisely as corporeal), this divide between subject and world, this difference, has always already been overcome, shunted aside. My corporeal existence is itself the demonstration that *it need not be the case* that this difference be explicitly drawn, that it become

4. See in particular Jan Patočka, *An Introduction to Husserl's Phenomenology,* trans. Erazim Kohák, ed. James Dodd (La Salle, Ill.: Open Court Publishing, 1996), chapter 8, "Incarnate Being."

operative in life as its defining characteristic. On the contrary: not drawing the radical difference between subjectivity and world is the condition for the development of empirical, "worldly" life, for it is the condition for that "naiveté" basic to the natural attitude. Thus it is this "achievement" that is fundamentally what "we" are, and it is the basis from which we need to understand the onset of human life as a unity of the self qua empirical *and* transcendental. To be sure, in contemplation we indeed draw out this difference, for it is part and parcel of the task of self-knowledge posed by philosophy, and is something which occurs from out of an act of freedom; but in our "life," in our presence to ourselves as something "real," something empirical, we are an "understanding" or a "thinking" that has always already taken another course.

By contrast, for Patočka this path of reflection would be misleading. Patočka does not interpret our proximity to things as the result of an achievement of passing over a divide between subject and world, but rather seeks to formulate the problem thus: how is it that personal being is something that arises out of, but which also bears within itself, its worldliness? The question here is not only one of being "at home" in the world, of bringing ourselves near to things by way of the familiarity achieved by our understanding of things and projects. The goal here is rather to grasp a more originary sense in which we are creatures "of" the world, to capture in our descriptions that sense in which our life still bears the trace within it of that out of which we have been individuated—and thus, as Patočka says, to win for ourselves a "more radical" concept of the world, of the "wherein" *(Worin)* of Dasein, than that of Heidegger.

The insight here is that, as creatures who live in possibilities, we are the realization of a mode of "being" as something that is not indifferent to itself (Heidegger); in this sense we are the exception to all that which is precisely indifferent, to the vastness of indifference that surrounds us. Patočka's question is: does not this difference somehow mark us, that difference which is not one between world and subject, but between being as life, being that is concerned with itself, and being that is indifference, that is in no way "self"? Is not the concreteness of our life—life as dynamism, as unfolding—in truth a "manifestation" of both, in the sense that our individuation is always against precisely the background of this indifference of being?

Here Patočka's path of thinking is comparable not so much to Husserl or even Heidegger (even the Heidegger after the so-called "Kehre"), but to the project that one finds in German idealism of tracing the emergence of subjectivity out of its own prior, unconscious being. Hegel's *Philosophie des Geistes* is mentioned in these lectures, and perhaps should be kept in mind as a fruitful source for comparisons. In particular the section that Hegel titles "Anthropology," in which he traces the development of emerging consciousness as it passes through stages of what we could call a "natural subjectivity"—that is, a subjectivity that has no awareness of itself, but is rather a pure sensitivity to things, and which is in fact the mode in which "nature" itself begins to feel its own being. One even finds here a description of the animate body as the medium through which spirit passes in order to transcend this sensuous immediacy of nature to the level of self-consciousness, to the subject fashioning itself as a knowing subject rather than a feeling subjectivity of (unconscious) nature. This body, in the end, becomes refashioned as the mere "sign" of the freedom of subjectivity, but its "presence" is always a mark of the unconscious nonself from which subjectivity has been individuated.

Patočka's own strategy is to combine the idea of personal being as a being in possibilities, grounded in a basic, originary concern for its own being, with Aristotle's concept of movement as an actualization of potentiality. Here the ancient solution of Aristotle to the problem of nonbeing, the argument for possibility *(dynamis)* as the presence of what "is" not (yet), is combined in an intriguing fashion with the Heideggerean problematic of the individuation of Dasein, of the projection of its possibilities before it but at the same time its being "taken up" by things, its radical dependence on them to be what it is. Dasein is this "situation" that opens up with the projection of its possibilities; but in what sense is this being "corporeal"? Patočka argues that it is corporeal, something real, physical, in a manner analogous to the real physicality for Aristotle of a movement: it is the physical presence of a process, of something "possible" in the mode of its being "on its way." In adopting this Aristotelian motif of movement, Patočka believes he can capture in his descriptions a tangibility of personal being that is lost in Heidegger, that necessary corporeal quality of this "on the way to" that defines life in possibilities.

Thus to follow Patočka here (or Aristotle and Heidegger, for that matter) is no longer to talk about possibilities in the abstract, reflecting on what something "could be," but is rather to demand that a sense of the physical enter into our description of this process-character of the being that we are. Is Patočka successful in doing this? Does the phenomenology of the body as it is lived provide us with a conception of corporeity that enables us to claim that I can still talk about situatedness in terms of bodily movement, a *physical process* of my developing life?

Of course, "physical process" here is not that of modern, or even Aristotelian physics; "physicality" is being employed in a metaphorical sense. The idea is to recapture a sense of "natural being" that is always a part of us even if we accept the idea of freedom as basic to human existence; it is not meant as a claim that situatedness of life is in the end a physical process. Thus instead of speaking of the body as the locus of biological processes, of "life" in the "biological" sense, we have in these lectures a description of the "rootedness" of human life, of the onset of individuation within a physical space prepared by others for its individuation. This is a realm that is both physical in the literal sense—life begins in someone's arms—and physical in the sense of a realm of affectivity, of a sensuousness, of a "rhythm" of individuation that has the "corporeal" characteristics of warmth, protection, safety, shelter. This is not a factual description of "real world" structures, coordinates within which subjective life unfolds, but is evocative of the feel that our life has for us, that this "rootedness" has an affective quality not captured in the more "cerebral" observation that our life always emerges "out of" something prior to it, that our future is always grounded in the past.

The second movement of human life that Patočka outlines is tied to the active formation of the environment, of a field in which pursuits due to need determine the rhythm of existence— and this too is physical in the literal sense, in that the world of things is something that I actually come "up against" in the effort of changing, manipulating, altering, destroying. Yet here as well Patočka strives to evoke the affective characteristics of this dimension of life, for his description does not operate with the relatively abstract concept of "pragmata" but with something that appeals to sensibility, to an aesthetics of life—his descriptions here appeal

to our sense of the transformation of life and world not in terms of an abstractly conceived "actualization," but as "labor," something we have a primordial feel for as that which is "burdensome." To be sure, Patočka is still attempting to show us something about personal being, about the self-having that is essential to opening up the world as the world of a life of projects—yet here the idea is to evoke the physical presence of this life, the affective rhythms of its self-realization.

There are a number of additional texts in which Patočka elaborates the philosophy of movement, and which are very useful to the reader in assessing its merits. This is particularly the case with respect to the "third" movement of human life, that of "truth," the most direct expression of which is historical life. Here is where this path of thinking that we have been outlining comes full circle, returning to the theme of philosophy as the self-transformation of life, the emergence of a new sense of "self" from what had been "before." This emergence, too, is a "movement" of human life, and not a pure spiritual act of transcendence—that is, the relation to "truth," to truth as the manifestation of all that is, is not primarily a task of *thinking* but of *living*. This movement of life, Patočka argues, becomes something "manifest" in the form of historical existence—i.e., not just in our "having" a history, a habit of telling ourselves the story of our past, but of "living historically," living in the light of the truth revealed by history.

This connection of history and truth from the perspective of the philosophy of movement is treated more fully in Patočka's *Heretical Essays in the Philosophy of History,* in particular the second essay, "The Beginning of History."[5] In addition, a key text on the idea of movement and its appropriation in the development of the idea of the "natural world" is the essay "Natural World and Phenomenology," especially the final section—this text has been translated by Erazim Kohák and appears in his *Jan Patočka: Philosophy and Selected Writings.*[6] This volume also contains a number of other essays by Patočka on Husserl and Heidegger, as well as Erazim Kohák's philosophical biography of Patočka, all of

5. Jan Patočka, *Heretical Essays in the Philosophy of History,* trans. Erazim Kohák, ed. James Dodd (La Salle, Ill.: Open Court Publishing, 1996).
6. Jan Patočka, *Philosophy and Selected Writings,* trans. Erazim Kohák (Chicago: Chicago University Press, 1989).

which serve as a useful supplement to *Body, Community, Language, World*. Also of importance for understanding the philosophy of movement are three texts that have been translated into German, and which appear in the *Ausgewählte Schriften* edited by Klaus Nellen at the Institute for Human Sciences in Vienna: "Der Raum und seine Problematik," "Zur Vorgeschichte der Wissenschaft der Bewegung: Welt, Erde, Himmel und die Bewegung des menschlichen Lebens," and "Was ist Existenz?"[7]

I would submit that the philosophy of movement presented in these texts is Patočka's most original and valuable contribution to phenomenological philosophy. Yet I would hesitate to say that this contribution is free of ambiguity, that it represents a clear step beyond what is best in Husserl and Heidegger. There is too much of a sense that the conceptual ground has not been prepared enough, that the force of these descriptions of human life rely too much on the commitment of the readers (and, originally, the listeners) to engage faithfully in the effort of "seeing" what it is that Patočka is endeavoring to put into words. To be sure, philosophy is also such a commitment, it always involves an act of faith in one another to follow an insight no matter how difficult, to be dedicated to the task of understanding what the other is trying to say. But there is also the hope that, on the far side of all of our struggles with ambiguity, we shall be able to speak what it is we see, speak with clarity and rigor—and here this hope remains just that.

Yet I would also hesitate to call this philosophy of movement "incomplete"—for are not all phenomenological projects incomplete? Indeed, what would it mean for a phenomenological analysis to be "complete?" Would it mean that there is nothing more to add, that the analysis does not take us anywhere further, that it has reached its limits of demonstration, or of what it was trying to show? But is it not the case that what makes phenomenology so fascinating still, some sixty-five years after the death of its founder, is precisely the fact that it is the *opposite* of such "completeness"?

7. Jan Patočka, *Die Bewegung der menschlichen Existenz. Phänomenologishe Schriften II*, in *Jan Patočka: Ausgewählte Schriften*, ed. Klaus Nellen, Jiří Němec, and Ilja Šrubář (Stuttgart: Klett-Cotta, 1991).

PART ONE

Body and the Personal Structure of Experience

First Lecture:
Subject Body and Ancient Philosophy

What sort of body? Not the body that anatomy or physiology examine, but body as a subjective phenomenon, the human body as we live it in lived experience. That *living body* is the presupposition of our even being aware of an anatomical and a physiological body. Such subjective body is no mere reflection of the objective body. It is subjective, but it is also objective in the sense of being a necessary condition of life, of lived experience. An entire philosophical tradition understood human body in such a way that the body as our own, as we live it and as it experiences itself, could never become a topic of philosophical reflection. To some extent, even presenting this thesis here is a transgression against our phenomenological method.

Phenomenology is a mode of philosophizing that does not take ready-made theses for its premises but rather keeps all premises at an arm's length. It turns from sclerotic theses to the living wellsprings of experience. Its opposite is metaphysics—which constructs philosophy as a special scientific system. Phenomenology examines the experiential content of such theses; in every abstract thought it seeks to uncover what is hidden in it, how we arrive at it, what seen and lived reality underlies it. We are uncovering something that has been here all along, something we had sensed, glimpsed from the corner of our eye but did not fully know, something that "had not been brought to conception." *Phenomenon*—that which presents itself; *logos*—meaningful discourse. Only by speaking it out do we know something fully, only what we

3

speak out do we fully see. That is what makes phenomenology so persuasive.

By phenomenology we shall not mean only the teachings of Husserl. What we have defined as phenomenology—learning to think and see precisely (how to read, how to articulate what we see)—is always present in philosophy. The entire philosophical tradition is a combination of the art of thought and the art of seeing. Philosophy moves between Scylla and Charybdis: between an inability to articulate consistently and precisely what it sees and wants to articulate, and, on the other hand, a precise formalism, keenly honed by tradition and devoid of content. Conceptual rigor is valuable even when thought errs; even philosophical errors are valuable from this standpoint, because they mark out paths (where the consequences lead, where the blind alleys are, and so on). However, to have a project to follow, a philosophy has to *see* something fundamental, something which in some sense defines the world. So for instance, the Platonic *idea* (the *idea* is a percept, something the mind sees). Or Aristotle's *entelecheia* (idea as a force exercising an effect—Platonic idea brought into act). The Cartesian *cogito*. The Leibnizian monad. The ability to see is constitutive for philosophy as such. To see not trivialities but what is fundamental, determining the world as a whole. This ability to see (as against depending on a hunch, on an "intuition") is what philosophy sought to master systematically long before phenomenology. How to comprehend what is seen, what is given in person, and not just as a form. Particularly the empirically oriented trends in philosophy sought to do this. There are profound phenomenological insights in Bergson's analysis of the *durée*, in Mach's analysis of sensation (what I see, a thing, is primordially given to us, sensations are abstractions from it).[1]

Husserl was not the first to discover the subjective body. Something of the history of the problem before Husserl: We encounter remarkable speculations about the body in the

1. For the concept of *durée*, see Henri Bergson, *Time and Free Will: An Essay on the Immediate Data of Consciousness*, trans. P. L. Pogson (New York: Humanities Press, 1971), pp. 75–139. Also, compare with the description of the immediate present given by William James in his *Principles of Psychology* (New York: Holt, 1927). For Ernst Mach's analyses of sensation, see his *The Analysis of Sensations, and the Relation of the Physical to the Psychical*, trans. C. M. Williams and Sydney Waterlow (New York: Dover Publications, 1959). *Ed.*

preclassical phase of Greek philosophy. Thus Parmenides: what kinds of thoughts we have depends on the interaction of our members. Empedocles: like perceives like (both the world and our body are mixtures of elements—protolives, protoelements, protoroots). Democritus: the human body is a mosaic made up of mental and physical atoms, the soul-*psychē* is a part of the body-*sōma*.[2] All of that presents a definite conception: perception is a natural process made possible by the unity of the body and the world. What body is that? The body we experience through the senses, which is distinct from us, not the body which differs from all others in my lived experience by being *mine,* by being the null point of my orientation, by my being able to draw away from (and approach again) all bodies-in-space except my own body. In Greek thought we encounter only such an external perspective of the human body. How far can such a philosophy go, and how far did it go? Up to anatomy, to physiology, to general biology, etc. The problems that arise on such a basis are those of the whole and the part, of composition, etc. Among the atomists we encounter the problem of that which appears and grows as an ephemeral structure founded on the elements, merely appearing, and yet at the same time continuous with the foundation that underlies it—*doxis epirysmiē.*[3] (So-called emergent qualities; a higher quality cannot

2. (a) *Parmenides.* Patočka is referring to a highly confusing (and controversial) fragment from Theophrastus (DK 28 A46), where the doctrine is ascribed to Parmenides that "As is at any moment the mixture of the wandering limbs, so mind is present to men; for that which thinks is the same thing, namely the substance of their limbs, in each and all men; for what preponderates is thought." The overriding gist of the Theophrastian commentary accompanying this "quotation" is that the perceiving, sensing (even "mixing") body is what underlies "thinking." See Kirk, Raven, and Schofield (hereafter "KRS"), *The Presocratic Philosophers* (Cambridge: Cambridge University Press, 1990), p. 261. (b) *Empedocles.* In the fragment of Theophrastus just quoted, Empedocles is said to explain sensation as the adjoinment of "like by like" (see KRS, p. 261). For the doctrine of the "four roots" as elements that are in a continual cycle of coming together (love) and being pulled apart (in strife), see Simplicius *in Phys.* 158, 1 (KRS, p. 287). Also, see KRS, pp. 302–5, which reconstructs the broad outlines of a zoogony from fragments culled out of Simplicius, Aristotle, and other sources. For Empedocles, the "roots" combine to produce bones, blood, and "the various forms of flesh," which, in a second stage, "harmonize" into parts of bodies. These pieces, before they unite into whole organisms, exist as disconnected parts: "Here sprang up many faces without necks, arms wandered without shoulders, unattached, and eyes strayed alone, in need of foreheads." (From Aristotle, *De Caelo,* 300b30; translation KRS, p. 303). (c) *Democritus.* See Aristotle, *De Anima* 404a1–16, where the "mental" atoms that Democritus identifies with the soul are described as spherical; they are also "light" and thus, in some sense, akin to fire. *Ed.*
3. The reference here is to DK B7 (see KRS, p. 410): "etē ouden ismen peri oudenos, all epirysmiē ekastoisin hē doxis," which Baily translates as: "We know nothing truly about

be reduced without remnant to a lower foundation from which it grows.) Dictionary meaning of *doxis* is appearance, though it is no mere appearance but rather something objective—that which appears (manifests itself) on the foundation of this mosaic of elements, that which emerged as that *doxis.*

It is the same in the second Greek tradition, stemming from Plato (since Socrates is intangible). As against Aristotle, who looks at things physically—from the viewpoint of *physis*—Plato looks at things from the viewpoint of *logos*—meaningful discourse, language. Only on the basis of discourse can I communicate with others and with myself, that is, return to my starting point as to the same. The need to understand myself and others, to communicate about "what there is," what words mean—that is the inspiration of Platonic philosophy. The meaningful word belongs to a meaningful world—to a world which can be read and spoken. (That is something different from the mechanical world of Democritus's atomism, a world composed of atoms, of elements, as literature is composed on the letters of the alphabet. Out of letters, we can make up all words, those differ from each other in terms of letters and of their ordering. However, it is not a matter of a reductionism as in modern mechanism; we have said that *doxis* is an objective appearance, based on shape, not reducible to the level of the elements.) Therefore the world is understood as an organic being, as a living organism, or at least as governed by living beings (sun, moon, stars—their movement is a sign of intelligence), a world that has a rational order, that is, a comprehensible, intelligible one ("if we open our eyes, we see gods").[4]

This tradition, too, pondered the phenomenon of the body—Aristotle and Theophrastus in particular.[5] It gave rise to anatomy,

anything, but for each of us his opinion is an influx." Thus "doxis epirysmiē" could be translated as "the flux of opinion," where, in Democritus, this "flux" is caused by atoms entering the body from the outside, disturbing the soul, thus giving rise to sensations. For a discussion of the Democritean theory of perception and knowledge, see Cyril Baily, *The Greek Atomists and Epicurus* (New York: Russell and Russell, 1964), pp. 156–74. *Ed.*

4. As illustrative, see book 10 of Plato's *Laws*, 895a6–899a2, where the Athenian Stranger develops the argument that the rational order of the phenomenal world—including both the movements of the heavens and the intricacies of human affairs—is explained with reference to the infusion of the world with "souls," or principles of self-motion. This passage ends with one of the earliest references to Thales' gnome, "all things are full of gods." *Ed.*

5. See D. W. Hamlyn, Aristotle's *De Anima*, books 2 and 3 (Oxford: Clarendon

zoology, botany—all of natural science, in the form of a descriptive science which lasted down to the eighteenth century. What I *see* in the light of the meaningful word, discourse, is idea-*eidos* (as with the Pythagorean theorem—if I grasp the proof it offers, then I *see,* I behold the meaning of the theorem). *Logos*—the word infused with meaning, always has its *eidos* in which it finds its fulfillment. Aristotle's *eidos,* however, is not only something I say but also something that lives in nature, we need to understand *eidos* as a vital function. The living body, the organism, is a system of vital functions—*eidos* at work, *en ergo.* Reality is *energeia,* idea at work. Aristotle analyzes the human body from this viewpoint, that of vital functions. That can become the basis for a physiology. *Peri psychēs: psychē* is a sum total of vital functions, not a new thing in our body but body itself, that which is at work in it, the *logos* that can be taken out and spoken, defined. *Logos* is an order which, of itself, is not fulfilled. We cannot ask whether body and *psychē,* life and its form, are the same (just as we cannot ask whether wax and its shape are the same).[6] If *logos* is at work, it is at work with a material—*hylē.* Body and soul thus stand in the relation of material and shape, dynamically understood. The three levels of life: vegetation—whose vital function is *trophē,* growth, multiplying. The vital form of the animate being includes in addition *kinēsis,* movement. That in turn depends on orientation based on *aisthēsis,* perception. *Aisthēsis* and *kinēsis* belong together as inseparably as a hill and a valley (though the characteristics above-below, fore-aft, . . . are taken for objective traits of space, not as functions of our orientation). *Aisthēsis* is the ability to grasp shapes independently of material, though only singly. Humans in addition have *logos,* the ability to grasp an order, not only individual shapes but shape as a manifestation of the eternal *logos,* eternal and universal shapes. Therefore humans are beings who have speech.[7] Thus Aristotle, representing the objectively idealistic

Press, 1968), for an interesting translation of the sections of *De Anima* pertinent to Patočka's discussion; for a translation of the *Theophrasti Fragmentum de Sensibus,* see George Malcolm Stratton, *Theophrastus and the Greek Physiological Psychology before Aristotle* (London: Allen and Unwin, 1917), which includes both the Greek text and commentary of the Theophrastus fragment. *Ed.*

6. See Aristotle, *De Anima* 412b6–9. The whole of book 2 is pertinent to Patočka's discussion here. *Ed.*

7. It is perhaps more accurate to say that, for Aristotle, what underlies "speech" (i.e., not only as sounds used for communication or other intentional behavior, broadly defined,

tradition in Greek philosophy, also sees the body as a thing avail-
able to perception, at a distance, not as *my* body. In ancient phi-
losophy, *psychē* is never understood as a subject (in our sense of
the words "soul" or "mind"), but always in the third person,
impersonally, as a vital function.

By contrast, modern philosophy begins with the words, *Cogito
ergo sum*. It is the thought that certifies itself. That cannot be
articulated except in the first person. Otherwise—in the third per-
son—it becomes an ordinary syllogism or a part thereof, present-
ing no evident truth about reality. There are certain propositions
even in ancient philosophy: "Know thyself!" (though that is an
imperative). "I have examined myself." "Thou wilt not find the
bottom of the *psychē* though thou travel all the paths, so deep is
its *logos*." (Heraclitus—the way from humans to gods).[8] Their
content, though, is different: Learn thy place in the cosmos, learn
that thou art a worm, that thou signifiest nothing to the gods,
etc. In ancient philosophy there is no subjectivity, all this philoso-
phy is in the third person. It does not know self-reflection, it does
not know the "I" ("I" is contained nowhere in a philosophical
thesis). Being is always *that*.

but as a set of meaning-laden and meaning-referring sounds) is not only "logos" but
"nous." Any sensing is a *logos*, or is the grasping of a *logos*—see *De Anima* 424a26–32,
where Aristotle explains that "excess in the objects of perception destroys the sense-organs
(for if the movement is too violent for the sense-organ its principle [*logos*] is destroyed—
and this we saw the sense to be—just as the consonance and pitch of the strings are
destroyed when they are struck too violently)." (Hamlyn's translation.) The use of mean-
ingful speech is the domain not only of creatures who "sense," thus "see" the world via
logos, but of those who "deliberate" or "calculate" on the ground of sense experience. See
De Anima 434a5–10: "Imagination concerned with perception [*aisthētkē phantasia*], as
we have said, is found in the other animals also, but that concerned with deliberation in
those which are capable of reasoning [*bouleutikē hen tois logistikois*] (for the decision
whether to do this or that is already a task for reasoning [*logismou*] and one must measure
by a single standard; for one pursues what is superior; hence one has the ability to make
one image out of many [*hōste dunatai hen ek pleionōn phantasmatōn poiein*]." (Hamlyn's
translation.) *Ed.*

8. "Know thyself!" (*gnōthi sauton*) is the inscription at the oracle of Delphi; "I exam-
ined myself" probably refers to Heraclitus fr. 101, from Plutarch, which can also be trans-
lated as "I searched out myself" (cf. KRS, pp. 210–11); and the last is also a gnome
attributed to Heraclitus (fr. 45; see KRS, p. 203). *Ed.*

Second Lecture:
Body and Person—Descartes

Modern philosophy, which discovered the personhood of humans, had not yet made the discovery of the personal character of their bodies. In most of the philosophical tradition down to our time the structure of personal relation, the protostructure of the situation in which humans always live, is not taken into consideration at all. Traditional philosophy is philosophy in the third person—he, she, *it*—to which other personal relations are reduced. Ancient philosophy is a philosophy of the thing. In the objectivistic conception, the world is an aggregate of things and is studied as such. The fact that our relating to the world always takes place within a matrix whose fundamental structure is always one of I-thou-it is overlooked, passed over as merely subjective. As a result, all older philosophy passed without notice over the fact that it understood that which is the *foundation* of our experience, the first presupposition of our dealing with things, with others, with ourselves—our body—not personally but in the third person, as an *it*—as a thing, an object of experience. Ancient philosophy with its double tradition, stemming on the one hand from *physis,* on the other from *logos,* conceives being always as the being of a third person. It is *it.* Ancient objective idealism unhesitatingly hypostatizes subjectival traits as entities in themselves. Thus for instance according to Plato the world is a sphere, can be said to be an organism and to have subjectival traits like the human organism. The movement of an organism is tied to perception. When we get our bearings, above-below . . . , these traits are taken as objective traits, the "subjectival" characteristics of the

9

universum, independent of human orientation in the world. We designate certain linguistic structures as "pronouns." This term points in the same direction. A pronoun is taken to be something that stands in for a noun, for a name. As things are basic to the universe, so nouns (the names of things) are basic to a language. Pronouns are substitutes for names. There is no awareness here that we can speak *only* within a personal situation, defined by the structure of I-thou-it. This structure is not derived from an objective nominal one, but rather belongs to the situation of discourse. Hence pronouns are not pictures of some objectively given complex of things (that whereof we speak), they are not substitutes standing in place of names/nouns; they express, rather, the fundamental structure of discoursing.

It was, far more, religion which discovered the realm of the personal. It opened up entirely new themes for focusing on our position in the world: fear, anxiety, dread of personal damnation, agony over one's own unworthiness—all that presupposes an *I;* a trust in help entails a *thou.* It was, however, only late Hellenistic thought and the Church fathers who made all that accessible to reflection. Their reflection, though, operated primarily in the moral and theological realm. It did not focus on the body as the center of orientation, as the starting point for experiencing the world, as that which makes us a part of the world, albeit a privileged part, with its own perspective. The body is understood as that which makes us subject to imperfection, to sinfulness (St. Paul),[9] as that which roots humans in the moral rather than the physical totality of what there is. Living corporeity is ignored. In theology, corporeity is thematized as incarnation—the Word embodied, the spirit in flesh. That, though, is a long way from anthropology.

It is modern philosophy (Descartes) that first starts out from the I. Descartes does begin with self-awareness, the consciousness of I, but the attention of philosophical reflection is soon distracted once more, from personality to something objective, impersonal, to a metaphysical substantiality. For that reason the problem of the subjective body remained undeveloped for so long. Descartes discovered the problem of subjective corporeity but hard upon that discovery he covered it over again.

9. Romans 7:25. *Ed.*

Interpretating Descartes's *Meditationes de prima philosophia*

Descartes's starting point is markedly personalistic. *Ego cogito* cannot be transposed into an impersonal, third-person form. Attempting such a transposition would yield the syllogism,

Whatever thinks, is;
Descartes thinks,
∴. Descartes is.

With that, though, the dictum becomes empty. It no longer demonstrates the certitude which automatically certifies itself when we attempt to doubt it. What drops out is the nature of self-certifying knowledge, of a thesis which itself makes itself a verified thesis, a truth. Cartesianism does not result in a personalistic philosophizing but in a replay of substantialist metaphysics. Its basic conception, its conception of what really exists, is *substance*—being that persists, that stands unchanged beneath all its specifications, a thing, something that we grasp in its nature when we express it in the third person. After a personalistic beginning, there comes a radical objectification, a conception of the world from the perspective of substance. In such an impersonal way Descartes understands the phenomenon of corporeity, only out of the corner of his eye does he glimpse something other—the body as his own.

Descartes's systematic doubt: to eliminate all that can be doubted, in the hope that the result will be something which I demonstrably know to be indubitable. I reach most of my experiences through my senses, by the way of the body. Descartes bases his general doubt about that bodily approach on the argument from the continuous dream.[10] There is no criterion for distinguishing dreaming from waking. Thus what we learn from the senses is not indubitable and we can make no further use of it. It is a pity that Descartes did not go further, that he overlooked the fact that even a dreamer has a body, albeit a dream body, that the dreamer is not disembodied, that a body is necessary even in the

10. See René Descartes, *Meditations on First Philosophy,* in *The Philosophical Writings of Descartes,* trans. Cottingham, Stoothoff, Murdoch (Cambridge: Cambridge University Press, 1984), p. 13. *Ed.*

world of dreams. I have to be somewhere; whatever I see (even in a dream) I must see from some perspective, from *somewhere* in space, from where I-who-see, I-who-think, am located. However, I can be somewhere only through a body; otherwise it is not I but only the thought of an I. The dream actually is no argument against the subjective body. For that matter, Descartes himself raised the objection that dream imagination presupposes non-imaginary components, that imagination means combining such components. He does not, however, apply this to his own subjective body at all but, surprisingly, applies it objectively: there are basic components (for instance, triangles) which are neutral with respect to reality or irreality, and there is a science of such components. It does not matter whether a triangle exists or not, a rigorous theory applies to it in either case. A geometric theorem can be proved both in waking life and in a dream. A dream can be at times coherent; there are truths that have been discovered in a dream. In a single leap, Descartes moves to something that is entirely objective, to the realm of geometry understood without any subjectivity, without any perspectival quality. Geometry can be put to metaphysical use, to define the essence of material substance, the essence of the external world as extension—*res extensa*. If geometry is what contains that essence, what communicates to us the essential, verified properties of things, then anything in bodily experience that is reminiscent of anything personal must be excluded as a subjective addition, a subjective reflection which in no way belongs to the essence of things. It is through geometric, quantitative definition that we reach the essence of all extended things. My body, too, is an extended thing, it belongs to *res extensa* and, with respect to its essence, cannot be observed except in the objective perspective of mathematical definitions: even about my body I can learn objectively only by geometric methods.

In his second meditation, Descartes clarifies the concept *substance* with the example of wax.[11] He shows that the apparent definitions of things at which we arrive by sense experience are superficial. This piece of wax has a certain color, smell, taste, etc., but, when we place it near a flame, the color, the smell, the taste change. Yet no one would say that it is not the *same* piece of wax.

11. See ibid., pp. 20–23. *Ed.*

Essence is that which lasts, and so it cannot be the color, etc. On the one hand, Descartes is speaking of the wax which someone can hold, on the other he wants to speak of what persists when attributes change. Are these experiences of the same order? A substance lasting through the change of attributes and a manipulated piece of wax—is that entirely the same? Is the wax with which I deal in practice a substance, a bearer of attributes? The manipulated wax is an object only in a special sense of the word, it is not a thing that can be analyzed from the viewpoint of what perishes and what does not. It is a part of our lived, meaningful world. Every aspect of it points beyond itself to a context, to circumstances among which it finds itself. That piece of wax is not the sum of attributes but a continuum of references that leads from one experiential moment to another, of references to the rest of the world and to its situations. It has no absolute color which it would sustain as its substrate; color changes with the time of day, pointing to the visual situation of the thing at a given moment. Substance as a firm substrate, a lasting bearer of attributes, is a construct of Greek metaphysics which, already before Aristotle though especially in his thought, sought to subsume all plurality under definite conceptual categories which would suffice to let things be spoken, to let them be read like a text. Categories are something like a Greek way of packaging things. Absolutization of the thing leads to a stilted concept of substrate and property, to impersonal metaphysics. Descartes thinks of that piece of wax in terms of that metaphysical tradition from the start, in evident conflict with the way the wax presents itself in our experience, and so comes to exclude sensible attributes such as color, odor, taste, and so on as not objective enough.

Descartes presents a list of purely objective properties in the third meditation. They include size, that is, extension in three dimensions, the shape delimited by this extension, mutual relations of bodies, movement, duration, number.[12] All of that we grasp about things clearly and distinctly. The ideas we have concerning colors, sounds, tastes, etc., are confusing so that we cannot tell whether they have a factual content or not. Clarity and distinctness—clear is that which is not concealed, distinct is whatever I cannot mistake for another. *Clara et distincta perceptio—*

12. See ibid., p. 30. *Ed.*

that is an application of the principle of identity and noncontradiction to perception. When we have a thing before us, we can have it either as a whole or in detail, but there is nothing concealed beyond it, nothing calling for further detailed cognition. Such a perception is veridical. Yet there is here a presupposition that has not been clarified—that in order to be seen clearly and distinctly, the thing must be present in the original, not through some substitute, in symbolization, in abbreviation. Why are not warmth, cold, color, smell . . . *perceptiones clarae et distinctae?* The reason is again traditional. It is because we do not know which of two opposites is positive, which contains the other. Is cold a lack of heat, light a lack of darkness, or the other way around? This is a clear case of a sclerosis of ancient philosophy. (Greek metaphysics understands qualities in fundamental pairs to which the qualitative diversity of a particular type is reducible. According to Aristotle, a quality is an intermediate position between two absolute opposites, as for instance colors can be defined in terms of their place between light and darkness.[13] The idea of lack differentiates between positive and negative qualities. That is how the ancients sought the essence of sensory givens.) Such qualitative oppositions are not suitable for purely objective determinations; only quantitative determinations and substances are objective. (Descartes forgot that he had included movement among the objective determinations and that here, too, he could ask what is positive: is rest a lack of movement or vice versa?) Descartes proceeds by tearing qualities out of the personal perspective by objectifying them, then points out a contradiction in qualities so objectified and rejects them as not objective enough, not sufficiently thinglike. That is how he understands even our own body which then is nothing more than a special structure of objective corporeity capable of being defined purely mathematically. The body is a mechanism; Descartes projects all else that belongs to the living functioning of our body to the other side— into our experiencing which is a special subjective accompaniment

13. Patočka probably has in mind "sense qualities"—i.e., the sensation of hot and cold, or any perceptual experience that involves judgments of "more or less" with respect to the extremes associated with a given sensuous quale. See *De Anima* 424a2–7, 424a32–b3, 426a27–b3. This should be distinguished from the *category* of quality (*poion, poiotēs*), which is understood in a much different manner than as a "mean" between two extremes. Cf. *Metaphysics* 1020a33–b25 and *Categories* 8a25–11a39. *Ed.*

of our objective processes. With that, he is done with the phenomenon of the body as subjective.

The depersonalization of this personally launched philosophy then goes on down to the subjective aspect, to experiencing itself. Descartes does have a theory of nonsensory cognition (that is, not mediated by the body) which goes beyond earlier tradition. The cognition of mathematical relations and of relations among ideas in general is of that type. Such cognition is independent of actual entities: truths about triangles do not depend on their existence. All earlier traditions assumed that we come to know ideal relations by abstraction: we single out something substantive that is given in experience and then we conceive of it as in itself, separately, even though in actuality it is a part of a context. For Descartes, mathematical cognition is not the only type of nonsensory cognition. Another instance is knowing our own selves in the immediate certainty of reflection, since its certainty is independent of any certainty about the body's existence. The existence of the body is in a certain sense dubitable, the existence of the thought we are presently thinking is guaranteed by self-reflection. Self-certainty is more primordial than certainty about anything else. Nonsensory intellectual cognition is in the first place cognition derived from reflection.

Cogito, ergo sum. Who am I, the one who thinks, what does it mean *to think*? Thought includes the full richness of our experiencing. For Descartes, thought is identified with conscious experiencing as such. To every experiencing there belongs an I which experiences, a definite mode of experiencing (judging, imagining, feeling, willing, doubting, perceiving, valuing, assenting, etc.), and finally that to which such asserting, willing, doubting, etc. refers—the object: a mathematical axiom, a decision, etc.—something that is distinct from the mode of experiencing itself. The I contributes a personal cast; in the mode of experiencing there is the variety of the acts of that I, while the type of act depends on what the acts concern—judging, willing, perceiving are all different. Thus Descartes gives rise to the modern conception of consciousness. The primordial structure of consciousness is *ego-cogito-cogitatum*, I experiencing the experienced. To the question of who the I is Descartes now replies as if it were a question about what the *thing* that thinks is. It is *res cogitans, substantia cogitans*. With that he injects a metaphysical tradition into the

personalistic structure. There is a sophistry here, to be sure, a four-term fallacy: *res cogitans* is understood in two senses. First, it is taken in the sense of *ego cogito,* a structural characteristic of experiencing which is the I, I who experience, the center unifying all experience. In the second sense, it is taken as a substance, a constant bearer of certain attributes, a *res*—that is, no longer as a center of experiencing. That is also the beginning of the objectification of the entire personal sphere which Descartes uncovered with his *cogito.* One entire school of psychology, the English, builds on that. We shall see how later all of modern psychology carries out a depersonalization of the personal sphere. It was with Descartes that that process began.

Descartes was satisfied with the result of his meditations. He believed that he had proved the distinction between the soul and the body and with it the immateriality and immortality of the soul, that he had offered a mathematical proof of God's existence and thereby also of the existence of external objects and so vanquished methodological skepticism. He had transformed skeptic tragedy into amateur theatricals. And now, suddenly, he encounters a comic difficulty regarding his own body. If the soul—*cogitatio,* consciousness—is entirely separate from the body, if it has in principle nothing in common with the body, then its connection with an arbitrary body is something metaphysically accidental. Antiquity presented the unity of the soul and the body, that we are never without a body, that everyone has a body. In Descartes, that becomes incomprehensible—the relation of the body and the soul turns into the psychophysical problem. Descartes resists it: it is not the case that humans consist of two substances; humans are one thing. But that is no more than a factual assertion, not a theory, not an explanation why every (nonspatial) soul has its place in a given body. Why could not the same soul animate different bodies, physically distinct from each other—distance, after all, means nothing for a soul. Descartes seeks to escape that in his sixth meditation. He cannot show a reason why all humans have their own bodies (which, from the standpoint of Aristotle's metaphysics, is a flaw, since metaphysics is a body of knowledge showing why things are thus and not other), but he does show that the body which insinuates its presence to us in a mathematically imprecise manner (it does not go to the essence of things) still does not altogether deceive us, that it does reveal a certain truth

to us, telling us, I am here, in this situation, this is whence I perceive, move, am hungry, have needs, am hurt, etc. Why should I believe my body when it is all as unclear and indistinct as the sensory givens in the case of the world, and when all that is dubitable? Descartes answers that I can believe it because the truth which the body reveals to me does not touch upon the essential. It has to do only with my needs, the body is a machine for my sustenance. The truth of the body is in its biological usefulness, not in revealing the true nature of things.[14]

Then the prospect is one of further development of reflection, of insight into the nature of things that will prove ever more dubitable, vanishing before us. For all its biological utility, we shall later learn to see in what the body tells us a more profound truth without which we can never be.

14. "For the proper purpose of the sensory perceptions given me by nature is simply to inform the mind of what is beneficial or harmful for the composite of which the mind is a part; and to this extent they are sufficiently clear and distinct. But I misuse them by treating them as reliable touchstones for immediate judgments about the essential nature of the bodies located outside us; yet this is an area where they provide only very obscure information." Descartes, *Meditations on First Philosophy*, pp. 57–58. *Ed.*

Third Lecture:
Body and Person—Modern Philosophy

Together with the discovery of the personal dimension, the discovery of the originary, direct access of persons to themselves, Descartes also discovered the phenomenon of the personal body which is not only the object of perception and abstract reflection but in a certain sense what *we are,* in which vital functions take place and which is the basis of our orientation in a context. Anatomy and physiology cannot grasp any of that because they start too late. Their analyses begin only after the body has developed its contacts with the outside to such an extent that it has placed itself among things, when the body has become so objectified in its contact with objectivity, with the world, that it can integrate itself within the totality of things. Descartes, however, no sooner noted than he lost this phenomenon—or, perhaps, devoted all his might to getting rid of it, to discovering, as soon as possible, an objective substrate for the phenomenon of the body, a correlate that would deprive it of the character of something essential, of an access to things, and would limit it to its pragmatic significance (Sixth Meditation). It is a discovery and an attempt to be rid of that discovery. For the phenomenon of the body is for Descartes an archetype of what he calls confused thought, irrational conception; it is a source of the confused thoughts that Descartes wants to shut out. The psychophysical problem is the price he pays for it.

Descartes's thought is suffused with the substantialistic tradition of Greek philosophy, that is, the philosophy of the object. All post-Cartesian philosophy and psychology followed this path back to the realm of the objective, of the impersonal, of the third person. This became most manifest in the philosophy and psychology of British empiricism. John Locke takes up the idea of the self-certifying *cogitatio*. His intent, though, is not the same as that of Descartes who sought to gain an indubitable foundation. Locke does not take up the self-reflection of the *cogito* with the intention of finding certain knowledge; what he wants is to discover the inner constitution of our *cogitatio,* of our consciousness. For him, that is an object like other objects in the world, only somehow subjective, reflecting in some sense all the world within itself. Locke is interested in the way this reflection is constituted. His answer is that it is built up essentially the same way as things themselves, that is, it is made up of simple and complex formations. These formations can be designated as ideas. Ideas are either simple or complex. Complex ideas are derived from simple ones and all ideas are ultimately derived from ideas which were once our impressions (of particulars). Thus the investigation of the genesis of our *cogitatio* becomes an investigation of the genesis of our complex ideas. Primary contents are impressions—colors, sounds, smells, and so on. Locke is interested in composition. He often virtually loses the distinction between the *cogitatio* and the *cogitatum.* He is aware of the *cogitatio* which is in contact with itself.[15] Yet, in his work, Descartes's remarkable discovery of the fundamental structure of experience—*ego cogito cogitatum*—gradually vanishes. In present-day phenomenological terminology, what is lost is the awareness of the intentionality of consciousness. In Descartes, there is at least a hint of the intentional nature of consciousness, that every *cogitatio,* every mental activity, every mode of being aware of something, has its object, its specific content, doubt having the object of doubting, perception the perceived, and so forth. Locke does not deny that, only loses awareness of it. He does not draw a sharp distinction. What interests him is the content of consciousness which for him

15. I.e., Locke's concept of "reflection." See *An Essay Concerning Human Understanding,* ed. Peter Nidditch (Oxford: Clarendon Press, 1990), bk. 2, chaps. 6–7. Ed.

at times seems to merge with what we might call the act of consciousness.

The recognition that our conscious functions always have their object does not appear to be linked to the personal standpoint. Already in antiquity, the impersonal tradition (Plato's *Charmides,* Aristotle's *De Anima*) stressed the object-orientation of our vital functions.[16] There is a difference between seeing and the seen, between science (as one of life's functions) and what science knows. This difference, basic to the conception of the intentionality of consciousness, thus need not be tied to the personal dimension. Aristotle distinguishes between *aisthēsis,* the act of intuition, and *aisthēton,* that which is intuited: the color red is distinct from the seeing of red colors. Animals have *aisthēsis,* an ability, given by the nature of their vital functioning, to orient within their life's context, they have organs that make it possible. It is, we could say, the ability to reproduce an objective quality, an external object. There is a certain agreement between the object and the image. *Aisthēsis* is the ability to accept and contain within oneself a certain *eidos,* a semblance devoid of a material substance. The eye does not take in the thing physically though it does take in the same *eidos,* the same quality, so that there is here an identity of species but a difference in the material substrate.[17] *Eidos,* quality, is the object of our functioning, it is something purely objective. It is the determination of an objective thing. Descartes's problem—what objective guarantee is there that my idea captures the thing?—does not arise at all; Aristotle overlooks it.

Locke and his followers proceed similarly. What empiricism took over from Descartes was only the self-certainty and the closure of consciousness. Our corporeity is only one of the objects of experience, of no specific interest. It is a body like all other bodies. This tradition totally lost the personal dimension discovered

16. (a) *Plato.* See 157c1–169c2 of Plato's *Charmides.* The discussion here is about the meaning of temperance (*sophrosynē*). After Critias introduces the theme of self-knowledge, the question arises whether temperance could be a knowledge of knowledge, or a "science of science." An important part of Socrates' attempt to cast doubt on this definition is the use of a series of body-metaphors—e.g., a vision that could "see" vision (itself and others); a hearing that could hear itself and other hearing, etc. (b) *Aristotle.* See *De Anima* 431a1–433b30. *Ed.*

17. See Aristotle, *De Anima* 416a32–418a26 (on the difference between *aisthēsis* and *aisthētos*) and 424a18–424b19 (for the definition of *aisthēsis* as a taking in or actualization of *eidos* without matter, or *hylē*). *Ed.*

by Descartes. *Ego-cogito-cogitatum,* the personal moment, is replaced by a subjective process and an object. This British tradition seeks to simplify the schema as much as possible and to reduce the personal moment (*ego*) to a structure of the *cogitatum*—so Hume, Condillac.[18] The *ego* is an aggregate of certain *cogitata.* That is a depersonalization of the *ego,* its transposition into the third person (transforming the *ego*-structure into a particular structure of the *cogitatum*). It is like observing my own body: my own corporeity, too, is an aggregate of *cogitata.* These *cogitata,* to be sure, have certain distinctive traits which are noted though not explained: while other *cogitata* in my experience change, these remain constant. These *cogitata* constitute something of a core which is always required for my experiencing—and that is all. It is a paradoxical situation: a philosophy which is at the same time subjectivistic (self-enclosed consciousness, reflection as a method) and yet has an impersonalistic thrust; it is an impersonalistic subjectivism. Though subjectivistic, it follows the model of the natural sciences—its task is to demonstrate the constitution of a particular reality from the simple to the complex in conformity with objective laws. A further consequence of depersonalization is that it renders the subjective passive. The subjective is no longer understood, as in Descartes, as self-verifying, grasping itself and reality in its knowing, carrying out a revision and a reconstruction of the edifice of its knowledge, etc.—all that is activity. In Locke, the subjective is an aggregate of ideas subject to definite laws (essentially the laws of habitual association) and so generating definite constructs.

That became the focal point of the first modern reaction to this conception, Kant's critical philosophy, stressing, in the

18. (a) *Hume.* See section 6 of book 1 of the *Treatise,* "Of Personal Identity," where Hume declares that humans "are nothing but a bundle or collection of different perceptions, which succeed each other with an inconceivable rapidity, and are in a perpetual flux and movement." He goes on to argue that, given the absence of a lasting impression of Self, the latter can only be an "identity" in the sense of an associative quality of parts. David Hume, *A Treatise of Human Nature,* ed. L. A. Selby-Bigge (Oxford: Clarendon Press, 1964), p. 252. (b) *Condillac.* [Etienne Bonnot, Abbé de Condillac (1714–1780)]. In his *Essai,* Condillac argues that reflection arises from, and is in a dynamic relation with, the mental constitution and reinforcement of the powers of attention, imagination, and memory. In this way Condillac seeks to improve on Locke, for in his own approach only sensation is recognized as the origin of ideas in the strict sense. See especially section 2 of *Essay on the Origin of Human Knowledge,* in *Philosophical Writings of Etienne Bonnot, Abbé de Condillac,* vol. 2, trans. Franklin Philip (London: Lawrence Erlbaum, 1987). *Ed.*

opposition of passivity and activity, the activity of the subject with a new emphasis on the *ego*. Here the personal character of experiencing is emphasized more than in Descartes. However, in reviving the personal character of experience, Kant overlooked certain phenomena, especially the phenomenon of the body as subjective. In Kant, the activity of consciousness, the I, means no more than that in the stream of experience we are not exposed *only* to the pressure of impressions and of ideas derived from them which would, so to speak, build us up objectively. Activity consists in our subject having its own *fundus instructus,* a treasury of certain components which it supplies to experience. Kant agrees with British empiricism that this *fundus instructus* of ours is not autonomous cognition but rather is always a component, never freestanding. That is the positive heritage of empiricism. (In Descartes, the turn is to pure *ratio*; in empiricism, we are exposed to a stream of impressions.) This component has no meaning in itself, it is not cognition of itself, only in combination with what is exterior. Activity alone is insufficient for gaining knowledge, it has no meaning of itself. Kant expresses this by saying that the subject supplies the *form* of knowledge. That includes the receptivity of intuition and the spontaneity of thought, of our judgment. The receptivity of intuition, our sensibility, contains in itself a certain germ of order—we intuit next to ourselves (spatially) and in sequence (temporally). We still have to *think* what we have intuited. Thought completes the constitution of a continuous and definitive order which does not relate only to the givenness of impressions but to their deeper aspects, their causes, their lawlike order. Sensibility and reason both relate to impressions. The objects of our experience are a product of both. Both are a purely spiritual/mental activity. Our body is once again an object among objects. Experience is built up on a purely mental foundation. Thus personality is preserved (and stressed further in practical philosophy), but it is abstract, floating freely outside human corporeity. Thus both in the tradition of empirical impersonalism and in the tradition of the personalistic criticism, the body is only an object, an object among objects, a product of experience which takes place essentially in an incorporeal subject. That means that corporeity is not denied but the fact that we have a body is a contingent datum like other impressions, incapable of being explained further. The question is whether our corporeity, too, might not belong among the conditions of our experiencing.

Not long after Kant came the French philosopher Maine de
Biran, a younger contemporary of German idealism (at the time
of Napoleon and of the Restoration).[19] He is not usually counted
among the great philosophers though he is important for our
problem. His starting point is a Kantian emphasis on personality
and activity which he sees lodged in the spontaneity of freedom
and will. He rejects Kant's method and once again discovers per-
sonality and the subjective body. Kant's method is that of a logical
analysis. Unlike Descartes, Kant does not carry out a reflection
that would capture the internal experience *ego cogito*; he has no
confidence in the empirical method. Descartes's *cogito* is originally
a captured fact; reflection is a type of experience which gives us
facts, unique facts. Kant does not rely on facts, he relies on the
conception of *validity,* on what is valid—so he relies on logic, on
logical consistency. Logic, however, is always general and
abstract—and it is precisely this abstractness of Kant's method
that Maine de Biran rejects. Kant's *ego* of the transcendental
apperception is not a personal, individual I, it is only the concep-
tion "I," a generic conception that must be capable of accompa-
nying all my apperceptions. Maine de Biran wants to capture the
individual, personal I. He returns to Descartes, to the method of
reflection of our consciousness on itself. Here he would capture
the primordial fact represented by *ego cogito*. In a sense, he works
empirically, with reflection as an internal empiricism.[20] He
believes, though, that he can capture the active I in it. For that
there is no need for a logical method and for the artificial con-
struction of Kant's conception of the activity and autonomy of
human cognition. The difference between passivity and activity
can be noted in inner experience. That experience is manifested in

19. Marie-Francois-Pierre Maine de Biran (1766–1824). The most pertinent texts
here are *Essai sur les fondements de la psychologie et sur ser rapports avec l'étude de la nature,*
in *Oeuvres de Maine de Biran,* vols. 8–9, ed. Pierre Tisserand (Paris: Alcan, 1932); and
Mémoire sur la décomposition de la pensée, ed. Tisserand (Paris: Presses Universitaires,
1952). *Ed.*

20. Maine de Biran has a number of expressions for the mental capacity that makes
this "internal empiricism" possible—e.g., *"sens intime," "aperception immédiat."* For a dis-
cussion in English of de Biran's methodology in contrast to the approaches of Condillac,
Locke, and Descartes, see F. C. T. Moore, *The Psychology of Maine de Biran* (Oxford:
Clarendon Press, 1970), pp. 9–80. See especially pp. 56–60, where Moore includes a
translation of an elegant journal entry of de Biran from 1823 that illustrates his concept of
"introspection." *Ed.*

the primordial phenomenon of effort. That effort can stand out of the world, that it can say *I,* rests on the reality that we can will freely—and that we are able to act freely. Willing is meaningless when I *can* not.

I have a primordial awareness of effort, of having certain possibilities, for instance, of moving my hand. The meaning of effort, of my purposive manipulating of my body, stems from myself. From this effort I know immediately that the movement stems from me as from an autonomous center. Awareness of effort is no peripheral impression, it cannot be reduced to mere sensation. Maine de Biran does not thereby deny muscular impressions, dependent on the conditions of our sensitivity. The consciousness accompanying automatic movements—that is just a passive mode, experienced as an alien will. In the case of effort, the stimulus is not external, yet a muscular movement does take place. There is no external force to which this power (effort) is subordinated. We are primordially an active I, exercising effort.[21]

Effort has its bounds: something resists it. It is not boundless energy, it is an efficacity in a body, a bodily effectiveness. Here it becomes evident that the I is possible *only as corporeal*—the I is a willing, striving I and, *consequently,* a corporeal one. This includes various modes—freshness, fatigue, exhaustion, etc. The hyper-organic power is one naturally related to its own resistance; even its own organism resists. An I is possible only in a biological organism. A biological organism becomes a real *person* in the moment when I *can do* something on my own (i.e., move). There is a double mutual relation here: the I is conditioned by the organism, on the other hand the I is no less real than a sheer biological reality. Like Descartes, (who dismissed the discovery), Maine de Biran discovered that the spatiality of our body experienced in the feeling of effort is different from the objective spatiality of our senses which locates things in an external space, *partes extra partes,* so that they have their limits, their neighbor-

21. "Le sentiment de la force *moi,* qui produit le mouvement, et l'effet *senti* de contraction musculaire, sont bien deux éléments constitutifs de la *perception d'effort volontaire;* mais le premier de ces éléments est si nécessairement un à l'autre dans la même perception complete, qu'il ne peut en être séparé sans que cette dernière soit entièrement dénaturée, et réduite à la simple sensation passive." Maine de Biran, *Mémoire sur la décomposition de la pensée,* vol. 1, pp. 54–55. Cf. *Essai sur les fondements de la psychologie,* chap. 2, "Recherches sur l'origine de l'effort et de la personnalité," pp. 189–203. *Ed.*

hoods, their relations among themselves and so on. The original spatiality of our body lacks this character of *partes extra partes* (outside itself).[22] Bodily spatiality is not articulated in that way. If for some reason we could not govern a body or if we were unaware of such a capability, we would have no opportunity of learning any movements. This ability comes first, there is a certain elementary differentiation, an awareness of what belongs to me and what does not. (Here Maine de Biran comes up against a more modern conception of bodily schematism, drawn from psychiatry: a general semiconscious awareness of the difference between my body and other objects; that is distinct from the experience of individual organs of my body on which I focus as on external objects; before I undertake that, I already have a general awareness of the location of organs in the body.) Maine de Biran's conception remains linked to Cartesianism. He does stress the dependence on the organism, but he stresses no less sharply that the effort stems from a hyperorganic principle, an autonomous one, and his overall conception ultimately results once more in the pure spirituality of this principle.

Chief Traits of the Phenomenon of the Subject Body as It Appears in Coming to Terms with Recent Authors

Since Maine de Biran's time, the problem of the body received further attention. There is, first of all, Husserl's contribution in *Ideen II.* Then there is Sartre, Merleau-Ponty, and, in a broader, more speculative form, Gabriel Marcel. Among the common traits of these authors there is the awareness that our own body is something that cannot be objectified, an "area of darkness needed if the projection on the cinematographic screen is to be visible,"[23] something we are without being able to objectify it, something

22. See Maine de Biran, *Essai sur les fondements de la psychologie,* pp. 208–16. *Ed.*
23. See Maurice Merleau-Ponty, *Phenomenology of Perception,* trans. Colin Smith (London: Routledge and Kegan Paul, 1962), pp. 100–1. Hume also makes use of the metaphor of the "theater" when describing the unity of the self, but makes it clear that we should not understand thereby the need for an "obscure place" in which the perceptions that make up the mind are projected: "The comparison of the theater must not mislead us. They are the successive perceptions only, that constitute the mind; nor have we the most distant notion of the place, where these scenes are represented, or of the materials, of which it is compos'd." David Hume, *A Treatise of Human Nature,* p. 253. *Ed.*

we are, though not physiologically. This *we are* is present here in the form of a certain knowledge. That includes a distinctive spatiality of the body, unlike that of other entities, of objects. We can describe its function as continuously leading, rooting the body amid things; we are the central point of perspectives, a center of our orientation in the world. The body is the absolute *zero-object* (Heidegger), that is, one *so near* that it is not thematized—it is something that we do not experience in our experiencing, what we overlook in most cases. However, under certain circumstances it becomes thematic unlike any other object: as an affective object (only in our body do we feel pain and pleasure), as a sensual object (only by my body can I feel, intuit, my own body; only this object is simultaneously active and passive—I can touch myself with my own body), as a kinesthetic object (I can move my body, without that it would not be a living body; a wholly paralyzed organism is dead). Sinking roots amid things leads us from the space of our body to space as such, to objective space. This process has its stages. Our body is a moment of a situation in which we are; it is not a thing. Just as a situation is a moment in a sequence of events with a definite structure and field of action, so our body is always a moment in an impersonal situation. Because our body is a situational concept, it has also the traits of human situation as such, that is, we cannot speak of it without noting that it places us in a certain reality which is already present while at the same time lifting us out of it, in a way distancing us from it. Maine de Biran's hyperorganic power actually means that in a certain sense we are entirely body, no more, but in a certain sense also that we *elude facticity.*

Fourth Lecture:
Personal Space: Reflection, Horizon

How can we formulate the spatiality of our body as a personal spatiality? What is the difference between this spatiality and that of the impersonal world?

It was Merleau-Ponty who noted the difference between a being in the third person and being which is in principle impersonal. The being in the third person exists in a relation to two other persons, even if the personal aspect nearly escapes notice. It alone of the three has its own dignity, the others being only moments devoid of a relevance of their own. By contrast, in the case of impersonal being the personal aspect is secondary, accompanying the impersonal, devoid of all autonomy and disappearing from view. Thus all being acquires an impersonal mien. The personal appears as dependent on, as derived from the impersonal. The model of impersonal being is geometric space as Descartes understood it. Democritus's conception of space heads in that direction—being in no person. Unlimited space in which there is no natural location, no privileged point, no possibility of orientation—that begins with Democritus.[24] In antiquity, Democritus was quite alone with that conception. If the report of the fall of atoms in a vacuum from top to bottom were taken literally, it would attest that not even Democritus could free himself entirely of a personalized conception of space. For that is already the beginning of orientation; above/below are relations which make no sense as purely objective. A Newtonian space is one of

24. In Leucippus and Democritus, "space" (or, in Democritus, "void") is the empty intervals (*diatēmata*) between atoms. *Ed.*

contiguity of punctile elements wholly indifferent to each other, a continuous coherent continuity.

Saying that ancient philosophy is philosophy in the third person does not imply that it is a philosophy of impersonal being. All its impetus, to be sure, aims at grasping being as it is in itself, as substantival being, existing autonomously, devoid of further relations, there for pure perception—what can be grasped at a distance, as an object. The definition of these objects, however, meaning concretely their integration within a whole, their properties, their relations, are derived from our personal experience. So for instance in Aristotle the whole is a spherical world in which each thing has *its* natural place in which it is fully itself, where it is at home. There is a hierarchy of such places which constitutes the natural order of the universe. Here there is an up and a down. There is the living aspect of an organic whole. Doing philosophy in the third person thus does not mean sheer impersonality. Two other persons are present here, unmentioned, while all interest focuses on the third, on what we see at a distance.

By contrast, modern post-Cartesian philosophy, Spinoza in particular, strives for impersonality. Universal substance, the ground of all particulars, is fully impersonal. This substance determines all order, all law in its foundation, it is what makes it the substance that it is. It is expressed in attributes—*extensio, cogitatio,* and others. The impersonality of the substantial foundation beneath the surface of these attributes lends an impersonal character to the system as a whole. That impersonal character manifests itself in the principle of psychophysical parallelism: *ordo et connexio rerum* is the same as *ordo et connexio idearum.*[25] There is a correlation here between the psychic and the physical, psychic events being dependent on a substantival foundation conceived as impersonal in principle. What in Spinoza might seem a metaphysical exaggeration is actually the principle which guides the thought of most modern philosophy, natural science, psychology. Translating this into a seemingly empirical sphere: nature is an objectively impersonal foundation to which mental events are added as a correlate, an epiphenomenon. What is needed is to understand their relation, the relation of the personal and the

25. See prop. 7 of part 2 of Benedict de Spinoza's *Ethics. Ed.*

impersonal, giving precedence to the impersonal and seeking in it the foundation, explaining the other as a "translation," as something intrinsically dependent.

This metaphysics of the impersonal, stemming from an excessive emphasis on the third person in the primordial structure I-thou-it, is something quite extreme. Every speculative thought must start with a certain phenomenal basis, something to which we can point so that the meaning of the speculative theme can be persuasively grasped and verified. The extreme emphasizing, absolutization, and substantialization of being in the third person in the experiential schema of *I-thou-it* does not take into account and cannot explain the experience that and how we are spatial other than objectively. We are spatial, yes—but the question of how and of whether our localization in space is the same as that of objective spatiality is not even raised.

The awareness that we are in space, in the contexts of extension, assumes a special structure which has nothing in common with objective extension in space *(partes extra partes)*. There is a fundamental difference between being in space as a part of it, alongside other things, and *living spatially,* being aware of being in space, of relating to space. That represents a certain addition to mere being in space. A merely corporeal being can exist in space, can relate to space, nonetheless the lived spatiality of our body cannot consist in its objectively geometric relations as a thing. Our body is a life which is spatial in itself and of itself, producing its location in space and making itself spatial. Personal being is not a being like a thing but rather a self-relation which, to actualize this relation, must go round about through another being. We relate to ourselves by relating to the other, to more and more things and ultimately to the universe as such, so locating ourselves in the world. When Heidegger says that existence is something that in its very being relates to its being, it sounds metaphysical and speculative. We shall show, however, that it is something that can be exhibited descriptively.

Self-relation involves the subject body insofar as one of its basic functions is to determine that we are somewhere and where we are. That cannot be done by a purely mental/spiritual I—such an I cannot be somewhere. Its self-relating could have the form of reflection; the I includes an original capacity for reflection. What, though, could it grasp except its own self? In the case of a purely

mental/spiritual I, we cannot find a reason why it should grasp anything else.—Kant's teachings do place such an I in space, but by means of an objective body. The I is always accompanied by certain experiences, so for instance the sense-appearance of personal body is constantly present as an empirical fact that integrates the pure I in space. The pure I is integrated into space as my continuously observed presence. Yet the I is never in space. That I only accompanies all this structure, the body is a purely objective accompaniment of the I. What is in space is my objective body which does not, as such, have any privileges over other things.[26] My own body as I imagine it is in no way privileged except that it has some exceptional traits—constantly present, sensitive, etc.— which other objects lack. Already Maine de Biran stresses that neither the subjective body nor the I can be something I visualize because it is a center of effort. The I cannot be purely spiritual. The I is not a blind force but a seeing one. That the I is capable of seeing is not a mere property. Without being at the center of our own attention, we yet live constantly with and toward ourselves. Already Aristotle knew that all seeing and knowing is a seeing and knowing *in order to* (for a purpose).[27] *Aisthēsis* and *kinēsis* are inseparable. Our seeing is always linked to movement. Knowing where we are is a necessary foundation and starting point of life.

An animal lives in an unceasing *immediately relevant* relation to its context, in the present, related to something that interests it immediately, affecting it. Humans, by the attitudes they assume, are constantly placing themselves into situations other than the directly present ones, into the past, into the future, with all their quasi-structures—quasi-present, quasi-past, etc. (remembering is

26. This split between the pure I of apperception and the I that is placed in purely objective, or objectified, space is essential for Kant (though for him it is not so much a question of the lived body as the difference between "nature" and "freedom"). For perhaps the most poignant example of Kant working out the philosophical implications of his doctrine (the main components of which are laid out in the Transcendental Dialectic of the First *Critique*), see *Kritik der reinen Vernunft* [hereafter "KrV"; for English see *Critique of Pure Reason,* trans. Norman Kemp Smith (New York: St. Martin's Press, 1929)], A446/B574 to A559/B587. Here Kant elaborates the difference between the "intelligible character" of human agency (i.e., the human being as a free being, a pure will) and its "empirical character" (i.e., the human being as an observable, empirical phenomenon—which includes its physiological being). *Ed.*

27. See Aristotle, *De Anima* 416b32–35. *Ed.*

going into the horizon of the past where a course of life that once had been present is repeated in tokens; we move in the past as if it were present, hence quasi-present), going into imaginary worlds, into the world of reading, of thought sequences, of tasks not met, of duties that place us into a special space which is and yet is not. At the same time we must be always actively localized where we are, integrating ourselves into the now. For us humans, what is immediately present in each moment is also a focus of other possibilities, of partial worlds and so on. What is characteristic of us is our variety of possibilities, a freedom from the present, from the immediately given. Human orientation, that is, is not an orientation in a context. Rather, given the plurality of possibilities thanks to which we are not rooted in only one context like the animal but free with respect to it in virtue of our tangential worlds and half-realities, our living with respect to what we are not is a living in a *world*, not simply in a *context*. The animal, by contrast, depends on its context. For that reason, in the case of humans the present is distinct from the immediately given; what is present, directly present, exceeds what is originarily, immediately given. For humans, the directly relevant and the immediately given grow far apart. If the objective pole of lived experience (what we are not) is excessively differentiated, exceeding the immediate given, then the subjective pole—the I—must accordingly have the character of something capable of transcending immediate givenness in its differentiation. It must be that which, in spite of its unity and simplicity, bears variety within it, a variety of possibilities, of modes of diverse relating.

That brings to mind the old dilemma: the I as a bundle of perceptions, an aggregate of conceptions, or the I as a simple conception which in its unity is the foundation for the unity of experience. Such dilemmas occur frequently. So for instance a table is one, a unity, given in various perspectival views, the same object given in various perspectives with each individual perspective pointing to all others. In the same way the world is one in the infinite variety of regions into which it can be divided. In our experience, the world or the object are not only a variety but also a unity. We can sum it up in a definite reference which can be explained, explicated. We say that it has its own inner horizon, its

way of presenting its variety out of its unity in an orderly manner for our experience.

Concerning the conception of the *horizon:* horizon is something that circumscribes all the particulars of a given landscape, its visual part, but transcends it. We always see a segment but we always fill it in to a full circle. If the center moves, perspectives change, objects change, shifting from the periphery to the center and vice versa, but the horizon remains constant, always here, changeless. It is imperceivable, unindividuated. An object can be reached by a movement from the center to the horizon. A fixed horizon is the self-presence of what is not itself present, a limit that shows that it can be transcended. A horizon shows that the absent is nonetheless here and can be reached. A horizon is the ultimate visible in a landscape. Everything within the horizon is defined in relation to it. The lines of perspective, the tangents of our visuality, meet at the horizon. The most distant, least fulfilled, determines the meaning of what is nearest, most concrete, most fully given. Where we can see least, there the content is richest. Spatial placement is linked to the bestowal of meaning. The horizonal metaphor applies when the same physical object comes up in different context. (For example, in his story "On the Mississippi," Mark Twain gradually places himself within the experience of the boatman and of the pilot who interpret everything in terms of danger to navigation, losing sight of the landscape as such; gaining a new horizon and losing the original, "poetic" one.)

The world is often defined as the horizon of horizons, the horizon of all reality in which each partial horizon has its place, where everything has its place—even dreams, the past, the future, imagination, schematization, nature, history—society, home, foreign contexts. We are always within it and never fully enough. Existence within it is the presupposition of thought. Our life ordinarily masters this entire continuum prior to all reflection while its conscious articulation exceeds all our mental possibilities.

Every individual reality is given with its horizon, it is never present fully but rather in various perspectives which our experience unwittingly synthesizes. This briefcase is present to me in various perspectival views while I know with certainty that those are perspectival views of one and the same thing. The object, that which is here given directly, that is a perspectival view and a hori-

zon, which is also given directly, implying, enclosing, and containing in token all the possibilities of moving from one perspective to another. To have an experience of things means to explicate horizons, to reach out into predetermined horizons. Even a thing I ignore captures me in its horizons. Every thing has an inner and an outer horizon. These horizons are not storehouses of memories as much as living fields which grasp us and lead us from experience to experience. A certain continuity of experience makes it possible to carry out a synthesis of superimposing and fleshing out—of *over*lapping. That something is the same, that depends in great part on the continuity of specific concrete data which overlap with the change of viewpoint, at most supplementing each other and introducing further contexts. At other times, the explication of references uncovers a disagreement with preceding experience; that, too, is a synthesis, a synthetic act not of agreement but of discrepancy which cancels a certain experience.

Horizons are not *mere* possibilities but are always already in part realized. To live in horizons means to broaden actuality immensely, to live amid possibilities as if they were realities. That is so banal that we tend in advance to consider such possibilities as realities. To live in horizons is typically human. We are wholly unconscious of the perspectivity of things; in our awareness they are as primitives paint them, without perspective, in themselves, so to speak, though still given in perspectives, in aspects from which we cull a self-identical core, transforming a horizon into a massive existent. We leap from one implication to another, flitting about amid the possibility of realizing these implications. We move about in the sphere of the virtual as if it were a sphere of realities. It is not, yet our experience petrifies possibilities as realities. That is why we can never fully explicate them. This transference of actuality is the significant, far-reaching motif of our experience. Imaginary supplements, that about things that cannot be actually presented, are real for us in a certain way, even when only anticipated, adumbrated, precisely because they are continuous with things which are given themselves. The self-given is what presents itself in our experience as the thing itself, in contrast with mere imagination. There is a difference between imagining Vesuvius and standing before it. There are cases in which things themselves stand before us. This table is there before me in visual experience, it is not a representation of the table. We live, though,

in relations which transcend such self-givenness. With the help of the transference of actuality, far more is present to me as real than what is actually given: whatever stands in some relation to the self-given is also actual. Things beyond our senses are present to us. Even what can never be given in the original, like the experience of others, becomes actual. We live by relating constantly to the experience of others in the world as to something actually given. Living in horizons, the transference of actuality, points to a powerful centrifugal stream that governs our life—out of ourselves, to the world. We live turned away from ourselves, we have always already transcended ourselves in the direction of the world, of its ever more remote regions. Here, in the world, we put down our roots and return to ourselves. This cycle will be a subject for further analysis.

Anticipating: on the one hand we are the stream of this centrifugal energy and on the other hand we are simultaneously that which this stream discovers in its return, that which finds itself as the axis of this stream. The projection into the world never ceases, we never live in ourselves, we always live among things, there where our work is, living in horizons outside ourselves, not within. In a certain sense this never ceases, in a certain sense this impetus returns to itself because it encounters a mirror—in entering the world, in moving away from itself, it encounters a place from which further continuation is a return to itself. This place is the other being—Thou. We shall show further that this placing oneself into the world has the structure of Thou-I. Nietzsche says that the Thou is older than the I. The I aiming outward in the sense of a centrifugal energy, preoccupied with things while overlooking itself—that is only an I with some reserve, since the fullness of the I, the personal I, is always the correlate of a Thou. If we start from that centrifugal stream, it is an I only insofar as the I is a horizon summing up within itself the references to all the possible reaches of this energy. It is what is present in reflection prior to reflection. As a unity, the horizon implicates; as a variety, it explicates. The I as a horizon differs from the objective horizon—in it the perspectives which exhibit the character of contemporaneity encounter each other. The subjective horizon is structured differently.

Let us return once more to the metaphor of subjective energy. Energy projecting itself into the world is a seeing and an affecting

force (Maine de Biran). Projecting into the world means affecting the world. We can bring about changes in the world through our bodily presence, our motions. As a seeing force, the ability to affect the world is equipped, so to speak, with a searchlight which opens the way into the world for it. Clarity about this way—those are the fields of sensations of our experience. Our sensibility can be also investigated purely objectivistically, in the physiology of the senses (nerve chains and so forth, purely objective terms positing a purely objective sequence of seeing). How significant, though, can such results be for us if we want to understand sensibility not only from a purely distantiated viewpoint, as for an objective observer, but in its living functioning? In that case we must bracket such results, not letting ourselves be misled by purely objective outcomes. For instance, the very principle according to which fields of sensations are something separated, linked only by association, by conditioned reflexes—by analogues in the nervous system. Can we maintain this when we look at the *living* life as lived, analyzing it without the spectacles of a third-person, impersonal view? The separateness of sense fields becomes problematic; the light that guides us is a unity of a kind.

Fifth Lecture:
Life's Dynamics:
Intentionality and Movement

Last time we presented the thesis that the I, too, is a horizon of a kind. What philosophical use can we make of the metaphor of horizon? In the concept of the horizon we have to do with a special phenomenon which, when we seek to describe it, leads to strange or downright contradictory tensions, for instance the contradictory turn that the horizon contains the presence of what strictly speaking is not present, what does not present itself to us fully—a presence of the absent. The horizon belongs to all manifestation, everything manifests itself within some horizon. Yet a horizon does not manifest itself in the same sense as the givens we encounter within a horizon. The horizon does not manifest itself as something that manifests itself from it. The thing before us is presented to us one-sidedly, it manifests itself in perception from a certain aspect, it is a phenomenon in the true sense of the word. By contrast an object as such, that which is unitary, identical, persisting through various perspectival aspects, is not a phenomenon in the same sense. It is something that is not actually laid out, something that is only anticipated, suggested by experience, and can also be eliminated by experience. What does not appear to me is present in a different sense from that which does present itself, in the original. The horizon is the appearance of what does not appear, appearing only in a certain sense and belonging to an appearance; what appears can never be without it but its mode of appearing is such that it forces us to use peculiar, virtually contradictory characterizations. The concept of a horizon is profoundly significant, important for the nature of what we undoubtedly have in our experience but what is yet not present with the fullness of the seen, so that it would appear fully. Our experience abounds in

such things. In our experience there is a great number of what we could call *demi-phenomena* which seem to want to but cannot become fully actual, to make themselves manifest; phenomena which announce themselves, press forward but which we seem to be shouting down, ignoring, not taking into account. It can go so far that the phenomenon is no more than a *hint*. Our experience would be unthinkable without such demi-phenomena.

Our primary experience of ourselves is of this kind, an experience of the primordial dynamism that manifests itself in our awareness of our existence as a moving, active being. This dynamism appears as distinctively linked to that which orients us in our movements, that is, to the phenomena appearing in our sensory fields, and that in such a way that our energy is always focused on something, on what we are doing. I listen and I am stretched out in the direction of the lecturer. When I am writing, the energy of my sensory fields and the posture of my movements focus on what I am doing; that becomes the center. Individual functions aimed at this goal are interchangeable to some extent, able to substitute for each other. What matters is that they contribute to the same goal. In this focusing on things our experience takes such a form that it is things that interest us, it is they that matter to us, it is their identity that involves us. We virtually ignore all else, including the changes in our experience, that individual components in sensory fields displace each other; all that we suppress, so to speak, all that becomes a demi-phenomenon. For instance the intuition of an object takes place in such a way that I carry out a synthesis of individual aspects presented in sensory fullness, as when I turn a piece of chalk in my hand. This synthesis seems to take place of itself. It is not an active synthesis, as for instance a judgment, the active connecting of conceptions (I constituting a relation among various conceptions); it is rather an ignoring of the changes that are constantly taking place; it is not an addition as much as a forgetting. Here our corporeal acting, the presence of the body, plays a constant role. Our body is originally present to us as a definite dynamism which does not originally appear to us—what appears are things, the chalk, the table . . . , interchangeable and partly interchanging parts of our context. That is connected with the dynamism of our body which, however, is not present: we are simply dynamically aware of it. That is the passive character of the synthesis of the percept. We

are aware of ourselves as of something that is here but is not a phenomenon in the true sense of the word, only presenting other things to us, causing things to appear to us.

That is immensely important for understanding the nature of our I. The agent I, the I that acts, never appears before us. When we speak of energy, of a dynamism, we need to think away all that is physical; we are simply articulating the initiative experienced in carrying out movements. This dynamism is a phenomenon in a different sense than that on which it is focused, than that which is its object. That on which it focuses is a *unity* of a kind. If we consider perception purely physiologically, it is as if we had before us individual functions, mutually unconnected; such a view fits in with the conception of sensory channels, centers, etc. A phenomenological description of the living function of experiencing, of immediate reflection, however, shows us that our various activities focus in the unity of an appearing object. This unity contains within itself individual sensory fields, accepting them as contributions to a unitary act. It is as if this unity were there prior to the individual contributions, not made up of them. This is an immensely elementary function. We have to assume its presence even in animals. A dog recognizes one and the same thing, one and the same person, in most varied sensory data, and focuses on it. Various types of sensibility are various means of realization, acting out this focusing on the object which is our most primordial dynamism. Sensory fields belong to the primordial dynamism of intention and fulfillment that characterize our life as such. Our life focuses on objectivity, the sensory phenomenon is only an answer given to this, our pressing "question," this primordial longing drive of our intention. Our physical existence presents itself to us as affecting things, not as a presence among them. Were we among things, we would have to appear as they do. We do not live among things but by following things and going out to them.

The primordial dynamism, as we experience it, characterizes the spatiality of our physical presence. That becomes apparent in the orientation of space around us, our orientation in space as we live it, with its up and its down, right and left, forward and back. Up and down make sense insofar as the primordial dynamism of our corporeal existence represents a certain effort, that our posture is an effort of a kind, overcoming resistance, defying gravity; right and left are the original symmetry of our active corporeity,

of hands and feet, the symmetry of our body, of our movements; forward and back is the direction of our activity, of the dynamics of work, of a force that sees. Our dynamism does not present itself to us in the way that things do, and yet it is always an orientation among things. This is why we encounter the characteristics of forward/back, up/down, left/right in what presents itself to us, in things, not in self-reflection. This specific subjective trait which we encounter in things is a trace of our primordial personal approach to the world, a hallmark of our corporeity as it appears in the world that surrounds us. That is *our* being *toward things.* What is manifested here is the mutual interlocking of the kinesthetic and the aesthetic aspect, of that which appears and of the way our body orients towards it.

Another fundamental characteristic of our bodily existence is that it is only in our body that we sense pain and pleasure, vigor and fatigue, and so on. That is a part of our experience of ourselves, of the way we are, or, as some languages express it, how we find ourselves: *sich befinden, nakhoditsia.* That shows us the starting point of activity, that I am here among things with specific traits of my own. It is a matter of a state, of something that is finished, given, not something we intend, it is a factual, received basis of our acting, of our possibilities—of what we have in mind. Pain and pleasure are continuous with the dynamism of our body; we sense pleasure, pain *somewhere* in our body. It is the fulfillment of something in corporeity that is suggested in some unfulfilled manner. But it does not present itself to us the way things do. Pain is not before us, as things are, it does not unfold in a unitary space. States of pain and joy are far more a special focusing of our dynamism on a certain situation of our corporeal existence. At other times it is not simply a bodily, existential situation but rather a bodily existence in its entire context, in all in which it belongs—especially in the condition we call a mood. In moods the situation in which we are presents itself not as something that has to do solely with our corporeity but rather as something that has to do with our environment and with the world at large. Some such states seem to narrow us down (acute pain encloses us, concentrates us on our corporeity, on its momentary state), others seem to open us outward. In the dimension of "how we are" there opens a *factual situation* in

which we are placed, as the start of further doing, a preceding disposition which is here before we do or propose something. Such proposing and doing always take place in the framework of a preceding disposition (for instance, we are thrown back on our corporeity, our attention can reach out to nothing else, the situation seized us). Corporeal experiencing is the necessary condition of all further activity. It presents us with a factual opening of access to the world offered by our corporeity, by our actual state. That does determine our acts, not totally, but still to a considerable extent. The modes of our activity vary, we work *in spite of* a headache, or with verve, absorbed in a task. Various moods modify our activity. We see how we are grasped, predetermined, placed into a certain region, cast into a situation. Even before we started acting, the world already has us (in a mood). Precisely this aspect of our corporeity first tells us "where we are." We are always already somewhere in the whole of the world. This is the basis on which our active doing takes place. I do this and that within the framework of the possibilities I have seized. Acting always takes place in a particular stance and movement. The world placed us in a specific region, the world addressed us—we speak of interest, of absorption. Various regions have their presuppositions in terms of moods. Sobriety, a cool distance, is also a mood. Critical rational examination presupposes something on that order. For artistic intuition, such a stance is neither adequate nor appropriate. The world addressed us in general, placed us in a certain context, now the need arises to take a stance with respect to the concrete particulars of this context. A region open in the awareness of how we are is a part of the phenomenon of the horizon. We feel certain regions as much as we sense them. A horizon is also a coloring, an atmosphere, not only a preconceptual indication; even the coloring can be brought out, explicated. A Chopin composition has its mood. As the composition unfolds, the hearer enters the horizon of a mood and explicates all it contains. All our acts are explications in a sense and have to do with definite physical stances and movements, even the most spiritual acts. Even a thinker meditating must assume a certain physical posture; even quieting down, negation of movement and dynamism, even interrupting the immediate thrust toward things, are physical accomplishments.

Our doing, our projecting always has the character of the *explicit* "I do." That is no longer simply a matter of the world having seized me, the world having placed me somewhere, in a particular situation. Here is the I's *response*. And the *I do* assumes that I can, I have the ability. I do—that means, I make movements selected among possible ones. The chosen movements are successful interventions, rites which keep the object within our reach and for our purpose. The perennial presupposition is that we have at our disposal the abilities (coordination, etc.), that is, that our body is at our disposal. My body has to co-*respond* to the "I do." A body which does not respond, which does not yield, which is not skillful, ceases to be my body in one sense and becomes an object for me. Thus there is always available to us a body with certain skills and habits (for instance, I can play the violin). That is nothing trivial. All our activity presupposes this disposition of the body. Every level we reach with a learned skill has to be achieved, presupposes a certain type of mastery over the world. To learn something assumes that there is a body at my disposal. That is not a volitional activity, that *élan*, that is not volition or from volition, it is the activity itself. We master our tasks and projects in a semiconscious mode so that our dynamism is present but it is not that which presents itself, the phenomenon—the matter we are mastering is that.

Movement is always a manipulation of things and is defined by its meaning, that is, it has the character of a goal, a direction, it is purposive, with its whence and whereto. Taking a step, reaching for something, a series of movements—a journey—can serve as examples. That gives it the character of a unified action: writing an article, preparing for an examination. There is always a whence and a whereto. Within the framework so defined, a movement is something unitary, indivisible. This movement is unitary just like experienced corporeity, as if it participated in the unitary spatiality of the body. Even though individual components are interchangeable (assuming a constant function, a goal), the movement remains intrinsically the same, for the same purpose. Aristotle made this peculiar unity of bodily movement the starting point of his analyses; thus the basic definition of movement in books 3 and 6 of *Physics:* movement must always have its starting point and its final goal. That is just what modern mechanics denies. Aristotle's text makes sense to the extent to which we realize that he was

drawing on the region of subject experience of the movement of our body, not on the region of mechanical movement.[28]

The lived body must always be at our disposal, must be obedient, docile. It responds to our impulse. That has a paradoxical character. Our dynamism is never an *object*, it does not present itself as a manipulated object which is just what it appears to be. We do not learn movements and coordination by analyzing and objectifying them. That is why I always need an object and am focused on mastering it (a musician, a clown). The entire dynamism is a thrust beyond itself, toward matters. Certainly, there are schools of music at which the student of the piano goes through a conscious drill, with the automatization coming only later. That, though, is a wholly secondary and exceptional phenomenon. It is virtuosity on the level of conscious reflection. Its basis, though, is the direct mastery which first shapes our relation to things and fits our dynamism to them. Merleau-Ponty tells us that it is as if our movement had a magic power, as if our *fiat!* had a magic effect not mediated by anything objective.[29] An objective mediation can be analyzed into components in space. Here we encounter nothing of the sort. I will, and my hand moves. I do not intend the movement of my hand: what I will is to write a few words on the board, I will to reach for an apple. The entire intention is meaningful as a mutual coordination of my dynamism and of a thing appearing to me. There is here something like a mutual coincidence of lived experience and reality.

Subjective movement is lived effectiveness. This fusing of effectiveness and lived reality is not complete; a movement fulfills an intention but not fully, since a movement is not a reality but a realization. Anticipation, too, is a part of it, its meaning is a change in what there is. For that reason the coincidence of the subject and the object has the character of a process that manifests a disagreement with what is, including a disagreement between my lived experience and the experienced. For that reason a movement is a realization of something that is not yet. There is a certain anticipation here. Every action has as its goal, making things appear as we wish and can. When we de-realize reality in play, what we seek to do is to broaden reality so that it would present

28. See especially *Physics* 200b1–202b30. *Ed.*
29. See, for example, Maurice Merleau-Ponty, *Phenomenology of Perception,* p. 94. *Ed.*

to us one possibility among others. Our thrust toward the world, toward the object, takes place in reality and in possibilities, it starts with the given and transcends it in planning, projection, imagination. Besides the concrete movements in the realm of corporeal dynamism, with their meaning and purposes, creating the rhythm of repetition—habitual melodies corresponding to organic rhythms—there are also abstract and symbolic movements, imaginary, transcending the field of the immediately given, of actuality, and following pure possibilities. Those, too, represent a thrust toward the world, embracing ever broader spheres.

In what sense is the I a horizon? The I as a seeing force thrusting toward objectivity passes through a range of relations to the world. It can transcend actuality in various breadths, various ways and dimensions, for instance, it can be marked by a predominance of possibilities or it can shrink to almost a mechanical repetition or to organic rhythms. The personal I contains these possibilities as something that can be unfolded, as a promise. There is a range of possibilities, of possible stances in relation to objectivity—and that is always already present precisely in the horizon, whether we are living on a spiritual or on a primitively organic level. This thrust into the world has its base where the I can return to itself and discover itself as a part of the world.

Sixth Lecture:
Recapitulation. Personal Situational Structures

Summing Up the Attempt at a Phenomenology of Our Own, Lived Corporeity

Our own corporeity presents itself to us as a force, a dynamism which "throws itself" into things, into objectivity. In this outward thrust we recognized certain phases or moments. There is, first of all, the general moment of emotional localization: what my disposition is, how I "find myself." Then on this basis there is my own activity with its projected possibilities. Precisely because it is a dynamism, a force bringing about an effect, this force has the character of corporeity. This dynamism is a phenomenon in a wholly different sense than external things that present themselves to us in their fullness, exhibiting themselves to us, perspectivally, yet in an originary manner. This dynamism is here, it manifests itself, it has *an effect,* but it does not present itself in its fullness: its *givenness* is that of a *horizon.* That differs from phenomenal givenness in a strict sense. A horizon manifests its presence but beyond that it points only to the nongivenness of what is implied in it. It is the givenness of what is not given. Corporeity, dynamism in self-localization amid things, is at the same time something concealed, a horizon manifesting itself in a special way; it is, as Merleau-Ponty described it,[30] the darkness of the cinema needed to make the image on the screen visible. Dynamism sees other things though we ourselves are not given among the things at which we aim. The way the dynamism is manifested is that

30. See Maurice Merleau-Ponty, *Phenomenology of Perception,* pp. 100–1. *Ed.*

47

dynamic characteristics appear in *things;* for instance, the original spatial perspective within which we locate ourselves receives its orientation from the possibilities of our corporeal activity (on the left, on the right . . .). The thrust towards things, the corporeal dynamism, has the trait of something that is here but does not of itself manifest itself in its fullness, its originality. Yet it is *aware* of itself, of its activities and functioning, of grasping things. Merleau-Ponty speaks of a magic relationship between our internal consciousness of movement and the obedient corporeity.

Involvement in things is only one dimension of our *self-localization in the world.* We localize *ourselves,* that is, this movement *is* aware of itself, i.e., in moving outward, toward things, it turns, returning to itself through the world. This return to the self is only a special mode of continuation, a stage on the way from the self outward. It does not break the original impulse that seeks to penetrate other regions of what is; it only, so to speak, bends it. Beyond the region of the immediate sensory given we encounter a reality whose objects we ourselves are; that is, if we seek to penetrate it, we become involved in its impulse and thereby turn back to ourselves. That is a further moment of our corporeal activity—*the personal moment.* Our original dynamism, summing up our organic corporeity, given in the mode of a horizon, encounters other dynamisms and does so essentially—our life in flesh is thoroughly interpenetrated by this personal structure. Such personal structures do not have the character of substance and attribute or of terms and relations but are, rather, *situational* structures. One might object that situation is a relational concept, that a situation is something complex, having components. To that we need to reply that a situation is something different from an objective relation that assumes termini external to it and to the relation; a relation is something other than its termini. I am in a situation in such a way that the situation is not distinct from me and I am not bereft of influence on it. We need to distinguish a constellation of conditions, of circumstance, and a situation.

When we spoke of corporeal spatiality, we said that in a certain sense we localize ourselves in the world and that we relate ourselves to our selves in this localization. That is reminiscent of the claims of existentialist philosophers. A situation is something existential, derivative from the relation of humans to themselves.

Therein we are in agreement with the existentialists. At the same time, though, we differ from them fundamentally. Existential philosophy, for instance the early Heidegger (in the period of fundamental ontology),[31] who is an analyst of existence, defines existence as a mode of being such that beings characterized by that mode of being are concerned with that being itself, that is, he defines existence in terms of self-relatedness.[32] Heidegger derives the concept of situation from this. Existence is essentially a being in a world, that is, *somewhere;* self-relation already contains something like self-localization. Heidegger understands the relation of existence to the world as a *fall* into the world. Existence must fight its way out of the world, must be liberated from it by carrying out a certain "purification." The fall consists of the important phenomenon that we fall into things, devote ourselves to them, and thereby objectify ourselves. Thus we become alienated from our original nature—we relate to ourselves. Liberation from the fall into the world is a liberation from this objectification, a return to existing in the strong sense, as distinct from mere being. The task is not merely to reflect on being but to relate to oneself, in existing, and in existing fully, authentically, not just vegetating like a twig of wood.[33]

Herein our conception is fundamentally different. The relation of humans to the world is not negative in that way but rather positive, it is not a self-loss but the condition of the possibility of self-discovery. What is characteristic of Heidegger's analysis of being in the world is how little space is devoted to the concrete phenomena involved, for instance to the phenomenon of corporeity. Heidegger's entire analysis takes place in the dimension of the moral struggle of humans for their own autonomy. Only by the way does Heidegger recognize that the struggling being is a

31. Martin Heidegger, "Sein und Zeit," in *Jahrbuch für Philosophie und phänomenologische Forschung,* vol. 8 (Halle-Saale, 1927); *Gesamtausgabe,* vol. 2, ed. Friedrich-Wilhelm von Herrmann, (Frankfurt am Main, 1977). (For a translation in English, see Martin Heidegger, *Being and Time,* trans. John Macquarrie and Edward Robinson [New York: Harper and Row, 1962.]. *Ed.*)
32. *Sein und Zeit, §9. (Being and Time,* p. 67. *Ed.*)
33. See *Being and Time,* §38. *Ed.*

corporeal one, without explicating it.[34] Yet precisely in the course of that explication does it become apparent that our relation to things is fully analogous to our self-relation, that it is a continuation of our life in the body. It is not something sharply different from the way we live in our body, relating to ourselves. Our being thrown into the world is at the same time the movement in which we become embodied in something other than ourselves, become involved, become objective. This becoming involved in what originally we are not but what we become reveals our possibilities to us. For instance, the emergence of writing—of controlled memory, (the possibility of controlling something that is originally given mentally), makes possible for humans systematic knowledge, science, life in history, organization of life in great wholes, poetry, creativity in imagination; those, though, are internal matters, relating to internal life itself. Life is made possible by a primordial impulse that transcends us, that relates to what is without, constituting what is external, or nature, as Hegel would have it, as our nonorganic body. Therein the sphere of new possibilities opens before us. That in turn makes it possible for us to look back at our organic body. Further, for Heidegger the dimension of shared being (that the thrust toward the world always involves being with others) plays a minor role; it is mentioned but not adequately analyzed and made concrete. In Heidegger's analysis of being in the world the entire problem of personality is not concretely developed.

A Study of Personal Situational Structures

Contemporary philosophers often emphasize that the other being, the other I, plays an important role insofar as only on the basis of our experience of the other do we become something objective for ourselves (so for instance Sartre's ontology of being for oneself, being for the other).[35] That is rather exaggerated. I am always to some extent an object for myself, even if I abstract myself from my relation to the other. I feel myself, to some extent

34. See *Being and Time*, p. 143. *Ed.*
35. See parts 2 and 3 of Jean-Paul Sartre, *Being and Nothingness: A Phenomenological Essay on Ontology*, trans. Hazel Barnes (New York: Simon and Schuster, 1966). *Ed.*

I see myself (as for instance Mach painted himself—the scholar lying on a sofa: we can see the sofa, the feet, a part of a nose, the eyebrows; in an ironic reference to Fichte, he called the painting *Selbstanschauung des Ich,* the self-perception of the I). Yet the phenomenon of the self as something objective is always *partial* only; we can never enclose ourselves in the phenomenal field as we do objects, as we do the other I. The I is a situational concept, the I is simultaneously also an it; I perceive the objective moments of my self. The truth in Sartre's claim is that I become a *total* object only in a relationship to an other, only because I live constantly in a personal situation, because I constantly see myself in the other who resembles me, as in a kind of mirror; I am myself with respect to a Thou.

In our experience of the other being, the other person is something present but not fully given; in this experience there persists the presence of the other, the awareness of the other's reality even though there is no direct givenness. We are ever with the other on whom we count without having the other present in the original, ever oriented to the other, reacting to the other's experience even though we never experience that experience ourselves. The other being is primordially given to me as an object, but just as in hearing words we do not remain content with them as acoustic phenomena but rather pass through their sensory appearance and focus on their meaning so that the words themselves seem to vanish, so, too, is it with the other person. We pass through the objective, sensory phenomenon of the other to the other's "within," to the dynamic impulse, to what the other is and does internally. However, I am again one of the objects of that impulse—I as the other's object. Thus I become a total object. I see myself in the eyes of the other. The other need not be concretely instantiated. It is a constant structure of our experience; I see myself ever as the other, as the other sees me.

This return to the self through the other is the *first type of explicit reflection.* Not that the original dynamism is not itself somehow given, self-aware; it is, though of course not in the mode of explicit self-relation but rather in terms of a constant self-forgetting. It is a peculiar horizontal awareness, aiming away from itself, the awareness of the self as a self-forgetting. In the return to oneself from the world through the other, however, we encounter the first explicit reflection. We see ourselves as an object, as we see

the other. The other sees an object in us, though in the same way that we see the other, as an inner dynamism. The reason is that we have a *common* world to which we both turn and in which we engage in an activity which we understand in *common*. The other, too, deals with this and that, gets dressed, orients in the world—I see that. I see the same in myself through the other. I see myself through the other not as an object only but also as a dynamism contained in the bodily presence. The Thou is *the other I*. The situation in which I find myself with respect to the second I is a double one, a mutual mirroring. I see and I am seen. I integrate this mirroring in myself. We could repeat that infinitely, but this repetition itself belongs to the meaning of mirroring. I am a Thou for the other, the other is a Thou for me but an I for the other's self, what for me is here is there for the other and vice versa, etc. This mutuality is the foundation of the structures without which language would be incomprehensible.

It was Hegel who first analyzed this double relation of the I and the Thou in depth and did so with a special metaphysical emphasis.[36] Hegel seeks to show that the I is not possible without a Thou. The I in the sense of a reflexive identity presupposes the experience of the other I. The I is not something in isolation, as modern subjectivistic philosophy since Descartes sought to suggest. The I intrinsically contains the other I. In Hegel, that is complicated by his far too specific metaphysical idea of what an I is, that we as spiritual beings are personalities which transcend, leave behind being in the mode of nature. The meeting of the two I's as Hegel sees it is not as innocent as it is here; it is a life-and-death struggle.[37] Each of the two I's needs the other for self-assurance, needs the recognition of itself on the part of the other I, as this free individuality which can rise above all of reality and even life itself. For this reason, the relationship is initially a mutual threat of the two I's, a struggle. The two are enemies to the very root of their being. The way we understand it, by contrast, is that the I, an existence projecting itself into the world, into objectivity,

36. See G. W. F. Hegel, *Phenomenology of Spirit,* trans. A. V. Miller (Oxford: Oxford University Press, 1977), pp. 104–38. *Ed.*

37. See ibid., pp. 113–14; compare to §431 of the *Enzyclopädie,* where corporeality is stressed as exemplary of the *Fürsichsein* of self-consciousness at this level of the dialectic. *Ed.*

is only seeking its meaning and content, so that we cannot say a priori what it is. For that reason we can save ourselves this whole metaphysical entanglement from which Hegel derives his entire philosophy of history (which, according to Hegel, is a product of a struggle for recognition in the relation of the master and the serf; that is the seed of history from which the whole problem of class struggle and class relations follows).

Initially, the Thou always means a presence or an imagined presence: it is present as a Thou. A Thou that departs from presence is no longer in the mode of Thou, just as a perceived I, I as seen, not the active I, is no longer an I in the strict sense. From the contact, from mutual mirroring, from exchange, the Thou departs into the realm of the *it* (which is itself multifaceted), that is, into its personal component (weakened personality). From the Thou a transition is possible both to the region of the it and to the region of *we* or *you(-all)*. The reason is that the world is a shared world. The dynamism which forms a nonorganic body for itself, transcending my own I, can in turn be articulated, either coherent with or antagonistic to the broader context. That is how the we or the you(-all) are constituted.

This involvement in the world bears a primordial structure with it: its center—my own I; the courtyard of my I's involvement—it; the center of that courtyard is the Thou. The structure of our perceptual world is profoundly shaped by the reality that this perceptual world has an other I as its entelechy, its teleological idea. That Thou is what we want to see, what interests us, the focus of our world. That is true even in its perceptual aspect, precisely because the Thou is a presence. We convince ourselves that our corporeity is profoundly personally defined. In some respects that is quite evident, as for instance in gender difference. The personalistic cast of our life, of our dynamism, however, is evident in all our experiencing, in all our self-placement in the world.

Seventh Lecture:
Personal Situational Structures (continued)

Our existence with its subjectival ("substantival") core, the I, is a thrust towards the world, a self-localization in the world. As such, it has something of a circular structure. It is not only a thrust aimed at mere things but primarily a thrust towards other beings like ourselves. Other beings are the cores of analogous dynamisms. These beings in turn focus on us. Thus it is enough to continue in the same direction in order to return to ourselves.

The guiding thread of our reflections is the grammatical structure of language. The core of language as *discourse* (that is, in a situation—we speak in a definite situation and we understand what we say in terms of that situation) is the primordial situation: I am speaking with Thee about it (her, him). That follows from the fundamental personal situation which in language is always already presupposed. Note here the role of pronouns: they are intelligible only in terms of a personal starting point. The primordial structure of I-Thou-It, however, is only the starting point, it needs to be continuously corrected.

The primordial personal structure appears on closer inspection even where at first we would not expect to find it. Even in the structures derived from analyzing our corporeity and our sensibility we already find that primordial structure of a being dealing with things, surrounded by things in perceptual contact—all that points to our being together with an other.

Community with others co-determines the structure of our context as it is presented in perceptual intuition. In visual

experience there is a marked difference between the sphere of the near and the far, which psychology recognizes. In the sphere of the near there is a constancy of the size of an object; in the sphere of the remote, distance and size become separate until finally in the plane of the most remote we no longer register distance, the object distancing itself, only differences in size. In the sphere of the near, that is, the distance of a thing does not determine its size, we see the object as ever the same.

The distinction of these two spheres determines at the same time the region of co-being, co-operation, of co-living in all the concrete modalities. The sphere of the near is precisely where our contact with the other takes place and that is what provides a measure of what is large and what small as a phenomenal trait. We see, we live, great and small phenomenal size differently than objective concepts. Those are relative, they represent objective relations, while lived great and small size are absolute, determined essentially in terms of other persons. The other persons as we see them, their appearance as they present themselves to us, are the basis of this absolute measure, the standard of what we call *normal* size.

Only in the sphere of nearness can I be effective, can I use objects; only here do things present themselves for my practice. The meaning of the other I's is attached to these things. Everyone using these objects must be understood as the same as I. Understanding objects is at the same time the sphere of possible uses of those objects. If I note something in my perceptual field that manifests comportment, meaningful dealing with things, I register it as an other, analogous being. Comportment, meaningful dealing with things, means understanding things as *things for something* (chalk is for writing, etc.). Those are practical characteristics testifying to the openness of things to my thrust into objectivity. However, thereby they are at the same time open to every similar thrust and from the nature of things I can read off the meaning of that comportment and so also the meaning of other subjectivities. Here we encounter something similar to what we noted about the primordial spatial characteristics relative to our bodily experiencing, with our subjective physical structure (at left/at right . . .), with the nature of our dynamic existing in the world. We do not experience it primordially in ourselves, in our bodies, but in terms of things external to us. That is analogous to

the case of the sphere of subject practice which may involve my subjective dynamism aimed outward (and not inward-turned lived experiences), yet I do not initially experience its characteristics, meaning, etc. as belonging to it but read them off things themselves. It is the same with the meaning and characteristics of other subjectivities.

The original thrust toward things is thus at the same time a thrust toward other beings like myself. This is what makes possible a return from the world to the self. The return to the self is not analogous to a reflection in a mirror; rather, it is a process in which we seek and constitute ourselves, lose ourselves, and find ourselves again. It is a process of self-retrieval from the world, one of the fundamental episodes of our life's drama.

There is a possible objection that has to do with the nature of all that is subjective: it is said that we can acquire an explicit I only in a return to ourselves that begins with a special reflection. How, though, can we acquire an I? After all, the I is minimally something that is aware of itself, that cannot be unaware of itself; it is in principle a part of its definition that it is not only consciousness but self-consciousness. How could a consciousness without self-consciousness be possible at all? Is not this quest for oneself something far too speculative, overdramatized? That is the objection that Fichte raised against older theories of the self, especially Kant's. According to Kant, the I is a conception that contains no element of passivity, not something accepted from without, but rather something that constitutes itself in its act, the act of reflection. For that reason, the conception of the I does not teach us anything about our nature; it is not something that would "testify to" our being. It is a mere product of our thought activity, of the act of thought turning away from things and to itself. When I carry out an act of abstraction from what is given as content and draw back purely to the act of thought itself, I see that the fundamental possibility of reflection, of turning to thought itself, is always a given. The I is a conception which must be capable of accompanying all other conceptions. The I is an act of spontaneity free of all passivity, all receptivity.[38] To that Fichte responds most

38. See Kant, KrV B131–39, with respect to the concept of transcendental apperception (i.e., the "I" as a pure spontaneity present only within the act of reflection as that which "accompanies" all representation). That knowledge of this "I"—i.e., characteristics

appropriately: such a reflective theory of the I (the I constituted in reflection) is circular. What is the subject on which reflection turns? Either we cannot say it is an I, in which case the equation I=I does not hold and that on which we reflect is not I but rather non-I, an object. Or it is I, but then that I is present already. When I posit the reflective equation, I=I, that is, I who reflect am the same I on whom I reflect, then either I must be aware of myself already (knowing the identity of the I with the I) or else I have no way of reaching such knowledge.[39]

We shall respond with a distinction. In a sense it is true that the dynamism thrusting itself into the world is aware of itself, but this knowledge does not take the form of an explicit orientation to the self but rather the form of not attending to the self, forgetting oneself in the course of our living. So for instance in moving around an object *I do not see* the movement, the change of what presents itself to me in this way; in perceiving I am not aware of what is presented in it but rather of that on which I focus objectively, that is, the identity of the object. I do not, for instance, see a *given* perspectival aspect but rather, in the sphere of nearness, I see objects as they are, nonperspectivally. Among the most elementary phenomena of consciousness there is a great number of phenomena such as that something is and simultaneously is not conscious (just as consciousness of a certain object presupposes a perspectival view of the object and at the same time seems itself to deny it). Our initial relation to ourselves is analogous: we are aiming, in a sense, away from ourselves. We arrive at the self at the point at which we become anchored in things and where our thrust into things makes it possible for us to continue along the objectival route, though now in the direction of ourselves. On this route we discover ourselves, though initially as an other sees us, as the Thou of the other I. The polarity of the I is given with the Thou. There are *various* I's, *various* types of I, each with its

that the "I" may have "in itself" qua "soul" or "thinking substance"—cannot be deduced from the functional characteristics of pure apperception, see the Paralogisms of the Transcendental Dialectic. *Ed.*

39. See, for example, J. G. Fichte, *Foundations of Transcendental Philosophy (Wissenschaftslehre nova methodo)* (1796/99), trans. and ed. Daniel Breazeale (Ithaca, N.Y.: Cornell University Press, 1992), pp. 114–18, 126–30. For passages where Kant excludes the possibility of an "intellectual intuition" (which would presuppose the "I" being in a passive relation to its own activity), see KrV B68, B72, B158, and B307. *Ed.*

meaning, its significance. The I of this first reflection is not I in that primordial originality of the original dynamism—originality in the sense that only I can live myself, a singularity that cannot be transposed into the plural. The I of the first reflection, presenting the I in the eyes of the other, is therefore an I like Thou; the I in the plural always presupposes a Thou. Even in reflecting on my original I (the only I that lives experiences, the only I that can feel my pain, that can live my perception of the world) I acquire this original I only in comparison, in a differentiation from the Thou, with the plurality of what I am and how I see myself in the eyes of others. Here, too, the way to the self leads along the way to the world and to others. Only then do I distinguish the I that I live from the I's that I am not. Reflection does not constitute the core of my I; reflection purifies my I of others, selecting me out of the subjective sphere in the world and making me myself. We shall leave suspended the question whether this purification is a purely intellectual act. (To make myself an I requires more than an intellectual act, there are also affective experiences that lead us further, not only experiences of the intellectual kind.)

Sartre sees the fundamental episode in the drama of human relations in this relation of I and Thou, I, my subjectivity, and the other. What Sartre says is instructive, but his starting point is different from ours. Sartre neither knows nor acknowledges the I: there is no identity of the subject being whom we call I. We say: I is a horizon by its very nature. Sartre does not use these concepts in his analysis of subjectivity. For Sartre, subjectivity is essentially characterized by a contradiction. There is no identity I=I, an inner unification, rather, subjectivity is essentially what it is not and is not what it is. Every attempt to describe it distorts it in some way. The attempt to define its character stems from a model of being other than the one appropriate to subjectivity. Subjectivity is always something other than what can be said about it, it is always *more* than what is given in it, it is *wholly* in the thrust of self-transcendence; wholly—that means, it is nothing other than this self-transcendence. It belongs to the thrust of self-transcendence to be always a subjectivity that has its past, its integration in the world, that is, circumstances that determine its thrust; those also include our corporeity. When a second subjectivity appears in our vital self-transcendence, we are for it what it sees, something given, complete, a thing. The moment I realize this situation my

thrust is frozen—the look of the other being in that moment fundamentally threatens me in my whole being. It is the other's look that threatens me. Hence the unceasing effort to come to terms with the other, to win over, to attract and transcend the other. (That is analogous to Hegel.) Here Sartre recognizes a number of gripping situations, struggles of two subjectivities seeking to seize the other subjectivity without objectifying itself thereby.[40]

Sartre's fundamental rejection of the phenomenon I, or, perhaps, if he acknowledges it at all, placing it on the side of a *mere* "phenomenon," not belonging to the core of subjectivity which is by nature transcendent, contradicts fundamental phenomenal data to which we are referring. We believe that the phenomena we have analyzed (linguistic structures, experiences of the lived body, self-localization) lead necessarily to structures that cannot do without such terms (the "I") though we do not think that we have already seen through them, exhausted them; rather, we need to continue analyzing them. We cannot cut them off, as Sartre does. In this respect, Sartre is a metaphysician, terminating analysis by fiat, once and for all.

Now concretely about the personal structures: we have distinguished two senses of the I. There is the I capable of being plural, the I appearing as a Thou, the I for others. The Thou is the second I as present, in reciprocity, in a mirroring, an I with whom we are in the contact of mutual understanding, the process of exchange, in this double situation (I here—you there, etc.). Then there is the I in absolute originality which only it itself can live, incapable of plurality. Every experiencing I is for itself an original I. Our terminology is inadequate here, we have the same term for two distinct things. The I is in this sense always double. That which the I is for itself encloses it within itself, making it inaccessible to all that is other. Yet I do know about other I's, abstractly, what I know of myself, that they are equally original, that they find themselves in the same situation of the absolutely experiencing I.

In addition to this I-Thou reciprocity, there exists another relation in the subject sphere of the world, a relation in which

40. See Jean-Paul Sartre, *The Transcendence of the Ego: An Existentialist Theory of Consciousness,* trans. Forrest Williams and Robert Kirkpatrick (New York: Noonday Press, 1957), pp. 93–106; also see Sartre, *Being and Nothingness,* p. 394. *Ed.*

reciprocity and mutual presence do not matter, more of a relationship of a certain solidarity of various subjectivities, a relation of belonging and mutuality, not excluding reciprocity but not urgently or necessarily presupposing it, parallel but distinct from it—*the relationship of we*. For these reasons it is an originary relation, not reducible to the structure of I-Thou. Thus if a second person leaves the sphere of presence, the mode of Thou, that person need not yet leave the practically personal sphere into the mode of It, in which I think of that person only as an object, where the other is but a thing devoid of a present practical relation, but rather can remain within the sphere of the we. The sphere of coexistence can be divided into the sphere of shared practice (I-Thou, we) and the sphere of mere coexistence. The sphere of the we extends as I extend my practice into the world, as it penetrates among things. The relationship of solidarity with the ancillary relations of distance, difference, perhaps also antagonism, is what creates the relation of *you(-all)*. The spheres of the we and of the you(-all) are not exclusive but rather relative. These are the most ordinary structures of our experience, though difficult to reach in reflection. It is not yet the phenomenon of the personal network, only observations towards one, its components. The all too ordinary we, *you(-all),* . . . that is a problem even phenomenology has barely begun to raise.

Eighth Lecture:
I and the Other: Appresentation and Being-With

Let us first introduce a concept important in Husserl's phenomenology, that of appresentation, presentifying: rendering present something that is not present, rendering it quasi-present.[41] That is possible only in a certain sense; the object becomes present in a sense while in another sense it remains absent and hidden. That is a very important concept for us. For instance, the back of an object in space is appresented, not given originarily though it is given together with what is given in the original, as intimately, essentially linked to it. Appresentation is particularly important in perceiving another person. Other living beings are not accessible to us in their original experiencing, in their stream of living. We never have the lives of other persons as they live them in the original. The others are presented to us through their appearance, as a phenomenon only and not in their primordial being, approximately as we are given to ourselves when we look at our body, as when we have fallen and are feeling ourselves. At the same time and in spite of that we have constantly the impression that others are not before us only as the front side of an object, a wall behind which something is taking place. All we see of them in the original is but a passage to what we do not see and what precisely interests us. Thus the other as a life is present to us after all. It is the same way with the read or spoken word. When we are reading, we are practically unaware of the visual impressions. We do

41. See Edmund Husserl, *Cartesian Meditations,* trans. Dorion Cairns (The Hague: Nijhoff, 1960), §§50–54. *Ed.*

63

not linger over graphic shapes, sound configurations, we overlook them and go on to the meaning behind them, passing through what is presented to what is not presented but is only appresented through it.

The memory of something that *was* present in experience and is so no longer offers another analogy.[42] The thing intended in memory is a former original presence. In memory I am aware of that mode of original presence but that presence can never repeat itself there. A memory never presents the thing in the original but rather in a quasi-present. I can recall a concert that takes place in a quasi-time as a quasi-present, that quasi-present has its quasi-past and so forth. We consider memory as the experience of the possibility of going into the horizon of the past, as something absolutely evident—repeating something once more as *the same,* though we can in no way compare or control the accuracy of that memory. The experience in memory is given in its fullness. The past is not originally presented to us in memory but rather in immediate recall, in retention, which is a special mode of forgetting, of de-presentifying the present in which we still retain the present in hand. Such retention opens up the past to us. In retention, what is no longer present still remains present, directly. Memory is built up on this retention, as a retroactive movement building up on the meaning of the retention—the passing of being, the depresentification of the present. Re-presentation of the present: what had been is here in the mode of nongivenness. A memory is an experience of a unitary past. By its very nature, a remembrance is fragmentary, distortive, confused, and yet it is the only mode of experiencing the past. That is the originality of remembrance. In a way, an original mode of experience can arise from the nonoriginal mode of givenness. A recollection is an awareness of a former *present*. It intends the present, though it cannot present it: it can present only a quasi-present and this quasi-present is the sole possible access to the past as the past. A remembrance is not an appresentation. An appresentation presupposes a presentation, the appresented is presented *through* something that is present. A remembrance is not presented through something present. The original here is secondary.

42. Cf. ibid., pp. 115–16. *Ed.*

A remembrance is a making present of a past present. The character of the past is essentially different from, for instance, the appresentation of meaning through acoustically given words. The example of remembrance, however, can serve to show that with respect to secondary originality there is something similar in the appresentation of the other I.

In appresentation, there is a component that shows me as incomplete, as needing, as receiving, as lacking. The experience of appresentation shows that, from the start, our shared life with the other is not a mere projection of our own person. Similarly as in the case of remembrance, I can be mistaken in my reception of the other, my understanding of an other life can be fragmentary, marked by gaps and so on. In principle, though, precisely here, with this experience, a new dimension opens before me, first qualifying me as a *fellow being,* not as the author of the other being; *life shared* is no mere copying but rather mutual enrichment, increase.

Life's drive into the world, to things and to other beings, makes us what we are. The most important drive is that toward other beings; reflection is a continuation of the drive toward the world at the point of encountering another being within our presence. The primordial act of reflection is probably something that belongs to the realm of appresentation. I appresent myself as I am in the other life. Most of our mental contents come from tradition, that is, from others; what we add to it is minimal. That is just what we can deposit for our part in other life streams.

Appresentation might carry with it a certain unfortunate suggestion of something merely spatial and temporal, as if being with an other meant no more than being next to each other, as things are next to each other in space. That, though, is not what is most important. Making the other present is a mode of access to the other. It does not mean simply bringing the other into spatial and temporal proximity. But we do need to have some access to the other. The path leads again through perception; that, however, does not mean that the experience of the other is a perception, that it is whatever the other being offers to view. Heidegger's analysis of *Mitsein* shows that being with others is neither a juxtaposition in space nor some psychological translation of this juxtaposition (mutually mirroring sender-receiver). Even Heidegger's

overall analyses of *Mitsein*[43] show that being together (the rela-
tion I-Thou, I and the other I in the mode of We, We-You[-all])
is a relation of mutual nonindifference, of mutual internal contact;
the other is relevant to me; indifference, irrelevance are only the
negative mode of this initial relation of mutual relevance. Humans
are never indifferent to each other, never alongside each other like
two stones. What being together means, what humans are to each
other, we cannot say at the beginning of our analysis. Humans are
close to each other in person in certain fundamental relations
characterizing their being together. Eugen Fink once tried to dif-
ferentiate these basic relations of being together into the relations
of cooperation, struggle, love, play, and the relation of the living
to the dead.[44] These relations constitute the field within which
we live. None is transferable to another even though they
do influence and shape each other mutually. We, though, do not
wish to make any such claims at the start of our analyses. We
have only got as far as the recognition that the personal field is
no mere geometric juxtaposition or a force field. The other is
the most powerful component of our experience, revealing to us
what we ourselves are and can do. So much for the concept of
appresentation.

Now let us return to the structure of the personal field. We
have seen a fundamental distinction between the original I
through which life initially streams, which is the wellspring of
experience and whose achievement all the meaning of our experi-
ence is—and the second I, nonoriginal, plural I in the form of
Thou. The original I gives meaning to everything, it is the source
of meaning. This originality it cannot delegate, no one else can
live it. Husserl occasionally says that the categories of uniqueness
and universality in their ordinary sense do not apply to this
absolutely original I. This I is unique in a wholly unique sense of
that word. The plural I is either I as the other sees me, or another
life stream for me.

Appresentation presupposes a field common to more than one
life stream. This field is constituted as I, the subjectivity originally

43. *Sein und Zeit*, §§25–27. (*Being and Time*, pp. 149–68. *Ed.*)
44. See, for example, Eugen Fink, *Existenz und Coexistenz: Grundprobleme der men-
schlichen Gemeinschaft*, ed. Franz-Anton Schwarz (Würzburg: Königshausen und
Neumann, 1987). *Ed.*

comporting toward an object, giving it a certain meaning which then belongs to it as to an object. The meaning of a practical object is presented as a correlate of our comportment: a chair is to sit, a chalk is to write. The meaning that the subject places in the object—that is the subject in the object. Our subject is thus given in practical objects. Consequently the comportment of any other organism, as it presents itself in my visual field, is for me also a carrying out of the same meaning, comportment in the same sense. Here we have that shared field.

The subject in the object is a subject in this objective field. It is subjectivity even though it is not experiencing. A chair—something to sit upon—is not life, life is something that I and not the chair live. There is here a realm of something common that is open to our comportment as it deals with things. It is an objectified subjectivity which we can project back into our own experience. Thus another level of I-hood arises—*an impersonal I-hood.* Here is the real root of what Heidegger calls the impersonal I, the impersonal subject *(Man-selbst).*[45] In contrast to us, Heidegger does not derive the impersonal I from the realm of sensibility but posits it as the original form of *Mitsein,* being together. For us, the impersonal I is continuous with appresentation, an essential structure of our mutual contact. We have somehow to reach each other, we are not primordially open to each other. For that we must project ourselves into the object. The projection of subjectivity into objectivity constitutes the shared sphere.

How does Heidegger characterize the *Man-selbst?* It is easy to say that our experience takes the form of "I experience this or that." But who is this I? Is it so certain that the *persisting* I is the true, adequate way of depicting existence, our experience? Persistence in continuity is the *modus essendi* of things, not a trait of human dwelling *(Dasein),* of a stream of experience. What if a true I is hidden behind this I? The true I originates from the *Mitsein. Mitsein* is a constant concern for others. In living together with others we are constantly comparing ourselves with them, catching up to them and surpassing them. Being together always includes this distantiation. If something new, interesting appears

45. See *Being and Time,* pp. 167–77. *Ed.*

in *Mitsein,* all involved appropriate it immediately (the leveling effect of "progress"). For all the distantiating, a public mind emerges, making the private public (the leveling public). In the distantiating and leveling tendency lies the essence of the original subject *Mitsein,* the mode in which we originally live. That is what we have in mind when we say "I." It is neither my original life, nor yours, rather, it is what is common to us. Here a certain nothingness of that I is manifest; this I is nonbeing. *Man-selbst* is something behind which our authentic existence is concealed. This also shows Heidegger's bias, his partisan stance—his tendency to add something that is not derived from matters themselves but rather from his bias against everything common, everything public;[46] that is understood as a fall. To be sure, Heidegger does see that the *Man-selbst* is a necessary part of existence, an inevitable stage in it.

46. As illustrative of this bias, see the sections in *Being and Time* on "idle talk" and "curiosity" (§§35–36). *Ed*

Ninth Lecture:
Being-in-the-Body and Phenomenology

We have assumed the standpoint of phenomenology, systematically elaborated by Edmund Husserl and his followers, especially among the French. Phenomenology is a philosophy that remains (or strives to remain) on the grounds of experience, of what can be experienced as original reality; in this sense, phenomenology is a philosophy of the concrete. Philosophy wants to penetrate to the whole, to the core of what makes reality a whole, to the core of what is. Phenomenology in its effort at concreteness sticks to what can be seen in experience. Phenomenology elaborated its drive for concreteness, for grasping what is essential, in a distinctive manner by focusing on what is essential in individual experiences rather than on what totalizes experience. In its descriptions, phenomenology developed ever more precise methods of grasping the perceived, the givenness of the particular, of what thought is in the sense of intention and fulfilled intention, what remembrance is, what the difference is between the awareness of a picture and the awareness of the past, and so forth.

However, as Husserl elaborated it, phenomenology never got around to the question of what it is that links individual experiences together. They are the experiences of a definite living being who poses the question about the whole of all that it experiences, of what is the common bearer of all the individual experiences. Phenomenology in Husserl's sense did tell us that the subject of all individual experiences (of intending, encountering the particular, going into the horizon of the past, etc.) is consciousness, a transcendental subject, differing in all its fundamental structure from the finite being we call a human. Within phenomenology, it seems as if that ultimate subject, the center that gives meaning to

all experiences and carries them out, was no more than an aggre-
gate of individual activities, as if that ultimate bearer had no con-
tent other than that relating to the world, to objectivity, and as if
it became completely diffused in this relating, in the experiences
of objectivity. We keep encountering the question of the differ-
ence between the being of humans and that ultimate, meaning-
bestowing transcendental subject that bestows meaning even
upon that "human." A human is a being among other beings in
the world. Husserl's phenomenology never tells us concretely
how the meaning "human" is constituted, what is the relation of
humans and of that ultimate ground upon which the bestowal of
meaning and all accomplishment of meaning take place. About
that we find only scattered remarks in Husserl's work.

Husserl points out that the relation of humans to the things
before them is not one of a higher level, of a higher grade of
objects (as mental objects are related to percepts they presuppose
and on which they build). Humans are integrated into the world
already by virtue of their *corporeity*. Precisely corporeity is what
places humans into the world as intrinsically living beings, living
a life. Our relationship to our corporeity is different from the
relation to the objects to which we relate through it. Our corpor-
eity is, so to speak, the condition of all our relations to objectivi-
ty. It is a *lived corporeity*, not an observed one, one which
belongs to us intrinsically, not as the object of the natural sci-
ences. Husserl presents some analyses of corporeity in *Ideen II*.[47]
Perception is relative to the capacity for movement. In Husserl,
however, it seems as if, in addition to the analyses of perception,
remembrance, anticipation, phantasy, etc., there were still a spe-
cial topic, that of the *body*, a phenomenology of corporeity.
Husserl did not reach the radical question—what is a human?
The way from the transcendental subject to humans leads
through corporeity. We might ask whether, in this chapter deal-
ing with corporeity, Husserl is not a Columbus in reverse. He
seems to have thought that he had found a new island in the
ocean of human meanings; it may be that he found a new way to
an old continent, to the continent *of the whole*, not only to one of

47. Edmund Husserl, *Ideas Pertaining to a Pure Phenomenology and to a
Phenomenological Philosophy. Second Book: Studies in the Phenomenology of Constitution,*
trans. Richard Rojcewicz and André Schuwer (Dordrecht: Kluwer, 1989) (hereafter *"Ideas
II"*). See especially §§18, 35–42. *Ed.*

its parts, to one particular experiencing, but to the *very nature of being human.*

If we want to understand the place of the problem of the nature of being human and its relation to the level on which we constitute meanings, possibilities of experiencing, significations, and so forth, then we need to set phenomenology aside and provide our reflection with an overview of the history of modern thought, turning to its greatest achievement, the philosophic epoch since Kant—that is, the epoch in which we still live, and we shall not get beyond it until we clarify this problem. Wherein consists the difference of the problems of this philosophic era from those of previous philosophy? It is that the thinker now inquires not only about the products of our experiences but also about who it is who experiences them, whose achievements they are. That means that we make the transition from what is seen and considered as finished being to what makes this being be as a particular meaning. We move from firm results, finished and at rest, to activity. An activity always precedes the finished result, and it is always some form of *practice.* The final stage in the development of the idea leads to practice. Even though there may be different theories, the entire epoch which so posed the question constitutes a unity.

To this era, there belongs Kant's attempt to ground the objectivity of human knowing in the autonomy of our mind and at the same time to ground the objectivity of the principles of our acting on the idea of moral comprehension, of a moral understanding which does not receive its principle from without but is itself a creator, a reason which itself becomes an agent. Kant raises the problem of autonomy and finitude. Kant thinks the two simultaneously by affirming finitude. Post-Kantian thinkers understand autonomy, human freedom, as an activity that encounters no resistance, that is unlimited, absolute, backed by infinity. That leads to insoluble metaphysical problems.

If we define metaphysics as the study that asks about the nature of being and responds by referring to *substance,* the highest being, then post-Kantian philosophy, especially Hegel's, may well be the last great fruit of the European metaphysical spirit. Not humans, but the absolute spirit is the ultimate source of all activity, absolutely free, creating not only thought but even being as such as meaning, and containing within it the totality of

everything spiritual. For Hegel, in the end everything leads back
to this metaphysical conception. Yet it has been shown that this
conception is possible only in contradiction with the idea of the
new inquiry, that the new question that wants to think freedom
plus finitude would lose itself if it were to end in an absolute
substance.

Kant's philosophical question had not been exhausted, only
one version of it; the inquiry traced out only one specific direc-
tion. Post-Hegelian thought—Feuerbach and Marx—thinks the
question of autonomy and finitude from the standpoint of
humans as *concrete beings* constituting themselves in their con-
crete daily form by working within definite social relations.
Concreteness is here sought in corporeity, in community, in his-
toricity. Hegel's *method* for resolving the problem of autonomy
and finitude—dialectics—is a method of thought in which every-
thing given, everything finished, is always considered only as par-
tial, as being surpassed and bearing the seed of that surpassing
within it. This method received a new form in the version of the
return from the absolute spirit to human concreteness, the form
of the self-constitution of human life, building up human possibili-
ties on the basis of the fact that humans at every stage of their
relation to objectivity constitute new possibilities of their own
selves, of their own lives, and so return to themselves by acting in
objectivity.

The word objectivity has many meanings. Pre-Kantian empiri-
cism and rationalism emphasized it as well. That is objectivity that
does not seek to base itself on what gives it meaning but rather is
massively accepted, simply as fact. It is facts that count in science;
whatever is observed, is—and we do not inquire any further. The
sum of facts is what humans need in life and what makes it possi-
ble for them to orient among realities; knowing is prediction and
so *power*. The positivistic bias is contained in the stress on obser-
vation of what cannot be changed, what cannot be disputed, what
can only be observed and described. Self-constitution through
objectivity and objectivity as a fact are two different things which,
in the nineteenth century, entered into a counterintuitive and
paradoxical personal union. That led to building positivist per-
spectives into the foundations of the solution of the question
of autonomy and finitude. For that reason, we need to
think through anew our Kantian heritage from the standpoint of

activity and practice, which Kant and his successors left suspended; we need to think through all of philosophy anew.

Phenomenology is a part of this complex, not just an episode, formation, but logically internal to the unfolding of this fundamental problem. It found an inner method of approaching the finitude of the human, not as seen from without, as mere fact, but from the perspective of life as lived, from understanding, as humans are accessible to and understand themselves. That is its merit. Here we can see all the ambiguities. When we say that humans are bodily beings, it can mean (a) an objectifying natural scientific perspective (mass in motion . . .), or (b) an analysis from the standpoint of living concreteness, of humans, beings who have a multifaceted and dramatic world, life in the tension that finitude and facticity, autonomy and activity bestow upon it. Finitude is not easily described though we can say what must belong to it. Human beings are always threatened; in all their acts they deal with their limitations. Humans are not delimited like stones or like animals who are not aware of their own perishing, humans know their limitations, are constantly relating to their own finitude as to their own being, caring for and looking after their needs. A phenomenology of corporeity is a phenomenology of this concreteness of ours. It is a matter of dialectical relations. Our relation to objectivity is a dialectical leap into objectivity, living not within ourselves but in what we are not, finding ourselves in what we are not. Here we apparently have the "dialectic of the concrete." That is not mutually exclusive with Husserl's pedantic intentional analyses in which he explores the individual acts of our life. Quite the contrary, those analyses are a presupposition for discovering those dialectical structures, discovering the philosophical problems of being human. Here we have what Feuerbach did not manage; he sensed that we need to turn away from philosophy of the absolute subject to the concrete human being but he returned to empiricism instead, to a pre-Kantian position.

Kierkegaard and existentialism represent a further step into this problem. They, too, belong to the context of German post-Kantian philosophy, that is, to the context of autonomy and finitude. What is the difference between the philosophy of existence (Heidegger) and the philosophy of concrete humans in their corporeal world? Existential philosophy singles out certain structures from the whole of active human relating to the world and to our-

selves and places them in opposition to certain other structures. Existentialism only lets humans, who are fundamentally personal, subjectival, fall into the world, so that the relation to the world is always negative while the positive means wresting oneself from the world by a negation of the world (thrusting the world aside, liberating oneself). Already Hegel analyzed the fundamental existential structures, showing that the way of humans to themselves is not an innocent and painless reflection, a magic act penetrating to the essence, harming no one. To penetrate to the core always means somehow to pierce the organism. Hegel showed that reflection, the encounter of humans with themselves, leads through hard conflicts, is a result of a struggle. The grandiose optimism of Hegel's philosophy is that, though it does not mask the hardness of reality, it understands all the sorrows of the spirit and of life as mere stages, as a way to an ever deeper reconciliation and peace, a passage to one's own interior, deepening both life and spirit. While existential philosophy does not go beyond private existence, saving only my soul, Hegel's philosophy (Hegel had Hamann[48] before him, as an example of existential reflection) sacrifices the soul so that all may gain spirit.

We are sketching the final period of philosophy from the eighteenth century to the present as a unitary problem *per apices,* leaping from peak to peak. This problem will no longer be understood as a succession of systems (dogmas), these are themes that ask to be understood as a whole. Understanding Kierkegaard presupposes understanding Kant, etc. The so-called collapse of German idealism did not come from without, it was, rather, an internal development of the problem itself. In Hegel speculative philosophy reached its apex, constituting an all-embracing system including the dimensions of history and of personal corporeity— that is its enrichment as compared with Aristotle and Scholasticism; then came the critical examination of this grandiose achievement that brought a sobering, a return; a stage we left out in our overview. In the German idealist experiment, the new problems at first appear in old forms. It is, though, ever the same problem of finitude and autonomy: beings placed in the world,

48. J. G. Hamann (1730–1788), German philosopher and radical critic of the Enlightenment. *Ed.*

aware of the world and of themselves, beings in the world among others and dependent on them (on others and on things) and yet living as free, not as a stone, as animals in merely external relations, but rather living an inner life.

Phenomenology, which might point the way, was at first unaware of its continuity with the tradition, with German idealism. At first it even turned sharply against it (for instance Scheler at first shows a tendency to build on the objectivity of Aristotelianism and of Scholasticism).[49] In the work of Husserl and of those who had been affected by existentialism the phenomenological questions soon led to the problem of the subject, of subjectivity, and in the course of those analyses to a revival of the questions posed earlier by German idealist philosophy. Husserl, however, managed to avoid the difficulties of eighteenth-century system building. Kant's a priori is an exceedingly over-wrought and oversystematized affair, even if it is based on deep insights. Husserl's a priori is more flexible and does not involve a fundamental gap between sense experience and thought. Phenomenology emerged at a time of giving up hope for philosophy. Brentano, in his introductory lecture in Vienna in 1870, *Reasons for Discouragement in the Field of Philosophy,*[50] observed that philosophy is over, that positivism alone remains. Everything belongs to the special sciences, knowledge is only special, no knowledge is left over for philosophy. Brentano sought to show through psychology that something might be saved from philosophy after all. In the beginnings of the twentieth century, philosophy draws a new breath. Science itself turned out not to fit the positivist conception of science as a collection of facts. Science is not passive observation. The new wave of philosophical activity around the year 1900 found a vacuum into which new initiatives could enter. And here it turned out that phenomenology, which sought no continuity and started wholly anew after the positivist

49. See the First Part of Max Scheler's *Der Formalismus in der Ethik und die materiale Wertethik,* which was published in 1913 in the *Jahrbuch für philosophie und phänomenologische Forschung.* It has been republished as volume 2 of Max Scheler, *Gesammelte Werke* (Bern: Francke Verlag). Also see Scheler's essay "The Idols of Self-Knowledge" ("Die Idole der Selbsterkenntnis"), in Max Scheler, *Selected Philosophical Essays,* trans. David Lachterman (Evanston, Ill.: Northwestern University Press, 1973). *Ed*

50. Brentano, "Über die Gründe der Entmutigung auf philosophischen Gebiet" (Wien: 1874). (In Franz Brentano, *Über die Zukunft der Philosophie,* ed. Oskar Kraus [Hamburg: Meiner, 1968]. *Ed.*)

interlude, the positivist interruption of the tradition, arrived at traditional problems once more and proved a continuation of the tradition that began with Kant. What we attempted here was to determine the place and the role of phenomenology within the tradition of Kant-Hegel-Feuerbach-Marx-Kierkegaard as a whole.

In the lectures of this past semester we have sought to show how the phenomenon of corporeity—of being-as-a-body—leads us ever deeper, how the phenomenon of the subjectively lived body is continuous with our personal existence. Our life takes place in a personal field and so through corporeity. For a personal field is not possible except through corporeity. I never live the other, I need have the other presented in the form of an object, as a body. The return to subjectivity takes place through the thrust into objectivity. Our concrete prehension presupposes the structure of the personal field—contact with objectivity takes place in the field of I-Thou-It. These words, though, merely hint, we need to go beyond such distinctions. Various forms of the It, the Thou, the We correspond to various degrees of the I. The originary I—never experienced by anyone—comes to itself through objectivity, though not in the form of a mere synthesis of natural entities but in the far more differentiated form of *the spirit*.

Tenth Lecture:
Three Types of
Phenomenology

We started out with the question of how experiencers are in space. We saw that they are not there like things, in mere adjoining locations; rather, experiencers must gain access to space and to self-localization in space in order to be experientially in it. It is not the case that as a part of our spiritual life we have some subjective space; rather, we have only our own access to space and to the things in it. Spatialized things are common to us. It is the unitary space of shared things. If we are to gain access to space, things must in some way appear to us and orient themselves, relate themselves to us. Thus we see that experiencers do not appear in the object field as its components; that would only mean their objectification. Rather, each of them appears as a center, as ordering the basic dimensions of near/far, up/down, etc. This ordering shows us experiencers as *corporeal*, as living as bodies. They are not subjects of thought, they are not Kant's I's that have to be able to accompany all apperceptions. These concrete dimensions are meaningful only with respect to the bodily. Experiencers always stand, lie, etc.—they are dynamically present. The I is an indubitable fact but it is not a pure act of spontaneity (Kant), but rather represents a unity of bodily dynamics. The I defines the experiencer in a horizonal manner. It is an overall balance, a unity of the components of corporeity. For instance, I feel my position in space, my leaning on the lectern, I feel the boundary between my body and its surroundings. When I sit down, the corporeal

schema assumes a different configuration. The corporeal schema is constantly present without being an object of awareness. I feel my position, the dynamic configuration of my momentary posture in space. The corporeal schema is nonthematic (thematic means literally at the center of my attention); by its very being, it is something I do and is present as such, not as an object of attention. The corporeal or dynamic schema is something entirely original; it is not a residuum of impressions, of perceptions. A functioning corporeity is an a priori of all experiences I have with my body. These experiences flow easily into the original clarity, the schema accepts experiential components into itself, as when I learn to swim. But its foundation, the fact that I am always aware, in a distinctive, practical mode, of the functioning of my corporeity, that is prior to all experience.

Thus we are something mobile, penetrating in definite directions, we have a sense of our situation. The corporeal schema points to something deeper. Phenomena like standing, sitting, holding on to something, and so on—these phenomena are anchored in something. The functioning of my body, of which I am nonthematically aware, is not self-enclosed. It has to do with the way we comport ourselves with respect to things in space. Stances, movements, always have some meaning. They belong to a certain continuity. That begins with our being "conscious" in some sense of our overall situation. That, though, is not a consciousness in the sense of "having something as an object," it is a certain clarity about ourselves, a practical clarity which yet does not focus on the way we are clear about ourselves. It is a clarity without an object, unclear in its objectivity, a primordial undifferentiated clarity about our situation. Normally we express it by speaking of feeling in a particular way. The lack of differentiation in this phenomenon can also be expressed by the word *mood.* *How we are* includes an entire scale of feelings and emotions, all in a practically undifferentiated mode. We do not reflect on this our situation, we do not objectify it. Even without objectification, there is far more to a mood than we might objectify, something is implied in it, more than merely a certain quality, more than a mental state. That is why a mood can be explicated, why we can ask why we feel as we do, to select the motivation of a mood from the way we are feeling. Not all persons can understand their moods. In a mood we find ourselves more authentically than in

states of thought and reflection. A mood "comes over us" but it is *our* mood, we are in the mood. We are wont to say, "How are you feeling?" In many languages it is, "How do you find yourself?" To find oneself—in a mood we encounter ourselves, we meet ourselves, though not objectively, as we meet a thing. In a mood we feel how we are. Depression or elation that rises up within us can tell us more about ourselves, about our interest, about what it is in which we have become involved, than an explicit, willing decision to act.

Mood is closely linked with corporeity, with being as a body. Our posture is rooted in a mood. Our attitude betrays our mood. Even language testifies to that: elation, depression, all these are terms capturing the continuity between a mood and the way we are doing. Mood constrains or encourages us. We grasp it corporeally, we feel it in our dynamism. We grasp certain possibilities in it: at times we live in a mode of defying all, at other times we float lightly, as on wings. The corporeal, dynamic subject is rooted in such postures. Further components of the way we are feeling—for instance, pleasure, pain—are corporeal states in the matrix of a self-understanding lived experience.

Our activity, leading into the world, into possibilities in which we have placed our being, for the most part unwittingly, and which thus represent our interests, grows out of such situational states. To live means to realize possibilities, to live in involvement, in interests. Those are possibilities with which we have, so to speak, identified ourselves. We do not have these possibilities before us as goals. There is a clarity about ourselves which is not objective, which is not a knowledge of oneself as of an object; it is a practical knowing—I act and, in some sense, it is clear to me. I need not, though, be clear about my aims; the goals we follow are often illusory. My aim, that for which I strive, is often concealed from me, I myself conceal it from myself. That is possible because our life in possibilities is an engaged life. I need not be clearly aware of my interests and yet they guide me, that is, I have a certain (nonobjective) clarity about them. We realize ourselves, we realize the possibility with which we have identified; in our possibilities we are always before ourselves (Heidegger: Dasein, being in the world, is always a task for itself).

We realize possibilities only by moving, by being physical. Every realization takes place ultimately through movement.

Abstention, holding movement back, inactivity, also belong among the movements of our body. Movement with the help of which I realize possibility is given in the sense that I can carry it out; I am clear that I can do it. But woe to me if I were to treat this clarity as an objectival one, if I sought to carry out my movements consciously, with an objective awareness—I would not do well.

Our life, caught up in possibilities, with its nonobjective clarity about itself, is at the same time the precondition of things appearing to us. For things are correlates of and responses to possibilities. A chair is a sit-upon-able, a room is there for presenting a lecture. The thing, precisely, is the correlate of possibility. Our dynamism (of possibilities) is for that reason also something that manifests us and the world around us. The dynamism we are aims into things, out of itself, toward realization, toward gratifying possibilities. Sociality is the most important component of objectivity—the others who exist in the world like we do.

We started from the recognition that I myself am not included in my own perceptual field. I situate myself in space by relating to things. I receive my place in the world from others. The personal component of this structure is impossible without corporeity. I am for others and others are for me as bodies. Through the corporeity through which I understand the other as sharing lived experience with me I can communicate with others. That is why the structure of the world as it naturally is, which can in no way be transcended, which every epistemology presupposes, is "I with others in a shared world" ("I"=bodily I).

How then are we as experiencers in space? As subjectively corporeal, by carrying out a movement to things, a movement which does not happen to us but which we are. It is movement in Aristotle's sense: it is an incomplete *energeia,* an incomplete reality tracing out possibilities, it is a realization of remaining possibilities.[51] Movement continues as long as some possibility remains. Every movement has its whence and its whither. Our life is a movement in Aristotle's sense: it has its whence—the bodily subject (which does not manifest itself)—and its whither—our doings in the world. What lies in between is the realization of

51. See Aristotle, *Physics* 200b25–201b15. *Ed.*

possibilities. Our actual movements are based on a primordial movement, an ontological movement in the strong sense of the word—this movement sheds light on the world. The world is the universe of all that is. Only this movement makes it become possible to say of things and people that they are or are not. In that sense it is ontological. How then are we as experiencers in space? On the basis of our own subjective corporeity made clear in a transparent medium in which the world appears to us, by means of the movement we are, explicating itself in the realization of possibilities which are already movements in the sense of concrete kinestheses.[52]

Methodological Notes to This Presentation

Let us now look at what we are doing here from a methodological standpoint. We seek to proceed phenomenologically, but phenomenology takes a number of forms:

1) There is naively ontological phenomenology—Scheler and a number of the adherents of the Munich school.[53] Its chief aim is to grasp the necessary essence in contingent things, to see, through contingent fact, a deeper structure which is no longer contingent, which makes a thing what it is—makes a person a person, makes red the color red, a work of art art. This phenomenology made a virtue of opening up a naive perspective on the world and thereby bringing to view what had been obscured by schemata derived not from the way a thing presents itself, not from looking at things, but from some theory, from some explicative schema. Some of its adherents were inspired by Husserl's *Logical Investigations*,[54] (expositions of pure essence and its relation to singular realities, or, in the second volume, a treatise of the whole

52. "Kinestheses"—i.e., kinesthesis is the compound of "kinēsis" and "aisthēsis," thus is a movement (in Aristotle's sense) that "sees," or a movement for and in which the world "appears." See First Lecture, p. 5. *Ed.*

53. We have already met Max Scheler in the previous lecture. The "Munich School" refers to a circle of philosophers associated with Theodor Lipps that included Adolf Reinach and Moritz Geiger, both of whom later collaborated with Husserl on the *Jahrbuch für philosophie und phänomenologische Forschung* between 1913 and 1923. *Ed.*

54. Edmund Husserl, *Logische Untersuchungen, vol. 1, Prolegomena zur reinen Logik*, Hua 18, ed. Elmar Holenstein (The Hague: Martinus Nijhoff, 1975); vol. 2, *Untersuchungen zur Phänomenologie und Theorie der Erkenntnis*, Hua 19.1 and 19.2, ed. Ursula Panzer (The Hague: Martinus Nijhoff, 1984). English translation: *Logical Investigations*, 2 vols., trans. John Findlay (London: Routledge and Kegan Paul, 1970). *Ed.*

and its parts—the whole always precedes the part—a sensitive and fruitful formal ontological treatise).

2) Husserl's transcendental phenomenology is a theory that is no longer naive (naive: preoccupied with objects as they present themselves without attending to the mode of experience which opens the way to them). Husserl also deals with objects but specifically from the viewpoint of experiential access to them. The fundamental thesis of Husserl's phenomenology is that access to the objects of any experience whatever can be studied only when we make that access itself the object of our study, following solely this access itself and not permitting anything else to enter into and distort our study. We must set aside any belief concerning the object of that experience. I can study the way experience approaches things without believing in the existence of its object. Even then experience remains objectival. But that means that consciousness (of objects; in Husserl, consciousness always has an object) is by its very nature independent of the existence of the world.[55] That does not mean asserting that the world does not exist. Husserl is only pointing out the superiority of consciousness in its very nature and in the full scope of its experience to the objectivity of which consciousness is conscious. Thus Husserl asserts that a (critical) examination of our experience, of its structures, of its verification (testing its validity) is not only independent of its thesis, of positing an object, but that, if it is to be radical, the positing of an object must be suspended. Only that way can the inquirer reach pure experience, without any additions. At the same time, this mode of phenomenological study is supposed to set aside all possible prejudice, it is to be the foundation of philosophy as a science guided by an ideal of total responsibility—it must be able to take responsibility for anything it asserts, give reasons for every step, and that in the sense that it is supported by what alone is valid, by the experience of the thing itself, the thing as it itself presents itself. Since it presents itself in reflection, reflection is the final court of appeal—that is a

55. I.e., world of "beings"—consciousness does not need any "being" in order to exist *(nulla "re" indiget ad existendum)*. See Edmund Husserl, *Ideas Pertaining to a Pure Phenomenology and to a Phenomenological Philosophy. First Book: General Introduction to a Pure Phenomenology,* trans. F. Kersten (Dordrecht: Kluwer, 1982) (hereafter *"Ideas I"*), §49. *Ed.*

Cartesian ground, *ego cogito*. On this ground the *cogitatio* is itself an object—it is self-evident.

3) The phenomenology of Heidegger's first phase (that of *Sein und Zeit;* preceded, to be sure, by a formative period, Heidegger forming his views out of the Rickert school).[56] We are now not concerned with a broad presentation of his position and of his phenomenology but only with his position with respect to the problem of a possibility of studying experience in reflection. Were phenomenology a study of consciousness in reflective access, in evidence, as Husserl thought, then today's entire presentation could not be considered phenomenological. It is true, as Husserl points out, that the act of consciousness is itself focused on the object and not on itself, that it is not thematic, that it eludes itself, but it is capable of being thematized, of being grasped, by its nature—and that because already prior to the reflective act it has an objectifiable form; its objectifiability is, it seems, self-evident, unconditional. Heidegger took over from Husserl the most substantive idea that every being (be it a stone, an animal, a number, a word, a mathematical theorem) instantiates a certain type, and each type is given by an experience of a special kind, given in the typical mode in which this type of being is understood. From that Heidegger deduces that understanding is the ground of access to the being of what is, which is only subsequently a basis for access to beings themselves. For instance, we could not perceive things in space if we had no notion of the sort of being a spatial object is, we could not understand a word if we did not understand language. After all, we do not mix numbers and animals, each group represents a page of its own. Understanding being is basic for the determination of being. However, from that we cannot deduce, as Husserl does, that the study of our experience, which makes possible access to beings and to being, is a study in reflection (alone), an objectification, that that on which I reflect already has in itself the character of an object which we need but set before our eyes—and there it is, in the original. In Husserl, reflection is privileged because it putatively provides us with consciousness in

56. I.e., Heinrich Rickert, a neo-Kantian contemporary of Husserl. The "school" to which he belongs had, in part, its intellectual origins in the so-called "Marburg School" founded by Hermann Cohen. *Ed.*

the original, only grasped in reflection. That means that consciousness is already itself grasped in the mode of object givenness, that consciousness has the being character of an objective object of perception, there before our view. For that reason Heidegger does not use the term consciousness, because it has been preempted by something which may exist, though only as a special case and under certain conditions—consciousness as an explicit positing of the object. So for instance the type of consciousness we confront in scientific judgment, when we explicitly posit this or that proposition, knowing that its content is either evident or nonevident. This act of positing can then be retrospectively analyzed but we cannot go beyond it. I cannot in this way grasp the meaning of this act within the process of life as a whole. Consciousness as a static structure of positing an object is a fact, but not all life (all "conscious" life) can be subsumed under this model. For instance, handling a pencil, a hammer, is also a mode of knowing but it makes no sense without a certain context from which it cannot be separated. Husserl does understand consciousness as a series of acts, but acts always pertaining or relating to an object. Objectification constitutes the firm structure of consciousness; the fixation onto an object is the primordial basis of knowing. The objective guide for analysis is the primordial model of phenomenological work. Consciousness has fundamentally an objectival structure. If we can show a clarity that is in principle nonobjectival, and if all objectival, objectifying clarity, all modalities of this objectification, are rooted in it, then we have gone beyond Husserl with the help of a Husserlian motif.

A further difference is connected therewith. Husserl's philosophy is a philosophy of pure *theoria,* of pure observation. An absolute science with an absolute responsibility. That was Husserl's immense courage—that drive to responsibility. It places life under the norm of the demonstrable, of truth. Husserl was an antipragmatist, an antipracticist. Carrying that idea out concretely, however, leads to the opposite of the original intent, that of a philosophy free of presuppositions and fully responsible. The ideal of philosophy as a rigorous science can, under some circumstances, be a misleading one. We cannot relent in it, we must assert only what is demonstrable, otherwise we should open the floodgates to arbitrariness. But that does not mean that lived experience in all

its scope is a demonstration, that experience aims at this meaning alone. Not every evident givenness need be objectival, demonstrable, not every consciousness need be accompanied by a self-consciousness, not everything evident need be evidently given.[57]

In the course of our presentation we have encountered numerous phenomena which are instances of a practical clarity, not turned in to itself, not having itself as its object. In that sense, this lecture follows the style of Heidegger's phenomenology though it is critical of it on the grounds of its (i) being far too formal, not stressing sufficiently the ontological implications of embodiment, of corporeity, and (ii) not posing the problem of consciousness in the literal sense of the word, even though Heidegger poses it more than anyone else. Heidegger was perhaps the first to pose the question of *the origin of consciousness,* not in the sense of natural causes (that belongs to psychology, biology), but in principle, in the sense of the ontological conditions of the possibility of clarity concerning the world. A living being lives ahead of itself in its possibilities, realizing its possibilities which it understands in a specific way—nonobjectively, by carrying them out. Practice does project before it a certain clarity about our experiencing: a spatial reality has to be seen. That is the distancing presupposed by all consciousness. Things then emerge out of possibilities as what objectively corresponds to them. Only in this context can things emerge, not, that is, in mere observing but rather in an involved living which identifies with its possibilities and realizes them. That is the *primacy of practice.* That is the grand scheme which dominates present-day philosophy and in which many see what Heidegger and Marxism have in common. Yet in Marx and Feuerbach this is understood far too much in a subject-object context. In Heidegger we have an ontological theory of the origin of consciousness (and of the subject), the origin of clarity in general. We have noted the difference between this type of evidence and a theoretical, objectifying one. Marx always expresses himself in terms of the subject and the object. He takes the subject for granted. Heidegger seeks the ground which is prior to this

57. Cf. Heidegger's own assessment of the importance—and limitations—of Husserl's phenomenology in chapters 2 and 3 of *History of the Concept of Time: Prolegomena,* trans. Theodore Kisiel (Bloomington: Indiana University Press, 1992), especially §13. *Ed.*

quality. This ground is dwelling in the world, the life of humans in the world, *Da-sein*. Humans are in the world—that is a single continuum, not an opposition. It is so prior to any theoretical distinction.

PART TWO

Being in the World: Two Phenomenologies

Eleventh Lecture:
Husserl's and Heidegger's Phenomenology

Husserl defined his phenomenology as a fundamental philosophical discipline, a *prima philosophia,* with the help of the idea of the phenomenological reduction.[58] That is a distinctive methodological approach aimed at rendering all of our experience, of things, of ourselves, of others, accessible in the full scope of its significance just as it naturally functions, as it puts us in contact with all such realities. Experience, that is, is to be seized in its primordial, original meaning, *without any interpretation, without any theorizing.* Our experience, on the other hand, contains all assertions and theories within it. If it is to be seized in its integrity, then such seizing of our experience must not presuppose any theory of either what experience or of what the world really is. Everything has to flow solely from following out experience itself. A philosophical approach must not include any supposition, it must be entirely free of any prejudices, any preconceived notions. Only then can we have a chance of grasping experience as it is, in its inner meaning and development, integrally. For that reason we need to set aside not only all sciences, theories, scientific discoveries, psychological discoveries, developmental theories, etc., but also all philosophies and all naive convictions that humans

58. See Husserl, *Cartesian Meditations,* §§2–11. *Ed.*

ordinarily carry in their minds. That does not mean rejecting them. Philosophers do not delete them, reject them, are not skeptical about them, only must not take them for granted, use them as starting points, for that can contribute nothing to their activity.

Among the presuppositions with which our mind constantly operates and which—unlike scientific theories—are not our products, is the unquestioned belief in the existence of the world. Philosophers must not accept it as a general presupposition. The world in one sense does not vanish for them—they are, after all, examining lived experience, the integral functioning of a life focused on a world, a life in a world. The world as an object of experience does not vanish, only the existence of a world is no longer taken as a premise. What is being examined is experience in its intrinsic, autonomous sense. That is a universal unfolding of an idea we encounter in the seventeenth century in Hobbes, partly also in Descartes. It is expressed by Hobbes's idea that our experience of an object would remain whatever it is, for instance perceiving or imagining a table, even if the world did not exist. The table belongs to the experience as its objectival meaning. But this objectival meaning is constantly manifesting itself as experience unfolds. Experience is only the gradual process of convincing ourselves of the existence of the table, demonstrating its aspects. That retains its validity whatever we initially believe concerning its existence. Demonstrating experience constitutes an experiential meaning, not the entity itself. The structures of our inner life— that is the *demonstration*.[59] For every type of objectivity there must exist rules of demonstration, a mode according to which this objectivity enters into our experience. For instance, objects of one type are the necessary presupposition of access to objects of another type; we cannot have access to numbers without having experience of things first. That is no random sequence but a necessary one, following from the nature of the matter.

To pursue experience in all its inner integrity—that is the task of phenomenology as *prima philosophia*. That is why Husserl also calls it transcendental phenomenology: from a primitive way of dealing with experience, from understanding objects as objectively given (to which we testify and about which we theorize), it

59. Cf. the first three chapters of the First Part ("Of Man") of Thomas Hobbes, *Leviathan*, ed. C. B. Macpherson (Penguin Books, 1985). *Ed.*

transcends to the mode of *how* these objects are given (how such testimonies and theories are demonstrated). *A priori* means, for Husserl, an internal necessity of the relations under examination; they are necessary relations about which inner perception can convince us that it is so and can be no other; not that we could know something before we have the object. On the basis of the method of phenomenological reduction Husserl sets about grasping experience as an autonomous, internally coherent whole of lived experiencing, independent of all else, which presents itself to us and can be grasped in the original; on the basis of this originary givenness we can determine not only what there is in fact, but also the internally necessary structures of this lived experiencing.

The result is to be a reversal of the position to which mathematical natural science had led our thought, namely, the belief that material nature, the external world, is a universally internally coherent whole of a mathematically formulated causality into which disjointed and discontinuous islands of conscious life are injected in a distinctive—and problematic—way, an addendum to material processes which are a part of that universal whole. Nature is supposed to be continuous, mind intermittent, causally dependent and sure to belong in some way—though *so far* we do not know how—to this universal whole. Husserl seeks to reverse this position: spirit, universal experience is a single continuous whole, logically built up within, forming a continuous unity in which the exterior does not intrude because in experience the exterior always appears as the meaning correlate of certain experiential coherences. A delicate problem for this Husserlian conception is the relation of individual subjects' experiences to each other. For Husserl, the experience of the other is something that has its determinate structure (typical, specific). The other is always presented to me as the other, always an object, never given in the original (otherwise it would have to be the experiencing I itself). Yet a part of the meaning of my experience of the other is that the other is living an experience just as originally as I live mine, and that these experiences enter one into another through the external world (*external* as an experiential meaning; the world is originally a world of meanings, not of objects). That is typical of my experience of the other. Individual experiences ingress in each other in that way and so form a continuous whole. To describe experience

is a supraindividual task. In a way it is an idealism that differs from other idealisms in that it is not concerned with polemics about the existence of an external reality but rather simply does not take it into account; not because it underestimates it but because it turns out that for the fundamental task—illuminating experience, the primordially given—it is irrelevant.

Phenomenological reduction was to be the apex of philosophical freedom from prejudice, it was to realize the Cartesian ideal—setting aside all prejudices, all unverified presuppositions which spell catastrophe for philosophy in its effort to verify all it assumes, to subject its viability to a test. If some presupposition escapes that, then the philosophical conception is compromised and we need to start all over again. And yet there are unverified presuppositions in Husserl's conception. Husserl's phenomenology as a *prima philosophia* was to be a rigorous science formulating its discoveries with total certitude, guaranteed because what phenomenological observers formulate as the results of their investigations is the result of a direct seeing of the object in question, in the original, in pure givenness. Otherwise—if the object were not given in the original—there would be no sense in building a phenomenology, a radical critique of experience. *Epochē* would make no sense if it did not lead us to something that is purely given. Evident givenness means that the thing itself stands before our gaze. The idea of pure givenness is, in Husserl, derived from a tradition—a tradition that is both very definite and yet undefined, the Cartesian tradition. *Ego cogito cogitatum*—the basic structure, form, of our experience is bound up with another of Descartes's ideas, that *ego cogito* certifies itself, that *cogitatio* is at the same time something that is certain of itself. Husserl formulated this idea so as to contrast the givenness of experience in reflection with external experience, for instance, with perception. He asserted that the object of external perception is a being which is always relative with respect to the modes of its givenness. A thing is inexhaustible in its aspects, each aspect referring to ever further experiences. This thing I hold in my hand is present to me in the original, and yet its givenness is relative, the givenness of a being which can never be known exhaustively. By contrast, the being of our inner experience does not have such a relative character, it is not given as an infinity of aspects referring on to other aspects, it is given at a stroke,

absolutely—absolute being.[60] That is apparent also in that to have access to a thing I must somehow live it, a thing implies a lived experience. Verifying the existence of a thing presupposes ongoing experiencing, that is, a different kind of being. By contrast, experience is always the experience of something but that something need not exist to make it so. For that reason, experience is pure being. That is a replay of the Cartesian thesis that *cogitatio* is guaranteed absolutely, easier to know, closer to knowledge than things which are knowable only through a *cogitatio*, which are mediated by *cogitatio*.

The thesis of the immediate givenness of the *cogitatio* was to cost Husserl a great deal of effort, especially when, in his analysis of experience, he discovered that experience is never quite so completely instantaneous and immediate but rather is spread out, has a temporal extension and contains also what is not given. Every experience must contain a retention of what had been and anticipate something not yet here. That is a part of its meaning, that the nongiven belongs to the given. Husserl himself showed that, by the very nature of it, every temporal sequence contains essentially a multifold temporal horizon which makes that temporal sequence what it is.

Husserl's metaphoric schema of time consciousness is shown on the following page.[61]

What is given to me includes a double horizon of the nongiven, of what is only suggested—the past and the anticipated. The givenness of the nongiven is the inner structure which we can note in immediate givenness, forming the inner link of experience pointing to ever further experiences. Yet how are we to understand the peculiarity that, in our conscious life, there is at the same time so much that is nonconscious, so much half-clarity; how are we to understand that retention—that things are somehow here, yet not objectively? (For Husserl, to be sure, that was not a sufficient objection.) What is experience, consciousness? A clarity interpenetrated by obscurity. Is it really something I can

60. See Husserl, *Ideas I*, §§42–44. *Ed.*
61. Cf. the time-diagram given in Edmund Husserl, *On the Phenomenology of the Consciousness of Internal Time* (1893–1917), trans. J. Brough (Dordrecht: Kluwer), §10. *Ed.*

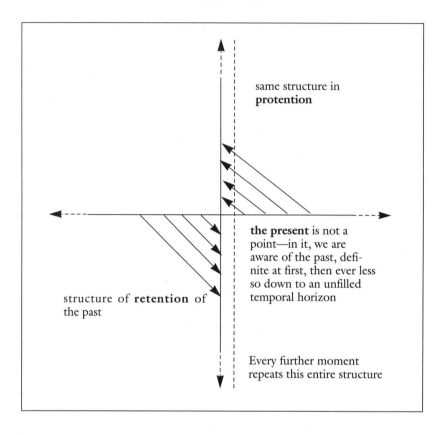

same structure in **protention**

the present is not a point—in it, we are aware of the past, definite at first, then ever less so down to an unfilled temporal horizon

structure of **retention** of the past

Every further moment repeats this entire structure

grasp in full clarity in inner vision, making it fully transparent to itself? Or is human experience by its very nature something essentially different from what can be given in object experience? That is a question which Husserl never raised. Experience itself does not give itself to us in the original evidently, as a thing, or at least does not give itself to us in its entirety. Is the idea of givenness in the original one that can be applied to experience? That is not to say that we cannot objectify experience. The question, though, is whether, if we so approach our experience, if we simply look at it, we do not already thereby transform it into something other than what it originally is, whether we are not depriving it of its own mode of being—whether, that is, we do not need to approach experience entirely differently. This approach, to be sure, does yield some knowledge, but it is a derivative approach to something whose more original mode of being might be different. I

look at experience as at a thing, as something presented to view, turning towards it; yet that towards which I turn is no longer truly the living I, the seeing I, the acting I. That is the whole problem of reflective philosophy. Reflective philosophy understands reflection as an inner intuition, as experience of oneself, experience turned within. Reflection on our own experience leads to a cleavage, to a duality of what is lived and the one who lives it, falling into a contradiction between the experiencing and the experienced. I look at myself—it may be I, but that at which I look is already passing, it is not the I that is doing the looking.

That is the question posed by Heidegger as he sought to come to terms with all of previous phenomenology. Heidegger asks what our approach to our own being is.[62] Is it a view of being? is it a self-consciousness? a look turned to myself? An inward look is naturally also a part of what we are, but our own being has a more direct access to itself. The mode by which our original, inmost being is accessible to us is that our own being is something we must do, create, achieve. We are not in the world like a stone to which the fact that it is means nothing, like the animal for whom its own being does matter in some sense but which does not explicitly relate to it. Humans are in such a way that they simultaneously *are* and *ought to be*. That they *are* has to be their achievement, they must literally *take it on*. But what does "taking it on" mean? It means that we are not indifferent to our own being, that in our present we always already anticipate, project something that we are not yet. Projecting is our present. Our past was like that, too, living means accomplishing our being. So it is not the case that we first are and then do something; our being takes place entirely in that doing. Our being is always on the way, we have a *spatium* before us. We are *for the sake of* something, we not only are and nothing more, we are for something. For what? For ourselves, for our being, for our life. In that way our life relates to itself, not in the mode of observing itself but rather in the mode of doing itself. The question of experience is the question of our relation to ourselves as beings who are carrying out their being, the question of how such self-constituting being is structured.

62. Cf. Heidegger, *Being and Time*, §§9–11. *Ed.*

It follows from our interest in our own being that such a mode of being includes a certain *clarity*. A being interested in its own being cannot be devoid of clarity. At the same time, however, it is not its own object, it does not objectify itself in its doing; it is constantly doing something *for the sake of* continuing to exist. It *bears itself* from present to present. It relates to itself in its doing. For that there must be certain open possibilities, since it does what is possible for it. Those are the possibilities of its own further being. In this most primordial structure—interest in own being—a temporal schema is given and nonobjective possibilities open up. Possibilities are not something objective, they are not there to see so we might look at them, rather, they are our possibilities insofar as we do them, realize them, identify with them. The possibilities that open up to us are present in a special mode so that we are aware of them but not so that they would be objectified but rather in the sense that we understand what surrounds us in light of them. We understand *practically:* that is, we are able to, we are familiar with, we know how to deal with. That is the original meaning of "to understand." That is how we first understand ourselves and things. That is how a child begins to understand a spoon, a saucer—as it begins to know how to deal with them. Our original structure of our being relating to itself opens various horizons which are not horizons of objects, of an *objective* and-so-on, but rather prevenient structures in the light of which objects appear to us. They are structures which direct me in the way I relate to myself, in self-realization. One such prevenient context in which I move in self-realization is that which brings it about that all the correlates of individual possibilities with which I identify are not isolated and that I can understand them precisely as not isolated.

What concerns Heidegger is naturally also consciousness, but not consciousness in the classic sense of the correlate of an object which can itself be objectified, which is itself a being of a certain type whose mode of being does not distinguish it from an object. In Heidegger's conception, consciousness—if we can ask about it at all—is something that first arises in the primordial clarity of a being that must accomplish its being, that is preoccupied with its own being. The point is the essential primacy of *practice*. At the very protofoundation of consciousness, of thought, of the subject, there is acting, not mere seeing. That explains why there is so

much opaque, obscure, in our clarity. Such a being, concerned with its own being, cannot in principle be grasped in its distinctiveness by observation. A mere observing look can never capture this active nature of our being for ourselves, its interestedness, its interest in itself: that is something we could never see if it were not what we are. The presupposition of our seeing is that that is what we are, not the opposite, that our seeing would be a presupposition of anything presenting itself to us in the original. Further, such a being, concerned with its being, is constantly exposed to its basic character, namely, that the being that it must accomplish does not depend wholly on itself alone—it can cease, not realizing the possibilities with which it identifies. The primordial interestedness does not give us only the fact that there is obscurity in self-clarity, rather, from it comes also the tendency not to see our situation as it essentially is. So not only nonobjectivity (original nonobjectivity does not mean nonobjectifiability), obscurity in clarity, but also self-concealment, a tendency to conceal oneself.

This nonobjectivity and tendency to conceal oneself are the great advantages of Heidegger's over Husserl's phenomenology. In virtue of that it can become the philosophical foundation of human science. Husserl's phenomenology would do as a philosophical foundation for the natural sciences. It shows how the experience of nature can be understood so that our judgments about nature would not be mere realities in the world but could become authentic truths about reality, even if asymptotically. That, though, applies to human and social sciences as well—for Husserl, that original absolute clarity of the spirit for itself poses no problem. Social sciences, though, are sciences because they uncover something about personal and social reality that we cannot learn by simple introspection. Social sciences normally appeal to mere empirical data. However, they need also a philosophical foundation in order to locate their fundamental problem, a foundation demonstrated by our essential approach to the subject of social sciences, the principles of encountering this object. The problem itself arises in the human disciplines as we penetrate to a certain aspect of ourselves which is clear to us in one sense and not in another. For that reason, for all social sciences, the point at which they become genuine sciences is penetration through self-illusions, self-deceptions, our idols of ourselves. Providing a

philosophical foundation for actual human scientific disciplines demands that we find access to this situation, not an empirical, but a foundational, justifying one.

Twelfth Lecture:
Existence, Phenomenon, Reflection

An objection might be raised against Heidegger's new way of doing phenomenology, sharply opposed as it is to Husserl's theory of reflection. That objection has to do with the special structure, basic for Heidegger, the structure of existence—of being that is charged with itself, must assume itself, must act itself out, achieve itself, without turning that "doing" into a mere reworking. A being, whose being is its task, is *its own*, own to itself; it must not include anything objective, thinglike, anything that could be simply noted. It is in its entirety in each of its determinations. Every determination which can be not so much noted as spoken forth about it is not something predicated *of* it, rather, it is something it itself is. Being its own being is marked by an ownness, by being own. That presupposes some kind of an I. And an I is something enduring, something we must presuppose in all our assertions. Every assertion presupposes an I, an I identical with itself. Then is there not a contradiction in Heidegger's way of doing philosophy? Isn't this attempt at determining the mode of being represented by our existence self-contradictory in presupposing something that defies any such conception of being? Being that has the character of ownness, own in every moment, presupposes an enduring I. For what else would it mean "to be one's own in every moment?"[63]

63. See Heidegger, *Being and Time*, pp. 67–68 and §18 of *History of the Concept of Time. Ed.*

To this we respond: in a certain sense it is true that existence does in some way entail a relation to an *I* (in a very indefinite sense of that word). Yet viewing existence as a wholly distinctive mode of being, incommensurate with objectival being, should put the concept of an I in question as well. The *I* as traditionally understood requires some clarification first. We cannot say simply that we always presuppose a constant I. The I as something evident, always clear about itself, as the initial presupposition of any thesis—is this presupposition itself clear? Just the philosophical controversies surrounding the concept of the I are reason enough for answering in the negative. Heidegger's assertion concerning the ownness of existence is not designed to deny the I, it is enough if it turns out that the I—if we understand it as the last or the first we have to posit, as the foundation of all other theses—is in this respect already something derivative, something we see from the viewpoint of a being that can be analyzed into parts so that here is the foundation, here is a construct upon it, then further and further constructs upon that. A being so structured is not something I do but rather something I see. So to approach the phenomenon I means to miss the phenomenon I in its originality, not seeing the I as I. To attribute to it the role of the primordial foundation means to grasp the I not in its originality but as derivative. The primordial I is being which can in no way be transposed into objective being. We need to grasp the I in the context of that being which relates to its own being, to which its being is not indifferent, I as a task, being as a task, being which accepts and achieves itself. Those, to be sure, are no longer Heidegger's terms. This doing and accepting—a dynamism that has a temporal character—contains the possibility of transmitting something to someone. It is within this task that the I takes place, here is the *spatium* for the I.

Heidegger's idea of an existence which in itself is nothing but existing[64] involves one fundamental difficulty. It is being which by its very nature is practice—a lived life, not life observing and observed, but one which acts and so brings about understanding. That means that it includes some kind of *clarity;* precisely from the nature of such being we can explain something like clarity

64. I.e., a mode of being that Heidegger claims is passed over by Husserlian phenomenology—see *History of the Concept of Time*, p. 110. *Ed.*

(while a philosophy correlating subject and object always already presupposes clarity, consciousness=clarity; here we have the attempt to see the origin of clarity in the nature of a certain type of being). The great problem is how such being might be grasped philosophically. That, precisely, is how such an objection would be formulated from Husserl's standpoint: *as philosophers* we must have some access to such being, just as to every existent and every being, and it is just this access that interests the philosopher. How is it possible to seize existence reflexively? If it is possible, then how is this way of doing philosophy different from reflective phenomenology which seizes what it sees when the mind turns in on itself? Is that not just a replay of that transcendental philosophy which cannot offer to itself any account of what it does? A philosopher reflects. If Heidegger philosophizes about existence, then he is reflecting on existence and thence derives the legitimacy of his approach. Phenomenology has to do with phenomena; a phenomenon is what appears; being must in some sense *appear.* If existence is a phenomenon, something that presents itself to the philosopher's view, then it is the object of such a view. If, however, existence is something that we do rather than see, then nothing can be seen of it, then it is not a phenomenon. Isn't this transcendental philosophy trying to step over its own shadow?

To this, Heidegger has no answer. Let us attempt one ourselves. Let us try responding with another question: what is reflection, and how is it possible? When Husserl speaks of the reflective act which grasps the subject in the original, when he claims that the radical reflective act means refraining from any prejudgment, refraining from any act of faith in the world—whence does he derive his assurance that such an act is possible at all? What is the point of reflection? Husserl wants to be able to assert what he says as a philosopher with absolute certainty, wants to be able to guarantee it. *He* must guarantee it, *he* sees it. Reflection includes a radical will to responsibility. But what is that responsibility? It is a certain posture of life, a way life relates to itself. The possibility of a will to be responsible is rooted in this trait of life, that life relates to itself. This being responsible means doing explicitly something that already life itself makes possible. Being that relates to its own being is at the same time unlocked for itself in some sense. The possibility of reflection is rooted in this openness. That is, the structure of such a being is what makes

reflection possible. At the same time, however, we need to under-
stand the structure of reflection itself differently than Husserl
understands it. If we are to understand how a phenomenology of
existence is possible at all, we must in a sense go beyond Husserl's
idea of evident givenness, the idea of reflection, of a stream of
lived experience which grasps itself in the original. For Husserl,
philosopher's responsibility consists in saying only *what is* and
what is accessible to him *in the original,* what presents itself to his
gaze. The presupposition of the philosophical judgments Husserl
makes, of his analyses of lived experience as such (acts relating to
objectivity), is that all of it is read off from lived experience. How
can we make that consistent with Heidegger's thesis that such
reading off, such reading in the original, does not yield our being
in its own being? The same can be given variously, it can appear
differently. The self-presence of something in the original does
not yet guarantee that it is given in its *originary* mode. Husserl's
criterion of philosophical truth, the requirement of responsibility
based on reflection, is not enough. True, in reflection I am in
some sense given to myself, but is that I in the most original
sense? Is reflection in the sense of self-objectification the gateway
to my self? Need we not go further, extending the concept of
reflection to include also that philosophical procedure which
grasps not only what is given but also the inward implication of
the meaning of the given, pointing beyond?

Here there is a difference between Jaspers and Heidegger.
Jaspers stops with the basic observation that existence is not an
object, that it is something that is not the object of reflection, or
that insofar as it is, then such reflection has only a practical signifi-
cance, is only an awareness, a focusing of the situation within
which the philosophizing I finds itself. Every attempt at grasping
it is *eo ipso* labeled as objectification while philosophy seeks its
content and its possibilities in the region of attitudes and of what
intrinsically belongs to them. Attitudes are always subjective. Thus
philosophy reaches the verge of irresponsibility, of a bad subjec-
tivism without a binding, compelling, and in that sense objective
truth. Jaspers's idea of philosophy is that philosophy begins where
binding, compelling knowledge like mathematics and natural sci-
ence end. Philosophy is not like that, it is an appeal to possible
existence. Jaspers sees existence like Heidegger, as being which at
its core is not indifferent, which is concerned with the meaning of

its being and of being as a whole. Jaspers seeks to locate philosophy in this region, at this core, giving it a special status as distinct from the status of mere knowing, of obligation in the relation of subject and object. In Heidegger's philosophical analysis of existence we have something of that sort but here there is the idea of *obligatoriness* as an unfolding of the original clarity about oneself which follows from the nature of our being.[65]

Clarity about oneself is different from clarity about the nature of things. It is a practical clarity entailed by the *doing* of our being, of being that must have its *spatium*, its horizon. This horizon spreads out in reference to our own being, being that must accomplish itself, which is not presented ready made, here finished, simply laid out—like the being of a stone. Built into the very structure of such being is a relation to what is not yet and to what is no more. That is the basis of that clarity. Built into that being is also an openness which does not mean knowledge or introspection, self-knowledge. It is a clarity which belongs to active doing, to living. Such being makes itself actual by identifying with definite possibilities which it grasps and brings about. To those possibilities and to that actualization there also belongs a partner, a correspondent appropriate to those possibilities. That is what speaks to us from the world, those are the *originally* given "objects." "Object" is an unfortunate word for capturing our original posture with respect to things. An object is the correlate of a subject. Things as they are primordially given to us are not objects in the sense of being given, being presented to some subject; there is no contemplative relation of a subject to an object here. Things primordially are not objects—if they were given in *mere* presence, they would not be what they are.

We might object that it does not matter whether, say, this eraser cloth, which is now here, also was here or will be here; that does not change the fact that there is here on the one hand a subject and on the other an object in a sequence of moments A1, A2, . . . ; extension beyond the present does not matter. Yet that is a perspective which has already formulated time in the relation of the subject to the object as a succession of moments. This, the eraser, is an eraser for me not because I look at it now and have

65. See Karl Jaspers, *Philosophy,* 3 vols., trans. E. B. Ashton (Chicago: University of Chicago Press, 1969), especially volume 1, pp. 1–100. *Ed.*

looked at it before but because it is a cloth for erasing the black-board, because it belongs to a context which, however, is not a sequence of temporal moments. The cloth belongs to the table, to the blackboard, it belongs to something being written on it, that blackboard belongs to the function of this lecture hall, and so forth. In observing the cloth within a subject-object schema I shall *see* that it is wet and so on, but that it is intended for erasing is something I do not see. Discovering that it is an erasing cloth does not require that we add ever further dimensions, observa-tions, but that we assume a wholly different posture. It requires less a most scrupulous observation than a practical perspective. If the cloth were not there and I needed to erase something, I would reach for my handkerchief; thereby showing that the cloth is an object for erasing. I did not discover that from observation but within the functional practical context which falls within my practical life. The way it works is that I open up the possibility of teaching and so at the moment I need, for instance, a clear blackboard.

Thus I uncover, discover things on the basis of the primordial open horizon of my life in which I grasp the possibilities it opens for me. *Vitam ducere.* We do not observe our life, that is not how it is given to us, rather, we realize it, we are charged with living it. For that reason also things as they primordially reveal themselves to us are not objects, just as they are not substances with certain attributes and relations. In order to designate things as they are first known to us, Heidegger uses a German word that is hard to translate, *Zeuge.*[66] Let us try a translation, albeit not a wholly sat-isfactory one: things are originally revealed to us not as objects but as *pragmata.*[67] Their mode of being is not present givenness, givenness in a certain moment, in some presence—*Vorhandenheit.* The mode of being of a pragma is *Zuhandenheit,* that is, availabili-ty. It means that it is good for something.[68] That includes a tem-poral dimension as well.

66. Cf. Heidegger, *Being and Time,* pp. 96–97. *Ed.*
67. "Služby," the word Heidegger's Czech translators use as equivalent of Heidegger's *zuhande,* here rendered *pragmata,* in common usage means "services" or "functions." *Trans.*
68. Patočka here etymologizes or perhaps puns on the Czech word for "suitable" to point to a temporal dimension: *vhodný—hod—hoditi*=suitable—a throw—to throw, so to project. *Trans.*

The world, the environment, being—initially, we do not cog-nize any of that and yet we do basically understand it. There is a fundamental difference between such basic understanding and cognition. Originally we do not cognize the world precisely because we do understand it. The possibility of cognition is rooted in understanding though it is not identical with it. People under-stand the way they breathe. When I take the chalk in hand, it involves a certain act of understanding—I know what it is all about. It is not a *knowledge* concerning a specific purpose but only an integration within a certain internal context which func-tions within me, grasping this as a chalk for writing. That way I initially understand both myself and that which is other than I. That is how I understand before I know.

This understanding and its special modalities are a part of our being. And, in turn, a part of that is that humans can never be amid a chaos. There are philosophers who imagine, erroneously, that that is the case—that human conception of a world grows from small beginnings, that an order crystallizes amid a primor-dial confusion of impressions, first concepts are constructed, then others and others added until the originary activity of the mind constructs a clear image of a world. Yet humans, insofar as they are *existence*, always exist amid something they understand. That is one of the meanings implied in the assertions that our life is a *Dasein in the world*, our existence an existence in the world. To be sure, chaos is also a kind of understanding, we can also have the experience of confusion, but that is something secondary, that is an anomaly, presupposing something else. The philosophers to whom we have referred see it differently: chaos as something pri-mordial that ought to be possible of itself.

Precisely because humans are always understanding beings they can explicitly indicate, explicitly explain. The explanation is present in my seeing this *pragma* (chair) in the original, practical light (as something to sit on). That is precisely why humans can speak, have meanings. Here problems of signification and mean-ing are placed in a context different than in Husserl; it is a context we cannot detect in Husserl.

Let us return to the problem of how it is possible to reflect on existence. Of itself, existence is solely a pure relation to itself, to our own being, yet at the same time, thanks to this relation, the world is revealed for it. Existence exists in most varied modes of

this self-relation. The difficulty lies in grasping these various modes. Reflective grasping is, after all, always also an alienation. But alienation in reflection is probably necessary for grasping that most primordial structure of givenness. Thus radical philosophical reflection, aiming at the primordial mode of givenness of self and things, depends on objectification but keeps going through it in the direction of that to which the givenness itself points. The givenness itself points to the fact that this cloth is not given as an eraser cloth in a self-contained present. In the present itself there are hints which tell me, "go on!" I have to detach such references from the objectifying meaning, I must cancel the objectification. Out of that there grows a new mode of reflection, a reflection on the primordial mode of givenness or, better, a new mode of approaching the world.

There exists a more original mode of approaching the world than objectification, than givenness in the original. This entails a change in method, in Husserl's method of objective guidelines based on objectification, on the givenness of things in the original. This is a new mode of doing phenomenology. Husserl's method consists in seeking out, in a certain object which is taken in its originality as it is present before us, correlatively to this givenness and to its regular sequence, those experiential structures which make that object accessible to us. On the basis of the method of objective guidelines we can then carry out the entire analysis in which lies the basis of the method of constitution of the object in experience. If, though, there is a more original approach, a more basic task for phenomenology, then the method of objective guidelines loses its fundamental significance. That which is most important in philosophy, that is, self-presenting originality, must be uncovered differently—patiently, not at one stroke, as in the phenomenological reduction, as in the *epochē*. Bit by bit we uncover the concealing moments of philosophical and scientific tradition. Hence also the immensely diligent interest in the history of philosophy. Not striking down history of philosophy at a stroke, as Husserl had it—the *epochē* which believed it was striking down all prejudices in describing phenomena.

Yet there does remain a reflective kernel on which this method relies. The idea of a more original access was, after all, based on Husserl's idea of the original and the nonoriginal; it goes beyond it, making it more radical and problematic, by freeing it from the

objective mode of the givenness of being. It seeks to go further with respect to the way being is given. Instead of givenness in self-consciousness—an essential self-relation, a relation of being to itself. Here there is something analogous to the structure of reflection, though reaching beyond it for the idea of the practical nature of this relation, toward something that is not mere givenness, self-presence in reflection, but rather has a practical nature, aiming at the idea of an original self-disclosing being. Thus Heidegger does in a sense set Husserl's phenomenology aside, though not dismissing it as worthless, only making it problematic as to its *extent*, how radical it is. It does not deal with ultimate phenomena to which all thought points as to its foundation. It does, however, remain immensely useful as a conceptual orientation. Next time, we shall speak of the limitations of this Heideggerean conception.

Thirteenth Lecture:
Reflection as the Practice of Self-Discovery

The confrontation we have carried out is significant for understanding the meaning of phenomenological work as we have engaged in it. Now we need to make explicit the debate between Husserl and Heidegger which in fact never took place but which is nevertheless to the point. It is one of the burning, unresolved issues of present-day philosophy. Nor shall we resolve it here, we shall only faithfully lay it out. For that, we shall now present some of the objections raised by Husserl's pupils to Heidegger.

The book we shall follow will be Gerhard Funke's *Phänomenologie: Metaphysik oder Methode?*[69] Funke's answer to this question is that phenomenology is merely an epistemological method. It does not unveil ultimate being because the entire mode of phenomenological inquiry is one of asking after the conditions of the possibility of demonstrating being; those are what is grasped in reflection. In a reflection which can never be brought to a completion, since every standpoint, once assumed, poses further questions. Every meaningful philosophical question falls within the scope of this reflection. There is no philosophical thesis about which we could not inquire on what foundation it rests, how we arrive at it; and that can be carried out only in reflection, in a theoretical, contemplative posture. In what sense is this a

69. Gerhard Funke, *Phenomenology—Metaphysics or Method?* trans. David Parent (Athens: Ohio University Press, 1987).

criticism of Heidegger? Heidegger wants to make the being of
what is the object of his inquiry. He claims that the being of what
is after the manner of existence (fundamental ontology) is some-
thing to which there is no access through contemplation, through
direct seeing. However, if being cannot be made a phenomenon,
then to ask about it makes no sense. In a way, Heidegger is right:
we cannot make the being of life as lived into an object in such a
way that the conception of it would be coextensive with it.
Fundamental ontology can formulate certain universals, but life as
lived is not a universal, it is something individual and inex-
haustible (as every reality).

Were Heidegger's idea of nonobjectifiability to mean only this,
it would be trivial. Our approach in reflection is always conceptu-
al. The fact that we always grasp the conditions of access to objec-
tivity conceptually shows that in reflection it is possible to grasp
both being and objects conceptually without identifying with
them thereby. Here we should not let Funke's objections mislead
us. First of all, Heidegger's question about the being of life as
lived, about existence, is not a question that would set aside the
question of access, of the conditions of possibility. However,
Heidegger seeks them, looks for them in being of just a particular
type. According to Funke—being cannot be made a phenome-
non, therefore the question is meaningless. But is it the same
thing to make something into a phenomenon (to make it appear)
and to make it an object of seeing? We need to ask in just what
sense existence is unobjectifiable. It is not in the same sense as
Kant's *Ding an sich*. Nor is it in the sense that it would wholly
elude reflection's gaze. Nonobjectifiability does not mean non-
reflectability. The meaning of nonobjectifiability in Heidegger is
that in the case of being like ours objectification in reflection *does
not suffice* for grasping this life in its own essence, in its very
being. That does not mean that reflection does not grasp any-
thing at all. Why, though, is reflection not enough? We need to
pose a question which Husserl does not pose, a question concern-
ing the nature of reflection, what it is, what it means.

Husserl, without any closer justification, regards reflection as
pure contemplation—as capable of grasping its objects without
having any practical relation to it, without affecting it. That is the
point of Husserl's disinterested observer produced by the phe-
nomenological reduction, the something extra that reduction

offers which the belief in the world does not. Is reflection really something on that order? Is it not, quite the contrary, a means which human kind of life uses to find and generate its own being, its own person? Do we not reflect for this practical purpose? Do we not reflect because by our very nature we relate to ourselves? That is Kierkegaard's conception (from which the concept existence is derived): humans are a relation that relates to itself, a relation between eternity and time, individuality and universality, contingency and necessity, etc. Therein—that this relation is concerned with itself, that it cares about itself—lies the possibility of reflection. Refection derives from the fact that we are not initially given to ourselves but rather must seek ourselves. It does not mean pure self-perception, self-observation.[70] That is Hegel's brilliant insight, on which all of *Phänomenologie des Geistes* is based: reflection affects the nature of the reflected, of reflected reality. That is not commensurate with Husserl's idea of absolute contemplation. Besides, if we look closely at Husserl's idea of the reduction, we shall note that it, too, has a distinctly dialectical structure. It is the problem of the relation of the I within the world and the I outside the world—in a certain sense, they are the same, in another sense not. Husserl is at times tempted to use the classic term, "the alienated I," for the I within the world, believing in the world, which is the object of the observer's vision, an I which turns from subjectivity into an object. All those are terms and problems brought up by German dialectical philosophy in its classic form.

That, then, is the question of reflection, of its nature and structure. Now from a different angle. Husserl himself raised the objection to Heidegger's ontology that it represents a regression to psychologism.[71] That then means naturalism, a naturalization of the spirit, and that in turn an incapacity of the spirit for truth, rendering a clear and consistent theory of knowledge and truth impossible. Whence does Husserl derive this consequence? From Heidegger's not carrying out the phenomenological reduction—

70. Cf. Søren Kierkegaard, *Concluding Unscientific Postscript,* trans. Howard Hong and Edna Hong (Princeton: Princeton University Press, 1992), especially section 1, chapter 2; and section 2, chapter 2. *Ed.*

71. See Husserl, "Nachwort zu den Ideen," *Jahrbuch für Philosophie und phänomenologische Forschung* 9 (1930), p. 551; and cf. the marginal notes of Husserl to *Sein und Zeit* quoted in Alwin Diemer, *Edmund Husserl* (Meisenheim: 1956), pp. 29ff. *Ed.*

the abolition of the belief in the world which, for Husserl, first
purifies experience and excludes the possibility of prejudice, gen-
erating the transcendental spectator. For that reason, Heidegger's
attempt must end up in a naturalization of the spirit and in skepti-
cism. Heidegger's fundamental ontology thinks it escapes this
objection because, (even though it does not carry out the phe-
nomenological reduction), since it reduces objectival realities to
objectival meanings no less than Husserl's phenomenology, it is
also a phenomenology of meaning.[72] What concerns Heidegger's
phenomenology are not concrete realities but the meaning of
such realities. It moves entirely in the dimension of understanding
meaning. We live in understanding meaning: the being of Dasein
is understanding oneself and others. For Heidegger, however, this
meaning is not primordially oriented to logical constructs but to
living meanings, to the original meaning of our own actions in
the course of our life and of what belongs to them as their corre-
late *(pragmata)*. This Heideggerean world, however, is no less
self-enclosed than Husserl's. Causal, objective effectiveness, as we
know it from the natural sciences, cannot penetrate into it. That,
though, does not mean that this world is wholly acausal. In this
respect, too, Heidegger is no better off than Husserl. Husserl, in
Ideas II, where he speaks of the constitution of our own person,
of corporeity, speaks of the continuity of soul and body, of nature
and spirit—causal efficacy is merely a condition for the constitu-
tion of meaning, it is not massive as in physics, yet even Husserl
admits some continuity of this type. The distinctiveness of causali-
ty in the realm of meaning is that, for the mental region, only
those causal sequences are significant which offer an opportunity
for the constitution of meaning; that means, not a passive process
in the third person but rather something meaningful, something
that belongs to an intelligible context.[73] Intelligible contexts
constitute a structure broad enough to cover understanding of
ourselves, of the world, and of others (as Merleau-Ponty puts it).
In both cases, the overcoming of naturalism is accomplished
the same way, and not by means of a reduction. Naturalism is

72. Cf. Martin Heidegger, *The Basic Problems of Phenomenology,* trans. Albert
Hofstadter (Bloomington: Indiana University Press, 1982), §5. *Ed.*
73. The relevant passages on the relation of body and causality/material nature in
Ideas II can be found in §§15–18, 41, 56. *Ed.*

overcome because causality *means something different* in the case of a psychophysical sequence than in the purely natural (physical) realm.

The next step in the debate did not originate with Heidegger's opponents but with Heidegger's question addressed to the author of the reduction. The reduction is to be a suspension of belief in the world on the part of the philosopher (the phenomenological observer). This suspension presupposes two things: (1) that we believe in the world, and (2) that this belief in the world is by its very nature something different from our belief in ourselves. Those are tacit assumptions of Husserl's position. For Husserl, what he thematizes as the natural standpoint and natural belief in the world is oriented to the assertions of natural science which represent explicit acts of positing a certain reality: this and that exists. Yet our original experience contains such a thesis only implicitly. It represents neither the positing of individual things nor of the world-all. Husserl, Heidegger believes, projects an entirely secondary, derivative phenomenon, the explicit positing of theses, into primordial experience, as if it were possible to draw a sharp distinction between the positing and the posited. What, though, if our initial experience is such as to preclude such opposition?

Let us turn to the way Heidegger thematizes the world. Heidegger raises the objection that Husserl does not differentiate the concept of the world sufficiently, that he has not posed the question of what the world is. In everyday life, we are constantly using the locution, "to be in the world." From that we can conclude that the world is something that figures constantly in our experience, ever making itself heard, that it is not something theoretical, something that concerned Greek astronomers etc., but rather that it belongs to our pretheoretical experience. The question is, what is this prescientific phenomenon, the world? what is the world of pretheoretical experience? In *Sein und Zeit* §14 Heidegger distinguishes four conceptions of the world, two ontic and two ontological.[74] What is the difference? Ontic

74. I.e., "world" (1) as the totality of things that are present-at-hand *(vorhanden)*; (2) as one's surrounding world *(Umwelt);* (3) in the sense of a realm that encompasses a totality of things in such a way that is definitive of their being (as in the "world of the mathematician"); and (4) as "Weltlichkeit," or "worldhood" of the world—the a priori character of "world" as such. (1) and (2) are "ontic" senses of world, (3) and (4) "ontological" or, in the case of (4), "ontologico-existential." See *Being and Time*, p. 93. *Ed.*

assertions pertain to existing things, be they realities or idealities; for instance geometric terms are ontic. Ontic questions are those posed by the positive sciences. Ontological assertions do not deal with objects of a particular region but rather with the mode of being of the objects of a given region. They have to do with the mode of being, with the way a given objectivity is. For instance, geometric formations have a nontemporal mode of being, time has no significance for them. *The world* can be intended ontically—as a complex of all that is and can be given. There is an ontological conception of the world that corresponds to that. If by world we mean a certain region, for instance all *reality,* everything real *in objective time,* we do not mean by it only the complex of all realities but primarily the mode of being of the real. When we speak less strictly of the world in a metaphoric sense, of the world of mathematics, the world of geometry, this, too, has its ontological aspect. Renaissance thinkers speak of ascending and descending worlds—the divine world, the angelic world . . . —spheres within which reality is laid out.[75] What, though, do we mean when we speak of the world of ancient Romans, a child's world, the world of the primitives, the animal 'world' (context; each animal has a distinctive context which belongs to it corporeally, in a way appropriate to its bodily structure; there are, for instance, original explorations of the constitution of the world of the bee, enabling us to understand how it is built up)? That is again an ontic conception of the world, though not of a world of being that is simply given but rather of the world of a living being. To that there belongs, analogously, an appropriate ontological conception: what makes the world a world, the worldhood of the world—a concept characterizing the being of a living creature, eminently of a human being. It is the ontological conception of the world that does not belong, so to speak, on the side of the object but rather belongs with us. The world in this sense, as an ontological structure, is not something characteristic of a being like a stone but, rather, of a being of the human type.

75. I.e., as in sixteenth-century Platonist writers, such as Pico or the Florentine Francesco da Diacceto, who took up the theme of soul as a mediator of two worlds from Plato's *Symposium.* See Paul Oskar Kristeller, *Studies in Renaissance Thought and Letters* (Rome: Edizioni di Storia e Letteratura, 1956), pp. 287–327. *Ed.*

If it is an essential trait of humans to be in the world (just like, for instance, being corporeal), then at least this aspect of worldhood is not something that stands *over against us,* and in this sense to believe in the world is no different from believing in oneself. However, the world in the ontological sense is, at the same time, the condition of our encountering other beings in the world. Their mode of being is of a different ontological type than ours. Being in the world is a condition of the possibility of believing in such beings. Thus the question of the world and of believing in the world is more complex here than in Husserl. Husserl, to be sure, distinguished the world as a horizon (presence of the absent, unexplicated but explicable structure of experience; the particular as set within a horizon), which is a condition of the way, of the sense in which the things we encounter are given. At first sight it might seem that in both cases—Husserl's world as a horizon and Heidegger's world as an existential (an ontological concept characterizing the being of our existence)—mean the same. The difference is that Husserl sees the horizon, too, primarily contemplatively, there to be seen, as the explicability of the implied, the possibility of ever further explication, like a ball of twine I hold in my hand and can unwind. For Heidegger, the initial continuity opened up in understanding is not such an explicability but rather a context that is primordially practical, flowing from our possibilities and their objective correlates, a context of *pragmata.*[76]

Here it would be appropriate to explain how Heidegger imagines the structure of the world, what the worldhood of the world means for him. He explains it in terms of several examples. He wants to show that the world, the condition of the possibility of encountering the particular, must inevitably retreat to the background, that it must not manifest itself to us, if things are to become manifest. That means that it is not a phenomenon. Under certain circumstances, however, it can become one.

No *pragma* is isolated. We cannot speak of a single *pragma* as we can of a single atom. A pragma isolated like an atom is impossible, a table belongs to the floor, to the room, to its furnishings.

76. As characteristic of the conception of world (and world-horizon, horizon of the given) that Husserl works with, see *Ideas I,* §§1, 27–32, 69. Cf. *Being and Time,* §§15–18. *Ed.*

We do not explicitly explicate this meaning, we simply use it. It is originally a practical meaning which we grasp, take up. We understand that meaning in practical action in which we realize a certain possibility. We understand the world of the classroom because you are students and I am a teacher; all of us here and at other times do something, take up some from among our possibilities which we actualize, and in their context there appear things which enable us to make it actual. As things initially function, their mutual internal coherence remains concealed—and so it should be. Smooth functioning, indication of meaning (a door knob to be grasped without thinking about its mechanism, without knowing its parts) is a condition for having reality before us in its ordinary inconspicuousness as our working context.

It can happen, though, that the smooth functioning is disrupted. For instance, something, some instrument breaks down, the entire context no longer works. Now we have to watch what we are doing, we look over the whole context which no longer works. That precisely is how that context announces itself to me and becomes a phenomenon.[77] That does not mean that therewith the entire context becomes thematic at a single stroke. We do not have before us the whole sequence of means and ends, of causes and effects. Such a thematization presupposes an explicit analysis, a theoretical interest. What we do have suddenly before us is that special understanding which at other times we merely use while it remains inconspicuous in our dealing with *pragmata*—that understanding now encounters a void, no longer finding that working context; suddenly we are surrounded by an emptiness. With that we introduce into the phenomenal sphere that distinctive mode of functional understanding which is a part of practical dealing with things, an overview which understands the interrelations of one *pragma* with another and so, indirectly, also the *whole* of such relations, the original world. Signification—pointing with signs—is the phenomenon which already presupposes the manifestation of this overview. That is possible only insofar as the references which function in our practice become clear and we make them even more clear by constituting special *pragmata* whose function is to stress, to make

77. See *Being and Time*, §16. *Ed.*

explicit, the original things whose practical functioning we understand.

If this perspective, this overview, is what functions primordially in the context of reference, then we need to ask about the mode of being of that which appears in such a mode. That mode of being is that of being as *pragma,* as we have already noted. Might we not, though, grasp and characterize that meaningfully? The pragmatic nature of things means that they belong to the context of our practice. We need to specify—in what way? An overview is a certain mode of understanding. This understanding has a special structure: I understand something *as* something. I always look at something *from some aspect.* What is it that presents to me the aspect I am now seeing? What I need to see of all things is how they are, their *suitability* for something. Things are always in such a mode that we get along with them in some way. As what do I see that thing? As a desk, but I can also stand on it, it offers an opportunity to lean on it, I see that it is not frail, that it will not give way. Another view tells me that it is wooden and could be burned, should there be a shortage of fuel. Understanding the suitability of a thing is something derived from a definite possibility I have.

A particular context in which a thing we meet functions is a definite whole of references. If we now take the entire aggregate of referential contexts, I can say that the world is that within which our self-understanding and our understanding of things always operate. Heidegger then tells us: that wherein our understanding moves in its referring, as that with reference to which it lets appear the things we encounter, as long as they are in the mode of *how we interact with them*—that is the primordial phenomenon, world.[78] Understanding means primarily understanding our possibilities; I understand myself as he who does this or that, acts thus or so; this activity takes place within a referential context; within it I encounter pragmata, things in the mode of *how I interact with them*. The framework within which understanding takes place, that is the world, that is the original phenomenon of the world; that is

78. Cf. *Sein und Zeit,* p. 86 (*Being and Time,* p. 119): "Das Worin des sichverweisenden Verstehens als Woraufhin des Begegnenlassens von Seiendem in der Seinsart der Bewandtnis ist das Phänomen der Welt." *Ed.*

what characterizes the worldhood of the world. That is the existential which characterizes our being in the world. That is how Heidegger thematizes the phenomenon world.

Fourteenth Lecture:
Phenomenology within the
Limits of Experience

Let us return yet again to the question of the meaning of reflection, to the debate between the viewpoint of absolute reflection (for a time Husserl's) and the conception of reflection as a part of human life in the world, the moment of authentic human life (Heidegger). The axis of the debate is the objection formulated by Gerhard Funke, that the perspective according to which reflection is a component of authentic existence does, after all, presuppose a certain objectivity of reflection, a distancing perspective which has the capability of *grasping*. It is this ability of grasping to which we need to hold on; not onto any thesis which would state once and for all what the object of reflection is, not onto any absolute thesis, but onto that which reflection presents in this or that instance. Reflection offers nothing absolute. Therein Husserl's philosophy would err, were it a doctrine of absolute reflection. Husserl's philosophy is not the gateway to the absolute. On the other hand—the view which states once and for all that reflection is a component of existence and that existence means bringing clarity into being etc. is also dogmatic. Both positions would like to be definitive and both transgress the limits of reflection, the bounds of phenomenology. Phenomenology is something third. Reflection tells us neither that it is the gateway to the absolute nor that it is a component of existence. True phenomenology will cling to Husserl's principle of all principles: to hold on to what presents itself, insofar as it presents itself and only as it presents itself, remaining within the strict limits of the

given.[79] That means that in reflection we examine the way in which any thesis is presented and what our approach to it is. Phenomenology is a method which can never become a metaphysics. It cannot be the gateway to an absolute thesis. Theses are for it always only occasions for investigating the conditions of the possibility of their givenness. Such inquiry is as nonabsolute, nondefinitive as every thesis. Theses are phenomena of being, not phenomena of themselves.

According to Funke, the debate between Heidegger and Husserl is one between two absolutist positions.[80] (We have followed it to the point at which it became necessary to carry out an analysis of the phenomenon of the world.) Now we must include in the debate, in addition to those two absolute standpoints, also this standpoint which seems to be the true phenomenology, opposed to any metaphysics. At first sight, Funke's thesis (he is a sharp thinker and a penetrating critic) does appear acceptable, as if it might be the true phenomenological thesis (rejecting anything said to be in itself and focusing on the sphere of what actually presents itself). Funke's position is very plausible if it is formulated abstractly, generally. Therein it is but a reformulation of Husserl's principle of all principles: in philosophy, experience is decisive, experience means the givenness of the thing as it presents itself, with all that presents itself and nothing more than what presents itself. This principle might appear rather impoverished. All philosophies believe that they are following it, that it expresses nothing distinctive. Only once Husserl begins to make use of all he considers experience, phenomenon, that wherein phenomena present themselves, differences emerge. As a consequence of this principle, precisely because he did not want to give it up in favor of some constructs, Husserl was driven to pose the question of the *givenness* of the universal: whether the universal is not in some sense given, not only thought as a mere opinion—hence the problem of eidetic intuition. This principle proves its fruitfulness only when it is concretely carried out. So, too, with Funke's general statement of the principle: we need to ask whether it does not obscure concrete problems, for instance the question of *what*, primordially, is life, the subject grasped in reflection, what is the primary character of its being.

79. See Husserl, *Ideas I*, §24. *Ed.*
80. See Funke, *Phenomenology—Metaphysics or Method?* pp. 124–42. *Ed.*

At one stage of his development, Husserl believed that reflection in the form of the phenomenological reduction is the gateway to the absolute, that it is wholly free of any presuppositions, that it is a creative act which can in no way be motivated or causally explained by the world, in human terms. Humans have no such need for reflection, they have no practical, vital reason to engage in it. What it involves is grasping the world from within and as a whole. Here consciousness, an island within the world, within nature, overflows into something embracing the world, an ocean surrounding all being. That is what takes place in phenomenological reflection. That reflection represents an absolute givenness: as soon as I carry it out, I realize that I can carry out this *act* of absolute reflection at any time, that it is within my power. Bracketing the belief in the world, disarming all mundane interests—that is a possibility I always have, therein I am absolutely free.[81] That, though, also entails that the object of reflection is understood in a definite mode—reflection, that is, must grasp its object wholly, the object presents itself to it appropriately, it is immanent to it. Absolute reflection includes a certain prior decision about the mode of being of what will be given in reflection, what will be enclosed in its gaze. It assumes that it will be possible to comprehend (the essential) totally, not only perhaps apodictically, but always partially—for then we would need to prove that what we comprehended was indeed what was essential. If ever our grasp were partial only, we could not help asking whether this concrete life grasped in reflection is the sort of thing that can be grasped in reflection or whether life by its nature, as an activity, a doing, cannot be exhausted in the present, containing the present and the absent fused within itself, whether the absent is not in principle present within it.

Thus Funke's perspective of relative reflection is no help. Nor is it new. Phenomenology cannot avoid the question concerning the nature of reflection. Even if we say that phenomenology is not the gateway to a transworldly absolute and cannot yield an absolute thesis within the world, such as the essence of existence, once and for all, and, conversely, if we were to avoid claiming dogmatically to know what existence is (which is the sense in which Funke's criti-

81. See Husserl, *Ideas I*, pp. 58–59. *Ed.*

cism of Heidegger might be legitimate, if Heidegger presented his thesis not as a preliminary theme for phenomenological analysis but rather as a final, absolute grasp of the essence of life)—the point would still be whether what is grasped in reflection as the nature of that illuminating life which relates to itself and so brings clarity, contributes to understanding actual phenomena. Furthermore, are the phenomena we have begun to analyze, for instance Heidegger's phenomenon of the world, phenomena at all, and in what sense?

Let us now return to the phenomenon of the world as Heidegger and Husserl see it.

Heidegger sees the phenomenon of the world as continuous with our practical activity which initially does not give us things as objects but as *pragmata,* as tools. The point is not what to call a thing or what nature to ascribe to it. For instance Scheler believed that we see things—both natural realities and artifacts—first in their thingness, their objectivity (color, geometric shape, etc.), only subsequently adding practical traits (that it is useful for something, valuable, etc.), as a higher stratum. That is not the way it is, that would distort the phenomenon. *Pragmata* are always in a context. There can be no single pragma. A thing as an object is always separable (*choriston*), existing as one object. As Aristotle has it, a thing is whatever is capable of autonomous existence. *Pragmata* are not that. A *pragma* stands always in the context of references, it is a part of a sequence, of a *circle* of relations. (We shall speak of the circular character of the world in detail later.)

For Husserl things are first of all objects, as we know them in traditional philosophy. In the analysis of perception, the object of perception presents itself as the substrate of various properties, a unity of diverse predicates. It is given in perception, but a perception is always a series of unending references (the front referring to the back, etc.), so that the object is in principle inexhaustible. A perception does not present the thing itself at a stroke, it presents the thing in the original, but always perspectivally. That is what interests Husserl. An individual thing as originally given is always given as a series of references, so that its context, possible perspectives, ultimately all the world, belong to it. Every thing refers to its own various aspects, to its surroundings, to ever further surroundings of various types. We are thus led from one object to another. As soon as we have an individual thing before us, its meaning leads us on to the world.

What is the difference between what Husserl and Heidegger have to say? At first sight, it seems the same, yet there is a substantial difference.

Husserl proceeds from one thing to the next; even when the next thing is no more than a hint, it still adds something. The world is as if an aggregate of tightly linked things, one growing out of the other, indivisible—it is a material continuum. It is due to the special structure of perception as such that things can be so fused, solely on the basis of their nonadequate givenness. Not even to a god could things (objects) be given differently than they are given to us, always only perspectivally, from one side.[82] To have things, finite objects in the original, is possible only in perception. That is a metaphysical thesis that runs counter to traditional thought (Kant speaks of the *intuitus originarius*—god sees reality in a perception which is simultaneously creation).[83] For Husserl, perception alone represents an originary access to objects. Were that not so, then perception would not be a presentation of things in the original but only a shadow or at most a representation, something that presents (nonadequate) reflections, not the thing itself. That is how Husserl sees the phenomenon of the world, at least for a time, as for instance in *Ideas I*. When he describes the natural attitude, the world of the natural attitude, he shows that things are given on the one hand in actually present impressions, on the other hand in *horizons* pointing ever further. A horizon can always be explicated, that is, we can reach into it and single out something actually present, a certain aspect of a thing.[84]

For Heidegger, a priori, no *pragma* is possible in isolation. It would seem that the same is true for Husserl. Yet for Husserl the meaning of an object is an autonomous being—an existent that can be isolated. What cannot be isolated is its givenness. For Heidegger *pragmata* themselves, in their meaning, are such that they belong to a certain context which is not merely a sequence of things.

Let us return to Heidegger's concept of a *pragma*.[85] A *pragma* is characterized by its utility, by being good for something.

82. See ibid., p. 95. *Ed.*
83. See Kant, KrV B72. *Ed.*
84. See footnote 76, above. *Ed.*
85. I.e., the concept of "das Zeug." See footnote 66, above. *Ed.*

Thereby it points to that which it serves. Primarily, it points to other *pragmata,* to a coherence of *pragmata.* Then it also points to that which that context of *pragmata* serves: it is a certain region of human activities. That points to the function of human life, to human life as the foundation of possibilities. That way, each *pragma* is integrated into a coherence which is not material only. These references have a circular character in that understanding opens out life in virtue of life's self-understanding, life is a life in possibilities, that is, it is not indifferent to itself, it is not indifferent to whither it goes. Life has to hold itself before it, a segment of that life must be lighted up before life passes through it. That presupposes a structured space into which something can project. A part of that context is also shedding light on what makes such self-anticipation possible, making it possible for me to actualize possibilities. Light from life is shed on things. The light shed on things—those are the references to this or that, referring in turn back to life. Light going out to things is shed back on life. Here the circle of the world, its circular character, is manifest.

Heidegger's definition of the world in *Sein und Zeit* §18: *das Worin*—that within which understanding by reference operates. Understanding is always self-understanding insofar as I am concerned for my being; that is something humans always understand in some way, life matters to them. (That is so already in Feuerbach: true being is that being which knows passion, suffering, pain, to which it is not indifferent whether it is or is not. For Heidegger, though, this is a wholly different mode of being than the being of things, while Feuerbach continues to see being from the viewpoint of determining what it is and that it is, in the duality of essence and existence—being is here, it is given.) Self-understanding lives in reference. I live for something, that *for* contains the difference. If I want to make something actual, I actualize it by means of myself and of some other means, of something that is not I. That means that self-understanding implies understanding that which is not I. The most basic reference is the *for the sake of,* followed by the reference of the primordial *in order that,* the *in order that* pointing to the *what for* (purpose) or *whereby* (means). That within which understanding in references operates as that with respect to which being opens up before us in a context—that is the phenomenon of the world. So I might be a clerk, having to go to the office. Everyone has something to do.

In ordinary understanding I am what I do. This is what I am and do in order that I might be. What must I do so to be—I must get to my work place. A workplace consists of a vast context of relations, as for instance transportation. Within the region of transportation, there is a certain means of transportation. That belongs to a certain context; streetcar means streets, tracks, signals, the police, the tram itself and the place it occupies. Those are the references.

Here we might object: all this—that is the world of human work. Heidegger is presenting the world of humans, but a special world, a derivative one. The world, though, does not appear to us only when we do our job, the world surely must be there already before that. As a clerk or a worker I surely do not see the world; as a clerk I only see certain things in a certain way—as *pragmata* belonging to the context of my activity. Surely I must have seen a great deal of the world prior to that. Seeing, things—that comes first. It would seem that Husserl is right. First there are things, objects as we see and hear them, to them there accrue the formations of our praxis. Let us ask, though, what seeing, hearing mean. Perhaps we might have to subject to a thorough critique the way Husserl and traditional thought look at seeing and hearing.

How does Husserl look at seeing, hearing . . . ? With the help of the concept of intentionality. Our consciousness always has an object before it. What is the mode of givenness of such objects when they are before me in the original? When I perceive them. What is perception? Though the thing itself be given in the percept, surely it did not jump into me. How do I do it, how do I come to the original givenness, how is that original givenness structured? (There are philosophers who claim that a transtemporal I is coordinated with the being of the whole world; we receive the thing acausally on that basis.) Husserl starts out from a definite model phenomenon which he uses as a model for understanding perception. He does not speak of that model. The model which guides him in all his philosophy is language. In language there are formations: phonemes; wholes of phonemes—words; wholes of words—sentences. We communicate by means of them, but our minds do not rest on them. Language is a transient, transparent medium through which something further shows itself. Linguistic formations are as if animated by something that

seizes them and drives on through them to something else. Our minds rest on that of which we speak, not on the words. Perception is similar. In perception there is a given basis which is the ground for intention, through which intention penetrates so as to bestow a definite meaning. I see a box—that is a meaning which cannot be seen with the eyes, it is something different than the foundation which is only certain *impressions*. Impressions are not properties of things. White as a property of chalk is not my impression, it is a property of the thing while the impression belongs to me. Still, some impressions must be there. Impressions are as if the ultimate building blocks (therein Husserl learns from British empiricism). Our intention animates them and bestows upon them a meaning distinct from impressions. Still, impressions are ultimate, Husserl did not go beyond them in any of his analyses of perception.

That is an immense difficulty for phenomenology which seems to force it to produce some construct. What Husserl has to say of intention which holds on to something is not erroneous. Husserl attempted to analyze all that is present in perceptual presence, what we actually see there, constructing nothing. He does not, though, go further, deeper. His writings do contain related analyses which do go deeper. For instance, if a sense perception points to further and further perspectives, then perspectives in turn point to walking around a thing—that is an activity, a *self*-movement, as distinct from objective movement. (Already Aristotle noted a fundamental continuity between *aisthēsis* and *kinēsis*.) The question is whether these phenomena do not point to a deeper unity, which is the basis for that intentional act which perception reads off.

Fifteenth Lecture:
World of Objects and
Pragmata

Last time we posed the question whether the world as Heidegger defines it, as an ontological concept relative to Dasein (as *that wherein*), is not merely the world of human work, a world which renders what there is meaningful at a certain level of its meaning constitution—a level which surely presupposes something deeper, a world that is pregiven, in advance. *Pragmata*, whose significance can be unlocked only by the practice of working humans, surely *presuppose* a perceived world, a world given in sensations, in the senses. Is not that world purely objective? Does it not offer data which are nothing but data? The world of immediate perception, of sensing—does that not testify that an objective, objectival layer precedes practical characteristics? The world is revealed to us by something other, on the level of what is given, not on the level of manipulative practice.

To reply to that we need to reflect on the structure of the world as Heidegger describes it. Anticipating: in one sense, the objection is valid, while in another sense it is not. It is valid in the sense that the world of practice which opens up the meaning of things as suitabilities, as pragmata, really does presuppose something prior to it. To claim, though, that what it presupposes is the sheer objectivity of massive givens, of sense data as British empiricism describes them, that we cannot accept.

Heidegger's world is a structure which contains both life and its context without differentiating them, the intrinsic relation of the living and the lifeless, self-understanding and understanding the other. It is not a region which could be said to belong to the

sphere of the subject or the object; it is something that is prior to that division, something deeper than the subject-object structure. The world is relative to self-understanding as the sphere wherein Dasein understands its possibilities. Dasein understands itself as the one who realizes its possibilities. Possibilities become actual in a definite context—that *wherein* they become actual is precisely the world. The world is the condition of the possibility of understanding being internal to it. Initially we do not thematize things, we do not objectify them, but rather deal with them, look after them. That points to a certain structure of our being.

Our being is Dasein in the world and Heidegger describes it in terms of a distinctive triple structure. Dasein lives by understanding its possibilities. Possibilities, that is, belong to it but not in the sense that it would imagine them, objectify them (then they would be objects, not possibilities), but rather by realizing them, by identifying with them, by being "borne" by them. That they might be possibilities, not blind forces of which we would become aware in retrospect—Dasein projects itself in these possibilities, reaching ahead of itself. Life in the projection of possibilities, life before it, life ahead of itself—that is no anticipated experience. We always enter a certain *spatium* (possibility) which is open to us and we know that it is open to us; at the same time that which we enter is less than fully real. That "ahead of ourselves" means that we who live so, in a certain way, in a certain mode, *have* these possibilities. We project their realization, they ripen in our hands, but in a way we are set among them. So (a) I am ahead of myself; (b) I am set somewhere, I am always already somewhere—where?—at that which unlocks those possibilities to me, from which I perceive what I can, that is, from the world—I am in the world; (c) I am *ahead of* myself, and in that *already* what I have to do opens before me—which is how I encounter things, intraworldly existents. The *ahead of* and the *already*, in which the *intraworldly* opens to me—those are the three structural moments of Dasein. Dasein has a constant structure. This entire structure pivots on self-understanding and understanding things. Understanding in its original form means caring for things (dealing with them, making them, repairing them, or leaving them as they are), understanding our possibilities and that to which they correspond, what unlocks them. Those are the basic traits of that structure. It is an ontological structure—the structure of the

being of Dasein. Heidegger calls it *care (Sorge)*. That has nothing to do with preoccupation, carefulness, grief (as a mood); it is, rather, a purely ontological structure—the triune nature of anticipation, of being placed in a situation and, within that situation, grasping that which opens before us, what concerns us in it.[86]

Now we ask: does not this understanding, structured as care, presuppose something else, prior to itself? Is care as such autonomous? Especially considering that the world is given to us through the senses. Are these not already meanings of a higher order, a derivative, meaning-bestowing layer? Here we could repeat what we said of objectival givenness of a being on the basis of sense data (the question we posed at the start).

In Heidegger, there is only a hint of an answer: in the chapter dealing with the temporal character of *disposition (Befindlichkeit)*.[87] Disposition has to do with one substantive moment of the overall structure of Dasein, namely, with situation. The three moments of Dasein's structure (projection-situation-that with which we cope in the situation) themselves point to something like a temporal structure. Projection, in which our life unfolds—taking on possibilities and identifying with them; realization—the authentic moment of existing (that is that *vitam ducere*, leading a life—not passively being but actively reaching out to our possibilities). Situation has the character of the *already;* whenever projection, disposition, realization get under way, they always presuppose something *already*. In the dialogue of these two extases (as Heidegger has it) lies the *spatium* in which we can first encounter something. We must not think of the temporal structure of Dasein as something that is in time, in sequence—in time *partes extra partes*. The original temporality of Dasein is of a different order. It is what makes possible an objective time—whose parts stand outside each other, one next to another, a time we abstract from innerworldly things. Situation is the original past. In Slavic languages, participles beautifully express the temporal structure of Dasein: *former (minulý)*=having the trait of the past within it; *futural (budoucí)*=having the character of projec-

86. Cf. *Being and Time*, §41. *Ed.*

87. *Befindlichkeit*, here rendered *disposition* to mirror Patočka's rendering of it in Czech, is commonly if somewhat misleadingly rendered *mood* by English translators; see *Sein und Zeit*, §68b, also §§29, 30, and 40. *Trans.*

tion, being in projection. There is a difference between former and past (*minulý* and *minuvší*), that is, contained in objective time as a previous phase. *Former (minulý)* expresses something which brings and retains the character of having been, (not just being past), of being situated. To express that in German, Heidegger must use neologisms (*gewesene Zukunft*);[88] in Czech that is not needed.[89]

Heidegger tells us that the affects of our senses belong to the coherence of the way we are, how we are disposed, to the situation, to that *already*. Dasein is always in the triple unity of that overall structure. Project, reaching ahead, is always situated, it always presupposes something before it, it always derives from something. A project in an absolute sense, as such, is not possible, it contradicts the structure of Dasein. Projection is always a *thrown* projection, a projection determined in some sense. Why thrown? Because we are *set* in our situation (in the sense of situatedness *as such*), we do not step into it. Within our situation we can comport ourselves in various ways, actualize, choose among possibilities, grasp a possibility or let it be, but what is primary, as a presupposition of any project, is that it takes place in a situation we did not project, which is simply present as a presupposition of projecting, something we have not modified thereby, something that does not have the character of a possibility. Hence *thrown-ness*.[90] Every project is a project in thrownness, reaching ahead in a situatedness. Situatedness manifests itself in some phenomenon capable of being characterized concretely, in which it becomes manifest how in a sense we also already understand the situation ahead of time. Generally, all that is a structure of understanding, care is a structure of self-understanding and in the context of self-understanding also of understanding beings of other types than Dasein. How does understanding a situation manifest itself? The phenomenon which reveals the understanding of a situation is *mood*. A mood is not rooted in the future. Traditionally, a mood relates to the future, to the understanding of a future (for instance

88. Cf. *Sein und Zeit*, p. 326 (*Being and Time*, p. 373): "Die Gewesenheit entspringt in gewisser Weise der Zukunft." *Ed.*

89. In English, the future perfect, *I shall have done*, might be used to make a similar point, though the point it makes most forcefully may be the dubious philosophic value of etymologizing. *Trans.*

90. "Geworfenheit" in Heidegger. Cf. *Being and Time*, §§29, 38. *Ed.*

fear is a concern about something to come, anticipating a *malum futurum;* hope is the anticipation of a *bonum futurum*). That, though, would mean understanding mood, affect, as something objectival, intentional. What actually reveals itself in a mood is my situation, the way I am living here, the givenness of my possibilities.

Heidegger seeks to show this on a specific pair of emotions, analyzing two modes of depression, two depressive moods—fear and anxiety.[91] He concludes that in fear we fear *for something,* that we fear something, that something fearful, threatening, is approaching; we are afraid we shall lose something (our balance); the feeling of fear is a feeling of a loss (loss of balance, of orientation), a disorientation. We fear for ourselves—and that reveals us in the way we are situated. We lose in relating to ourselves. As losing, we treat ourselves as if we had no more possibilities, in our fear we forget our possibilities, that is, we forget ourselves. The way we react testifies to that—for instance, in a fire we tend to rescue the most pointless things; that is a forgetting of ourselves, of our possibilities. This feeling does not present us as ourselves, rather, here we forget ourselves, are given to ourselves almost as a *thing*—and that not thematically (in reflection) but in immediate understanding. That stems from the awareness, from the unacknowledged realization that here everything is at stake, life itself—and that it is in this life that being is realized. Anxiety is also a depressive state but the threat is not understood as coming from without and we are not understood as a thing which has to be saved before all else. In anxiety, we come to understand that the threat is internal, we have understood ourselves, that we, as being reaching out to its own being, bear within us, in our very nature, a threat, that our being is exposed being which nothing can save, which must yield to something. That places us in a situation in a wholly different sense. Both are purely vital understandings, understanding a situation, but each of them presents something substantially different even though both deal with the same.

Self-understanding is linked to Dasein's being always on the way *(unterwegs)* from somewhere to somewhere, that it is

91. §§30 and 40 of *Being and Time,* respectively. *Ed.*

dwelling in between. Dasein is *movement*. (Heidegger does not say that explicitly.) That *to and from somewhere* means: we are in contact with something, we are leaving something. As we realize our possibilities, the constellation of our context changes, it *appears* ever different. That it can *appear* different, have a face, that it somehow affects us, is based on the reality that our thrownness, our situatedness, moves in the sphere of dispositions, of moods, of affects. The world which can address us as being in a mood is a world which *has a face,* which appears in some way. In that sense the possibility of affect, of sensing, is rooted in our situation.

Sartre in his *Theory of Emotions*[92] (his theory of emotions is intelligible only on the basis of what we have said here concerning the structure of situatedness and thrownness) tells us that emotions are a way of doing magic, making use of the extremely close relation of perception and affectivity so that, when we yield to emotion, then instead of changing things in the world, keeping our distance, we change our world, our relation to the thing, the relation in which things are presented. Emotionality is the art of the magician without magic. Paralysis in horror, fascination, are attempts to modify a situation so that the threat we should master in other ways would vanish in some nonnatural way (for instance, fainting). This Sartrean theory is a highly problematic modification of Heidegger's assertion about the grounding of our sensing (of our affectivity) in the situatedness of Dasein.

Let us, though, ask of Heidegger: what of animals, of children? Heidegger tells us: only a being which finds itself, whose meaning enables it to have itself, a being which exists in the mode of pastness, can be the "object" of affects. Affects ontologically presuppose presentification—bringing a movement back to itself as past. That means that the world makes a certain impression on us (the ceiling presses upon us, the sky is leaden, the air is heavy, the surroundings are boring). This entire impression, that which thus affects us as present, places us in a way ahead of ourselves as situated and so as existing previously. That remains a special problem in animals and children. We always have two possibilities.

92. Jean-Paul Sartre, *Esquisse d'une théorie des émotions. Actualités scientifiques et industrielles,* vol. 838 (Paris: 1939). (English: The Emotions: Outline of a Theory, trans. Bernard Frechtman [New York: Carol Publishing, 1993]. *Ed.*)

Analogously to fear and anxiety, there are two modes of hope: I can hope for *something*, passively awaiting and so easing my life, or I can open myself for my possibilities and in that sense for existing in the strong sense of the word—hope in the mode "in spite of," in which I hide nothing from myself and yet am borne up by it. That is how human affectivity places us ever before us in this *discrimen*. The world then addresses us—affectively, in feelings, and at the same time in senses, impressions—in connection with this differentiation. Yet in the case of the animal and the child we also have to do with a world given in perception though there is no such *discrimen* present. Still, there is here also a "psyche," that is, an interiority relating to the world. How is that here?

This question pertaining to animals and children is significant for the problem of *human* existing in the world as well. Heidegger is leaving something out, setting it aside. It is true that our sensing, our sensory, sense-given world of impressions, is narrowly linked with situatedness which, as a human situatedness, is one of a free being concerned for its being. For that reason it is true that human life in percepts, human sensibility, must be in principle other than that of animals and children. It must be more flexible, richer, and have a tendency to objectify itself in the perceptible world of objects (in which the world of work becomes manifest). Something fundamental, though, remains the same; the world may have different sense vibrations where we give ourselves up and where we come up to ourselves, but the elementary protofact of *harmony with the world* is the same for humans, children, animals. That can only mean that in human living not everything is given solely by understanding, as Heidegger would have it. In Heidegger, the entire human life with its relations is primordially given in self-understanding and in understanding that which is in inevitable partnership with life as its necessary context. Heidegger underlays the world of knowledge with a world of understanding. Life is a life of understanding. What, though, if there is a more elementary ground still—the world as an empathy of a kind, as a sympathy?

Refer back to our lectures concerning the natural world and what we said about the philosophy of life at the end of the eighteenth and beginning of the nineteenth century (Hamann, Herder, Goethe). That flowed into Hegel's philosophy of subjective spirit.

Hegel is always criticized for his fanciful philosophy of nature, for its forced constructs which completely ignore modern natural science. And yet Hegel in the philosophy of the subjective spirit shows this much: the elementary, primary, immediate life of the spirit cannot be understood in itself. The life of the spirit as sensing, grasping the world by the senses is possible and intelligible only because the spirit is the ideality of an organism (an ideality—something to which time and space are irrelevant). It is not contained in it as a part. The organism is a whole, not an aggregate, *partes extra partes.* However, this organism as a whole is a part of nature; that means, nature bears ideality within itself.[93]

Is not ideality present in nature in another way still? Is not our sensing an evidence of this ideality with which our spirit can resonate? We as spirits, as idealities of nature, are in harmony with this aspect of nature as a whole. Our spirit is evidence that the world is not a mathematical world but rather a light; it shows that there is something in nature with which our spirit can be in harmony. It is not as if in that sensing we encountered something that exists *of itself;* every "of itself" solution is already *eo ipso* false. What makes it possible for us to perceive is the transformation of nature into something that is already more than nature—life is the middle term, life is capable of going along with the other. Modern psychology and phenomenology show that the first impression of the world is a physiognomic impression, attracting or repelling, that the world affects our emotions instead of simply presenting us static and lifeless qualities.

93. See G.W.F. Hegel, *Philosophy of Mind, Being Part Three of the Encyclopaedia of the Philosophical Sciences* (1830), trans. William Wallace and A.V. Miller (Oxford: Clarendon Press, 1971), §381; also see the first section of the *Philosophy of Spirit,* the "Anthropology," especially §§388–90 and 403. *Ed.*

Sixteenth Lecture:
Affection and Sensibility

We now conclude the theme of the sensory, perceptual harmony with the world which, according to our hypothesis, is what Dasein presupposes as its antecedent layer of heterogeneous possibilities without which existence would not be possible.

In Heidegger's conception, the world is relative to understanding of its own being. It is *that in which* Dasein understands its possibilities and, with respect to which it is possible for Dasein to encounter entities of different types of being than Dasein itself. This Heideggerean delimitation of the world is incomplete. We need to add that this understanding (understanding itself, its possibilities) takes place in the mode of *co*-being. Encountering innerwordly existents is an encounter which involves *other* beings who exist in the mode of *co*-being. For the moment, though, the simplified schema will serve our purpose.

This encounter, for Heidegger, bears the characteristics of a procuring preoccupation. Dasein has the character of care; understanding oneself and things has a practical, pragmatic cast. The question is whether this working world which we take over, work on, transform, etc., does not presuppose something previous. The world of work presents us with correlates of work, with *pragmata*. That is the character of significance which, surely, is not of itself the character of givenness of our senses. How does sensibility fit this schema? Does not Heidegger's world already presuppose a sensory datum, something neutral? That is a conception of sensibility inculcated in us primarily by empiricism. Empiricists understand the mental as a set of data. Data are subjective, private, belonging to us. However, they have the character of components

out of which wholes can be formed. Therein the spiritual does have a character of *res extensa* after all (divisibility into ultimate components, atomistic schema). By contrast, Heidegger stresses that the affections of our senses belong inseparably to our disposition, to our situatedness. We illustrated disposition concretely on the phenomena of moods. A mood belongs to disposition, to that temporal character of care as a structure of Dasein we call its past—not in the sense of something that once was but rather as its structural characteristic. Moods (dispositions) belong to the past of Dasein because they place us *before* Dasein as *already* present in the world.

The structure of Dasein is care. That includes existing in possibilities, understanding oneself as a self-realizing possibility, as a project actualizing itself. (Just as the project of daily schedule in which we live, which grasps us now and hands us over to the next moment.) It is not the case that we would imagine our possibilities, but rather that we grasp and realize them. Our acting, our active living is in this sense always ahead of what we are realizing at the moment. This being ahead is itself something situated, something that comes from somewhere. That from which it comes is another situation in which I had projected the "current," the presently actual. In projecting, however, I also arrive at a situation which I did not project; the situation I project is a part of an overall situation which I do not project as such. This finding oneself is rooted in our past just as projecting (understanding) is originally futural. The analyses of fear and hope we mentioned in the last lecture were supposed to show that mood (disposition) is not a fleeting state of mind but rather a fundamental trait of our existence—of an existence which is not only set into a specific situation but set there so that it is in charge of itself, that it comports itself in a definite way both to the situation and to its own being. Comportment is marked by a special ambiguity of the depressing and the elating.

Heidegger says: only that being whose being is such that it allows for it finding itself, a being which, while existing, is past, can be the object of affects. Ontologically, affects presuppose a presentification in which Dasein can be led back to itself as former. Only being which is thus substantially former can be in an affective state, can have sense impressions. An affect is the givenness of something we encounter, it is that encounter. The

meaning of an encounter, an affective posture pertaining to dispo-
sition, is that the encounter affects us, does something to us, does
not leave us unchanged, indifferent, pertains to us in bringing us
back to ourselves as to something that is here *already*. In affect,
we seem to go out of ourselves, yet at the same time the affect
turns us back to ourselves as to what is already here, what was
here already. That encounter *addresses us*—as able to hear and
respond. The encounter leads us back to that about us that had
been addressed. It leads us back to ourselves as to that about us
which is capable of being addressed by that which we encounter.
Because our disposition contains a mood, depressing or elating
us, we are addressed in that aspect. Thus feeling is incomprehen-
sible as mere datum. It is always a challenge to this aspect of ours,
a challenge in which the world announces itself. We are an exis-
tence which in its being relates to its own being. Thus being
addressed confronts us with this possibility—to come to ourselves,
or to forget ourselves. Impressions are for us, beings in the mode
of Dasein, always something that is not indifferent to this our
basic task of existing (of relating to ourselves). With this defini-
tion, according to which our sensibility belongs to existence, to
the context of movement, to the context of our being in the
world, we have made headway on the way to answering our initial
question: whether our being in the sense of Dasein, our pragmatic
understanding of things and ourselves, does not presuppose
something prior to itself.

What is *human* about the affect is this being placed before
ourselves as before an existence, as before being which contains
within it the task of carrying out its being—*vitam ducere,* the pos-
sibility of an authentic and an inauthentic mode of such being.
Let us ask, though: what if there exists, at the base of this our
possibility and precisely at this point where we confront this, our
fundamental possibility, a mode of being in which we are not yet
actualizing the mode of *the former* which sets us into this *dis-
crimen* of existence? Could we not imagine a mode in which the
discrimen is not yet brought about? Can there not be a projection
which does not invoke an understanding of being? Our human
past, emotionality, and affectivity are co-determined by being
existential, by being the past, the emotionality, the affectivity
of an existence. It remains an unresolved problem how we
could trace out, how we could ontologically delimit affectivity

and emotionality in something that is *merely* living, that lacks existence. We need to deal with it, though, because our human existence in a (working, pragmatic) world presupposes the existence of the childish and of the animal-like within us. The animal-like within us, to be sure, does not persist unchanged as some specific layer or as an autonomous element in our mode of being. The being of Dasein in the pragmatic world might have to be understood as a transformation of a different mode of being to which life in the form of Dasein itself internally points. We are in our mode of life, in the pragmatic world, always at a remove from a different mode of being, a remove from that which we understand (understanding is distance); we live in this distinctive interval with respect to worldly reality (we understand being other than ourselves). Our world is ever placing us into the alternation of the present and the absent. Of any reality that has a depth and a far side, only the front is ever given. Does not this distantiating mode of life, by being a duality of the given and the not given, of the present and the absent, of being and not-being, itself presuppose a level of life where that remove with respect to things does not yet obtain—where there is a different, distinctive mode of life, where what is in our case only one dimension is a whole distinctive mode of living, an entire relation to the world?

That leads us to the animal's and the child's prelinguistic mode of being, of relating to the world. This relation is not that of our understanding (of things and of ourselves in the course of existing), and even less is it a cognitive relation; that does not mean, though, that this relation is a mere automated mechanism. The animal and the child are wholly submerged in a relation of empathy, of fellow feeling with the world. This relation is an *internal,* not an external one, but it does not presuppose a relation to oneself, understanding oneself, an openness to possibilities, an unlocking of its own being. Here, being is not entrusted to such a being as a task, it is prescribed for it by the way it lives, in such a way that it is wholly preoccupied with the demands of the present. As a result (of its having no task), being has no meaning for it, being does not exist for it. The animal and the child thus cannot be said to exist—not in the sense in which an adult exists. They do not relate to their own and other being, they turn to other things not as being but as simply present. We must not imagine this presence analogously with the presence of our exis-

tence. What is missing here is what for us makes the present a present, the presence of further temporal dimensions. In this present, the whole situation is summarily enclosed, the creature belongs to it as a part. There is a double presence here—the presence of the universal situation, of the environment as present overall, and the presence of the creature in a situation. The overall perspective on the present also has an overall correlate: *a prospect* of sorts, which in a way already places this creature in a situation, concerning it in some way, being not a sheer spectacle but rather moving it, sustaining it in movement, in e-motion. Therein lies the primordial inner connection between *aisthēsis* and *kinēsis* (Aristotle). This feeling and perceiving are inseparable from the e-motion, the movement of the animal (which includes rest as well). It is not, though, a passively mechanical movement, but rather moving in response to stimuli, to motives. The movement is a *response* to a stimulus, the animal moves itself. That is its way of reacting to the way the world looks at it. The situation to which it reacts is one of constant attraction and repulsion. The creature's impressional affectivity is the root of its e-motion. Thus the animal mode of being is not one of comporting towards its own being, relating to its own being, nor, consequently, to the being of other things. Even though it has life itself as its goal—life returns to itself and rests in itself. That is Aristotle's *entelecheia,* being which has its own being as its goal, which is self-motivating. Because of its character of present immediacy, this life cannot be a life of symbols, it cannot have a language. Its present, to be sure, is structured, it contains tensions, aims—vectors. It is not a razor-back present. Yet this mode of purposing is different from the interweaving of the present and the absent, from our living in unexplicated, explicable horizons.

In human sensibility, life as an empathic harmony with the world is transcended, that is, it is preserved yet modified. Our sensibility is relative to our pilgrim state, ever on the way from somewhere to somewhere. Humans, too, move ever in the realm of attraction and repulsion. The world presses in on us with its physiognomy, it has an appearance, a unified expression in a varied plurality. Yet we are in this expressive field only at a distance, not yielding to it fully, not fusing with it. We overlook the primordial affectivity of the way reality regards us, we overlook it and set it aside in our practical handling of things. Yet yielding to this sensi-

bility is no less a definite possibility for us. Sensibility is not some-
thing changeless, it is a rich realm in which we can submerge
deeply or from which we can withdraw; we can live in it profoundly
or superficially. Humans endowed with sensibility can draw, out of
the stream of our affective sensibility, what others do not see, what
they overlook. In a certain sense human sensibility is richer than
that of the the animal; an animal exceeds us only in a specific
dimension, for instance in the keenness of its vision or of its hear-
ing, but it is humans who bring out the endless, the cosmic, in
sensibility precisely because sensibility is for them a world, an infin-
ity. An animal is wholly submerged in the world, it is wholly root-
ed in the cosmos.

Our sensibility is not an aggregate of data but rather an open-
ended physiognomy which has secondarily isolable components.
These components are not separated in lived experience, their
separation comes subsequently. (For instance, we see a kind face;
subsequently we single out details of forehead, eyebrows, etc.)
The affective impressional contact with the world comes before
the threshold of presentation of being. Here being is not posited,
either thematically or nonthematically. It is a region in which we
are being moved rather than moving of ourselves. This is the
region of emotionality proper. Here everything stops with what a
being already is and has been, what it carries along with it.
Emotional-instinctual acting is something that eludes itself, has
no control over itself, is essentially incomplete. What all belongs
here? To this level prior to language and prior to work, the level
of empathic harmony with the world, belongs our presence, as a
being that senses but does not exist because it does not under-
stand its being. This level, too, is marked by an indifference
between what we might call actual perception and imagination.
That plays a role in half-conscious states. It is here that our life
initially takes shape.

The phenomenon of empathic lived experience in the region
of the senses has been the object of analysis of numerous contem-
porary authors reacting against empiricism: Erwin Strauss,

94. See Strauss, *Vom Sinn der Sinne* (Berlin: Springer, 1930); Goldstein and
Rosenthal, *Zur Problem der Wirkung der Farben auf den Organismus. Schweizer Archiv für
Neurologie und Psychiatrie,* 1930. Merleau-Ponty refers to both of these works in
Phenomenology of Perception; see in particular chapter 1 of part 2, "Sense Experience." *Ed.*

Merleau-Ponty, Goldstein, Rosenthal, and others.[94] It is not carried through to the end. They agree on the continuity of human sensing/feeling and human comportment. For instance, qualities (such as optical ones—colors) as the correlates of a certain mode of comportment (such as a response to red which we encounter among animals as well). They not only bring about impressions but also evoke a reaction, a specific mode of comportment; that, conversely, opens space for certain affective qualities. Synesthesis is not just a pathology, it is a fundamental trait of sensibility which pathology only makes more conspicuous.[95] It is an overall integration into the physiognomy of the world. Merleau-Ponty says that as monocular seeing is a component of binocular vision, so a child's life is included in our living. The unity of the senses is the unity of a comporting body.[96] If we let a stimulus (for instance light) increase beyond subliminal intensity, there will first come a bodily response, only subsequently a cognitive reaction. Why and how does red mean effort and violence, green rest and peace? We need to learn to experience colors as concrete forms of rest and violence, as an animal lives them. So sleep comes when an intended stance reaches its objective confirmation. We lie down, relax, sleep is at first an intention, from intention it is transformed into being.

Already Herder was aware of the harmony of our body with its context.[97] That is the sympathic unity of a living being. That is what Hegel elaborated in his philosophy as the subjective spirit *(Enzyclopädia)*.

95. "Synesthesis" is actually a term for the harmony of different or opposing sense impulses; the pathology that Patočka is referring to is "synesthesia," where the patient experiences sensations that are different from what is being stimulated. Merleau-Ponty discusses synesthesia and the synesthesis inherent to perception on pp. 228–29 of *Phenomenology of Perception. Ed.*

96. Cf. *Phenomenology of Perception*, pp. 230–42. *Ed.*

97. "Man is a permanent *sensorium commune*, who is affected now from one quarter, now from another"—this quote is ascribed to Herder by Merleau-Ponty on p. 235 of the *Phenomenology of Perception. Ed.*

Seventeenth Lecture:
Care and the Three
Movements of Human Life

Our exposition of affectivity, of the possibility of sensation and affect, in the last lecture was intended to show that our life as lived includes a certain layer, to some extent isolable, which forms the basis for other layers and modes of our life. In humans, to be sure, this instinctual, simply given layer is not something that would escape being profoundly modified by the rest of our life, by its other layers. The instinctual and affective layer of our life is the locus of our most elementary capability as beings disposing of bodies, beings that move and sense. That, however, does not exhaust our life since that life transcends sensibility and unmediated action.

The framework of existence, as Heidegger elaborates it, its basic structure, is *care,* a *project* in a given *situation* which brings us into *contact* with things, a situation in which the things with which we deal and which we modify are revealed. Assuming this basic structure, the task of our interpretation is to understand it not as a trinity of undifferentiated moments but rather as a trinity of *movements* in which our life unfolds, which depend on and link up with each other in a distinctive though not a uniform way but rather so that the elementary, instinctive-affective movement at first dominates our life almost exclusively, then subsequently is modified by other movements, tinted and increasingly articulated by them. The language of movement is no mere metaphor here, it has a deeper significance. It springs from the most originary conception of movement without which we could not comprehend any special sense of that term, not even physical motion such as the falling of a stone. Precisely here do we encounter this most elementary conception of movement. We need to become aware

143

of the fundamental *corporeity* of our existence. Having a body at our disposal is at the same time the basis of life and an understanding of its most basic possibility. In our self-movement, we understand that we move a body and that its guidance depends on us. If we did not understand that, then all our higher mental life, all lived experiencing over and above that, would become impossible. So it is not just that movement belongs to existence, rather, existence is movement. What sort of movement? What conception of movement do we here take as fundamental?

In modern times (since Galileo and Descartes) movement has come to mean locomotion exclusively, conceived as a quantifiable pattern (free fall, uniform motion, and momentum, etc.). It is a movement which can be analyzed in certain parameters, in components like trajectory, time, velocity Such quantitative parameters can stand in relation to each other like the elements of a triangle; they can be derived from each other. We deal with movement as a geometrician deals with a static configuration. Movement is reduced to a structure, static in form, its intrinsic dynamism sifted out by the strainers of mathematical terminology. Besides, the basis of the modern conception of movement was not the idea of movement as transformation (something that is happening) but rather as a condition. The practical conception of movement, governed and governable, is the foundation of technology.

In addition, in modern times we encounter a different, subjective conception of movement in Bergson. For Bergson, the starting point is lived experience of movement, movement as it appears to me, as I live it when, for instance, I reach for a certain object. This movement has its starting point, its goal, its inner unity, rather like a melody. A melody is not composed of tones, like a mosaic; individual tones are synthesized in it in a definite way, in a sense they flow together, interpenetrating each other, preparing for and responding to each other. (Bergson does not speak of the intentionality of individual tones preparing a melodic line.) Here there is an inner synthetic unity which is grounded in the internal unity of our lived experience. That in turn is grounded in the former always being somehow present in each moment, not explicitly, not in details, but in the overall timbre. (What I see now depends on whether I am seeing it for the first time or whether it is an everyday sight.) The actually present lived

experience unfolds against the background of former lived experiences, of what remains alive of the former. The past flows into what is present. The former lingers on, there is an accumulation of what had been. That precisely gives every present a new, original cast. Each new moment is new because (nonexplicitly) it contains all former life. Bergson understands movement as a certain lived temporal structure. Going for a walk, drinking a glass of water, all that I understand as a unity, as a single movement; it does break up into component movements, but only as a melody breaks up into tones.[98]

Yet even this subjective conception of movement as the lived experience of movement will not do as a characterization of our existing. The reason is that it overemphasizes the aspect of the passive lingering of what had been, of cumulation (life is cumulation of experience; Bergson uses the metaphor of snowballing). We have a far more profound conception of movement in Aristotle's conception of movement as transformation, as possibility being realized. Heidegger says that our life is a realization of possibilities—of possibility which we do not visualize, in which we transcend what we are at the moment. Ours is a life in possibilities which are not indifferent, lifeless possibilities, rather, the possibilities in which we are involved, in which we transcend the present, are more than what is currently given. That is very much like Aristotle. For Aristotle, movement is the act of a being which has certain possibilities, if it has these possibilities. So a house being built. It is being built of bricks, mortar, beams. All these elements can be put together in a particular way. If they are arranged as the architect intended, we have before us no longer the possibility of a house but rather an actual house. There is a double reality here—the reality of the house and the reality of its realization, the becoming of the house. The movement is not a result, a sediment, but rather a process of realization. Stones, beams have the possibility of being assembled in a particular way; all those possibilities are there before us until the moment we have an actual house. Building is a movement which a person carries out with inanimate things, one which springs from a skilled craftsperson,

98. See Henri Bergson, *Matter and Memory*, trans. N. M. Paul and W. S. Palmer (New York: Zone, 1991), pp. 188–218. *Ed.*

independently of the things themselves.[99] The example of the
movement of a living being is much more profound, reaching
deeper into the nature of movement. Here, too, there is some-
thing like material, material elements, but those are always
already activated by a definite actually existing organism (for
instance, the organism of the parents functions much like the
artist in the construction of a house). Life unfolds in such a way
that materials, at first indifferent, ingress in the process typical of
a living being. Each of its movements realizes its life, everything
returns to it in turn, life itself is the goal of each individual move-
ment. That is the protomodel of movement. Here, too, there are
definite possibilities (a certain kind of seed will always yield a
definite kind of plant), life is the realization of such possibilities.
The unfolding movement of life is a march up to an apex which
simultaneously prepares processes that prepare the way back,
downward. Aristotle stresses a different aspect of movement than
Bergson, namely, that at which movement aims, the future.
Movement unfolds from something that is not yet, something
not yet given.[100]

And yet, Aristotle's conception of movement is still too static
and objective, for all its depth and strength (the being of that
being consists of movement, it is the being of movement; a being
constitutes itself, constantly constituting its being, not having it as
an attribute). Yes, movement takes place from the future, it is a
movement of a self-constituting being, yet at the same time it is
only one aspect of some being: that being persists through its
changes (a leaf turns, dries). Change, movement is possible only
because something persists through it. The movement of our exis-
tence cannot be understood that way, it is not like the turning,
fading of a leaf, the fall of a stone, a shifting of a thing from one
place to another. In those cases the thing, its unity, is the founda-
tion and the presupposition of the change which takes place in it,
of the transition from one state to another. To understand the
movement of human existence, for that we need to radicalize
Aristotle's conception of movement. The possibilities that ground
movement have no preexisting bearer, no necessary referent

99. Cf. Aristotle, *Physics* 200b1–202b30. *Ed.*
100. Cf., for example, Aristotle, *De Anima* 432a15–434a20; *De Motu Animalium*
700b–703b35. *Ed.*

standing statically at their foundation, but rather all synthesis, all inner interconnection of movement takes place within it alone. All inner unification is accomplished by the movement itself, not by some bearer, substrate, or corporeity, objectively understood. Corporeity is a part of the situation itself in which the movement takes place, it is not a substrate sustaining some determinations in which it finds itself one moment and not the next. A movement of this kind is also a *dynamis,* a possibility being realized, transiting into reality, but it is not a possibility belonging to something that already exists but rather of something that is not yet present and that can take the given into itself and forge it into a unified meaning. That again is reminiscent of the movement of a melody in which every component, tone, is a part of something that transcends it; in every component something is being prepared that will form the meaning and the nature of the composition, but it is not a movement of something that exists already at the start. While the composition is being performed, its overall meaning remains to some extent futural, still being formed. Just as a polyphonic composition is a movement of movements, so the movement of our existence unfolds in a series of relatively autonomous sequences which modify each other and affect each other. The corporeity of our existence does not mean that the body is the *hypokeimenon,* the constant foundation of changes taking place on it and in it. The primordial phenomenon of corporeity, living, lived corporeity, is not such a *hypokeimenon,* a material, objective substrate which passes unchanged through a range of contrasts, as, according to Aristotle, is the case with a change of color. Here the substrate is a surface (for instance a blackboard, black at first, then covered with white, receives new determination). Colors, determinations, constitute a scale, the transition from white to black. It is not possible for a tone to change into a color, a color into a smell. The surface is a *hypokeimenon* which takes on different determinations in the process of change. Our corporeity, however, does not function as a substrate; the body, which is the basis of lived life, does not have the character of an objective entity. It is a lived, existential corporeity.

If we are to explain the movement of our existence, its fundamental diversity of movements, we need to appeal to a triad of movements which presuppose and interpenetrate each other and whose basic relations need to be examined phenomenologically:

(i) the movement of sinking roots, of anchoring—an instinctive-affective movement of our existence;

(ii) the movement of self-sustenance, of self-projection—the movement of our coming to terms with the reality we handle, a movement carried out in the region of human work;

(iii) the movement of existence in the narrower sense of the word which typically seeks to bestow a global closure and meaning on the regions and rhythms of the first and second movement.

Our earlier analyses should help characterize the first movement. It is a movement of instinctive-affective harmony with the world and, on the other hand, of the original control over our own organism which is presupposed in all our further, freer modes of comportment, of relating to humans and things. This primordial movement is related to our primordial past—to that aspect of our existence which is our situation (that we are always already set into a world). Our corporeity, too, is rooted in this sphere.

This movement has the significance of a foundation in the sense that an instinctually affective life is possible (albeit in a rudimentary form) without the two further movements which build on it. Every dealing with things, instruments, *pragmata,* all practical comportment presupposes control over our body, a sense contact with things, an orientation in the world. However, in the case of humans, the instinctual-affective life is broken up in a distinctive way, it is not an animal-like life. In humans, all animal functions pass through a refraction due to the instinctually affective life very early taking place in a human-produced context, the product of human work and creativity, in the context of a tradition constituted by the second and the third movements. The confrontation of these movements, the shattering of the instinctual-affective sphere, constitutes the drama of a distinctive repression of this sphere. It is not as the result of a certain contingent social structure that this shattering comes about. Already the fact that our life, our existential movement, takes place in a polyphony of three voices, leads to a transformation of the instinctual-affective sphere. In spite of that, the instinctual-affective sphere totally and continuously co-determines life in all further spheres.

In all that is cosmic about our world, in all about it that is not simply a matter of working and utilitarian interaction, our world is determined precisely by this region. The affective movement does not submerge us into the world as into a purposive, practical milieu but rather as into an all-embracing context of landscapes which address us in a certain wholeness and a priori make it possible for humans to have a world, not only individual entities. It is in great part a function of this first movement that the world is not a mere correlate of labor but spreads out into the distance and into temporal depth, that it bears within it a central vital core, a core of vital warmth which is not only an addition to the being of what surrounds us but a condition of the being of our life.

Each of those three movements is always a movement *shared*. In the sphere of sinking roots, that *sharing* is manifest in our dependence on an other who provides us with safety, with warmth, it is manifest in attachment, protection, sympathy. That is at the same time a compensation for the bodily and spiritual individuation and dispersion among life's individual foci. The acceptance of the newborn into human warmth compensates for the separation of the body, for bodily individuation. Spiritual individuation, release into the world of adults, does not mean leaving the instinctual affective movement behind; it is only a reversal of one's situation, a repetition of that movement, though no longer as accepting but as giving.

Just as all movements, this instinctual-affective movement has its inevitable referent, that to which the movement relates. As moving beings, we are drawn to something that is motionless, that is eternally the unshakable ground—the earth. The earth is the referent of bodily movement as such, as that which is not in motion, which is firm. At the same time, we experience the earth as a power (not a force in the physical sense—that has its correlate and also receives effect, while here the countereffect is negligible), something that has no counterpart in our lived experience. It is a power also as the earth that feeds us, something that penetrates us globally. By our nature, by the structuring of our life, we are *earthlings*. The corporeity of what we strive for in our life testifies to the power of the earth in us.

The initial existing, the first movement (just as all the movements) has not only its temporal dimension but also its fundamental situation—a boundary situation of our existence

(Jaspers).[101] In case of the first movement, that situation is contingency. Life in this sphere is determined by all manner of contingencies, biological, situational, traditional (customs), individual (skills).

As all the movements, this movement, too, is shaped by its distinctive lack of self-understanding, by self-concealment, a kind of original inauthenticity. Here that primordial inauthenticity becomes manifest particularly in interaction with the second movement, that of extending and projecting our activity into the world, the movement of work whose basic categories are those of the purposive, the utilitarian, the pragmatic. In the instinctual-affective sphere, that intrinsic inauthenticity is brought about by repression, by the suppression of this sphere as we turn away from it, ignore it, marginalize it. In extreme cases, it is as if in our conscious life it just did not exist. Here there is a region of special phenomena which we can regain from life only in interpretation, phenomena for which simple self-reflection is inadequate because our perception itself is co-determined by the sphere of work within the everyday human community.

The second movement is one by which humans reproduce their vital process (humans reproduce their life through work, not instinctually-affectively). That is a movement without which human life is not physically possible. It, too, is a movement shared. In it, humans are not isolated, or perhaps even isolation is a relation of a kind, mutual taking note of each other. The movement of self-extension is not merely one of personal or community self-extension but rather one of constituting our inorganic body, extending our existing into things. This is the sphere in which we primarily live, it is the sphere of meaning. According to Heidegger, in this sphere of meaning our world is one of tools *(Zeuge)* which point to themselves and so to our possibilities of work and productivity. It is a movement in the dimension of the present. Its overall character is determined by coming to terms with what is given in the form of things, of what is present. This movement, too, has its boundary situations—conflict, suffering, guilt. Those three are closely linked with each other. Generally we

101. See Karl Jaspers, *Psychologie der Weltanschauungen* (Berlin: Springer, 1960), pp. 229–80; cf. Jaspers, *Philosophy*, vol. 2, pp. 177–83. *Ed.*

can say that even though at first sight it is not evident that world and life would not be possible without conflict, suffering, guilt, our actual situation as finite beings working together, setting out on work shared in a factual and contingent world, is such that we can always only lessen the situation of conflict, of suffering, of guilt—though only with the hope of amelioration, not of breaking free of this situation. This movement, too, has its distinctive mode of inauthenticity, a failure to understand oneself, blinding others and oneself linked to the situation of conflict, suffering, guilt—a blindness, necessarily imposed on others and ourselves, that would not see such things. The reason is that existence in this entire realm is an *interested* one. This is a realm of the average, of anonymity, of social roles in which people are not themselves, are not existence in the full sense (an existence which sees itself as existence), are reduced to their roles.

The third movement is the movement of existence in the true sense, the movement of self-achievement in the sense that all that in the previous movements remained beyond our field of vision, all we had sought to exclude and avoid seeing, is now to be integrated back in a distinctive way into our life. What existence seeks to integrate is what the previous movements neglected because they have no "time," no energy for it, because it does not belong to their function. The first two movements are movements of finite beings which self-realize fully within their finitude, wholly plunging into it and therein surrendering themselves to the rule of a power—of the Earth. The third movement is an attempt to break through our earthliness. Not by inventing illusions: rather, detachment from particulars brings us to a level on which we can integrate finitude, situatedness, earthliness, mortality precisely into existence; what before we did not see ("I forgot it like death itself!")[102] now becomes visible. Existence then in some way comes to terms with all that, integrated into a whole. The corresponding inauthenticity here is one of being blinded by finitude. The corresponding temporal dimension here is the future. Existence, in the sense of the third movement, is neither a matter of sinking roots in the world nor of the prolongation of being but rather a task for all of life in its integrity.

102. A Czech idiom. *Trans.*

Eighteenth Lecture:
The Three Movements
of Human Life (continued)

What we are attempting here is a philosophy of a distinctive kind, one which takes movement as its basic concept and principle. That is nothing new. Both in antiquity and in modern philosophy there are a number of philosophies that start out from the concept of movement. What is distinctive about our attempt is our interpretation of movement; we understand it independently of the dichotomy between subject and object. That dichotomy presupposes on the one hand an objective world, complete, self-enclosed—and on the other hand a subject, perceiving this world. We wish to show not only how the world itself can change, how it *is* change by its very nature (a mode of change—a development), but how within this (nonstatic) world there can arise comprehension, understanding, cognition, truth. How does that come about? Every philosophy assumes cognition and comprehension. If, though, it sets out from a ready-made dichotomy of subject and object, this fundamental problem appears to it already resolved, once and for all.

Earlier, we cited instances of understanding movement from a purely objective perspective and from a subjective psychological one (the lived experience of movement): modern mathematico-physical conception of movement and Bergson's conception, movement grasped from within as the experience of this movement. On the one side we saw movement disintegrate into an infinite variety of mathematical functions, on the other, reduced to the lived experience of the unity of movement rooted in immediate memory and retentionality (holding back, holding onto) of internal time.

In addition, there is Aristotle's ontological conception which, in its emphasis on *dynamis,* on the realization of potentialities, seems to reach out to a different dimension—a protentional, futural one. In Aristotle's conception of movement as a realization of possibilities, the same concept seems operative (*dynamis,* potency, possibility) as in the modern analysis of being human in the world which, by analyzing the human mode of being, seeks to reach once more that ontological philosophy whose classical instance and model for Western tradition is precisely Aristotle's teaching. Is there something in common here that we could take as a starting point for our conception?

A single common word, to be sure, does not yet mean that, deep down, the intention is the same. Aristotle's concept of possibility is not the same as that of those analysts of movement who assert that we understand life as possibilities in a process of realization, that we live in possibilities, in projection, not in states but in projecting an activity which goes beyond the given. Aristotle's concept of *dynamis* has a whole range of aspects that do not fit the conception of possibility used by the analysts of existence. Aristotelian *dynamis* is always perceived in relation to some substrate that makes change possible. Its presupposition for change is a persisting substrate, the precondition of change is *a changeless something.* In change, there must be something that lasts; something that has various possibilities which are realized and displace each other upon this substrate. By understanding movement in terms of the substrate's capacity for passing from determination to determination, Aristotle objectifies movement, making it into something that requires an objective bearer to make its dynamic aspect possible. Movement presupposes an unmoved object as the ontological foundation of unity for its unfolding.

In spite of that, Aristotle is our starting point and inspiration. Aristotle analyzes especially one specific form of movement, the movement of a living being, specifically, of an animal.[103] For Aristotle, life is a movement from start to finish. Movement renders possible the *physis* of that being which is the source of movement and of rest. The *physis* of an animate being is *psychē.* That is

103. I.e., in *De Motu Animalium.* See footnote 102, above. The movement of animals is also discussed in several passages in *De Anima,* most notably at 432a15–434a21. *Ed.*

not soul in the modern sense—the inward aspect of a being, in particular consciousness. For Aristotle, *psychē* is what sustains an animate being in a particular kind of movement—*psychē* is in that movement.[104] The vital movement of a plant is growth, fruition, degeneration. In an animal, there is, in addition, an oriented locomotion, oriented by the ability of *aisthēsis*—of smelling, sensing, being moved. The movement of a living being is continuous, made up of many individual movements, though, in all of them, a unitary meaning of that being's vital movement from birth to death is being acted out. All comportment, all functions together constitute the unitary line of a vital movement. Each individual task, function (hunting, digestion . . .) is meaningful with respect to life itself, to its continuation, to that from which all these movements stem. The movement as a whole is what is realized in individual movements, comportments. Aristotle recognizes a distinctive duality of life: the overall life line (from birth to death) and individual functions, comportments, movements.

Let us try to compare this Aristotelian conception of movement with the modern conception of existence. Let us try to understand existence as a movement, from the standpoint of movement. What will its meaning be, what shall we gain thereby for understanding the phenomenon of existence? And, in turn, what can existence contribute to understanding movement?

The key to the answer lies in the concept of lived corporeity. To understand existence as a movement means to integrate it concretely into the world, to understand it not only as a somewhat concretized subject but as a genuinely real process. This real process, however, will have neither the character of what we purely objectively observe, nor that of a substrate—which is what Aristotle's concept of *kinēsis* presupposes. Lived corporeity is precisely something living, a part of life, of the vital process, and so is itself a process, not only something at the base of the process of living but its condition in a sense wholly different from that of a *hypokeimenon* (a substrate making a change of determinations possible). To understand existence as movement means to grasp humans as beings in and of the world. They are beings that not only are in the world, as Heidegger tells us (in the sense of under-

104. Aristotle, *De Anima* 415b10–12. *Ed.*

standing the world), but rather are themselves a part of the world
process. This movement, precisely because it is something that is,
though in the mode of a movement of existing, is a being that
understands itself (understanding possibilities in realizing them);
it is a being that makes possible clarity, understanding, knowl-
edge, and truth. In Aristotle himself there is a remarkable hierar-
chy of beings which he simultaneously takes for a hierarchy of
their activities—hierarchical in the sense that each higher level *is*
more fully, "*be's*" more. This principle of the possibility of a hier-
archical ordering of being (expressed in activities, movements)
leads Aristotle to place something like comprehension, under-
standing, knowledge at the highest level. Not, that is, because he
would proclaim *aisthēsis* and *noēsis* to be a priori the highest val-
ues but because they represent the highest levels of being—most
positive, containing least that is negative.[105]

Thus the attempt we sketched last time is partially inspired by
Aristotelian philosophy, though distinctively understood. When
we spoke of the three basic movements in which existence
becomes actual, we had in mind precisely something like the over-
all vital lines which to Aristotle appear as the impetus of living
from birth to death. When philosophers of existence say that life
is an ongoing journey, aiming from somewhere to somewhere,
they have the same in mind. That then suggests we ought to trace
out that line, its meaning.

We have tried to distinguish three basic vital lines, three move-
ments of human existence linked to its temporal character. One
movement is by its very nature rooted in the primordial temporal
dimension of the past. We are always already somewhere, we are
in the world, integrated in an instinctual affective ground and
released by the Earth, singled out as individuals, yet still bound,
still determined by the natural ground, retrospectively taken into
it. We called this anchoring or rooting. We have shown how the
instinctive affective foundation of a human being permeates it
throughout. It contains both the empathic harmony with the
wholeness of nature and a response to the global physiognomy
with which the world turns to us: bonding to it and resisting it.
This bonding/resisting contains bodily movements as the basis of

105. Aristotle, *De Anima* 429a16–430a26. *Ed.*

our comportment, our original control over the body without which there could be no life, of which we are directly aware but which is not a mere conception of mastery. It is the a priori framework within which all our experience of our capabilities for movement unfolds. We have seen that this original movement of sinking roots has its definite overall line and rhythm, integral to the overall significance of the intrinsically affective movement. This significance continually renews itself in the experience and the satisfaction of needs. That presupposes safety, the warmth created by the human microcommunity—it is a movement shared. The instinctual affective bonding is the basis of safety, of vital warmth. In this world, in the mutuality of living beings, the ruling principle is that of pleasure, the world is oriented to it and fulfilled by it. The individuation of the individual is balanced by it; the world has this all-governing goal. This is the context in which humans discover their initial possibilities as sensing and moving beings, only within this, so to speak, external interior humans can develop—into a being capable of penetrating from this sphere to the outside. The movement of sinking roots is a movement from one sphere of vital warmth, which we receive, to another one, which we create. To this movement there belongs, not as a part but as its integrating core, a certain self-understanding, understanding of our fundamental possibilities, which first makes it possible to sense, to encounter things as being in the world and at the same time to intervene in that world by movement.

In this second movement of self-extension, of self-projection into things, of self-objectification and of humanization of the world, we are governed by that from which we have singled ourselves out—by the Earth (we do not say "Nature" since we are reserving that term for something broader), though no longer in the form of an immediate instinctual power. Here the immediate instinctual gratification is deferred, or, possibly, in some parts of that human community which constitutes this shared movement, it is reduced to one dimension and repressed. In spite of that, even here the instinctual determination of life's goal retains its validity in various forms, depending on how people are organized for this common task. The realm of self-extension, self-projection into things, is the realm of mediation (abolishing immediacy), of work. It is a world of means in which instinct is replaced by

interest, instinctual goals become conscious, habitual. This is where understanding begins, no longer simply as immediate, but as intelligent, the sphere of intelligence, of understanding both objective and personal relations and interests.

There is a special relation between these two movements. Even though both belong to the sphere of the rule of the Earth—from which we differentiated ourselves, which is our original world, the global context on which we depend—and, in that way, are linked, there is still an antagonism between them, a mutual suppression; they are not possible without each other, yet they mutually disrupt and suppress each other. For that reason, as soon as the movement of self-extension becomes dominant, the sphere of the instinctual affective movement is repressed and forgotten. That is a special mode of nonunderstanding, of being in untruth. The second movement, too, has its distinctive mode of incomprehension, one that has to do with the way we are involved. We note primarily what agrees with our interests and we overlook what goes against them. We automatically create the means of an inner rule of the Earth over ourselves and others.

Each of the two movements is linked to a particular boundary situation, to that in life which cannot be overlooked or mastered, but must be accepted as a fact of our being in the world. Instinctual affective life is linked to the realm of the contingent, of chance; we are born into definite conditions, into a definite tradition. In the movement of placing ourselves among things there is a link to situations of suffering, conflict, and guilt. In both cases we are dealing with an affinity for certain aspects, facts of being in the world which cannot be further analyzed and thought away from our existence.

For that very reason, each movement is also linked to a particular ideal of life. Instinctual affective life aims at an aesthetic ideal, it strives for a moment of happiness, of pleasure, of immediacy, it is the home ground of what we call happiness. Think back to Aristotle's analysis of *tychē*:[106] it is purposeful but its purpose is external. Say that while going shopping I meet someone I need to see. It is a lucky chance: while carrying out one purposive activity

106. At *Physics* 195b32–198a14. *Ed.*

I chanced to encounter something different that fits into my projective scheme. Lucky chance is indissolubly bound with the fundamental boundary situation of contingency in our life. It is a challenge of the contingent to the purposeful. The wish that the immediate might include as much as possible of what gratifies us and pleases us calls for bonding. The aspect of immediacy can be maximized with calculated sophistication—the pursuit of pleasure. There is no freedom in that since the goal, the orientation, is given by instinct. It is an extasis of our life which has already anticipated any free decision we might make, anchoring us in what is already given, already here in the structure of our life. Thus in this aesthetic realm there can be no continuity, no being true to oneself or to something other than this instinctual goal; nothing here is freely chosen, there is only a fascination with something to which a person had previously self-committed—or better, to which a person had been committed. The ideal of the second vital line is the ascetic ideal. Self-extension takes place in the context of self-denial, overcoming instinctual, immediate desire. Though ultimately it follows an instinctual goal, the means is self-control. Purging oneself of the immediate, of the instinctual, is what asceticism makes self-conscious.

The first vital line is a circular one, closing in on itself. The second line is a straight one, aiming ever further on. That aspect of the second movement, though, is only dominant while the movement of self-projection still involves something reflective, discovering oneself and one's possibilities. It is not a single line, it is a whole cluster of lines stemming from a definite center and running off excentrically in all directions, with each line splitting up further.

Opposed to these two Earth-bound movements, there is the authentically human movement, the movement of existence in which humans attempt to break the rule of the Earth. In the realm of the first and the second movement, life is not an autonomous whole, it is not a whole in itself. In the instinctual affective region, it is fragmented into individual moments of good luck and ill, of happiness and sorrow, on which life focuses as if it had no overall conception; life is a series of moments. In the second region a basic mediation, a lack of closure, prevents an overall conception. The third movement is an attempt at shaking the dominance of the Earth in us, shaking of what binds us in our

distinctiveness. We are individuals, separated out of the whole of nature, but at the same time nature permeates us internally, determining us through internally given needs which rule us and so keep us in separation, following previously set goals. Historically, the attempts to shake this fundamental situation have been diverse. It would be appropriate to work out a systematic historical presentation of them, but we shall restrict ourselves to only two examples of this attempt at shaking the rule of the earth in us, at arching over the first two movements in which the dominance of the Earth comes to the fore in an immediate and a mediate mode. It is always an attempt to integrate into our lives what in the two earlier movements basically cannot be taken into consideration, cannot be seen, what must be overlooked and forgotten. That is first and foremost one of our basic boundary situations—our finitude. Our finitude is contained in our life in virtue of our being bound to an instinctual goal. Here we do understand it (we know that failing to satisfy our needs means to perish) though in such a way that we are constantly overlooking it; our entire effort is to respond without having this situation ever before us; we are aware of it but do not look it in the face. Our condition is analogous to that of an animal—a finite being which cannot become aware of its finitude because it is too preoccupied with, too taken up by that finitude. The Earth preoccupies us too much, leading us to live within our individual preoccupations, so that ultimately we would not need to see our finitude, our life as a whole. Therein precisely consists the rule of the Earth over us. We do not conceive of the attempt at breaking free as a grasp at mastery, at seizing power, it is not a will to domination but an attempt to gain clarity concerning our situation, to accept the situation and, by that clarity, to transform it. Let us cite two examples of an attempt to reach to the very root of the domination of the Earth within us, one from the sphere of Buddhism, the other from that of Christianity.

In Buddhism, the basic idea is that the domination of the Earth within us is the domination of thirst. Thirst, need, the intentional character of life, filling some emptiness within life— that is the bond with which the Earth binds us to it. Thus extinguishing this aspect—extinguishing need, the intentional wellspring of our life, is the focus of this conceptual sphere. Here we have genuinely an attempt at breaking the bondage of life to

something that is external to it and yet dominates it internally. It is an immensely radical attempt at a breakthrough, reaching to the very root; however, understanding, life itself in its very nature as understanding, comprehending individual existence, perishes together with that breakthrough.

In the Christian conception, the intrinsic bondage is not that of thirst, suffering, toil, deprivation but rather of a vain separation, an orientation to oneself, enclosing oneself in a personal, private sphere, centering the world on oneself, on one's private personal I, inevitably unfulfilled and unfulfillable in its finitude. In attacking that, we do not abolish understanding: life remains unbroken, the world as world retains its validity. Only the self-enclosure of the individual I is overcome.

Only by starting out from these three fundamental lines, from understanding how they presuppose and negate each other mutually, can we, after analysis, achieve a certain insight into the way in which these three strands (two movements governed by the Earth, a third breaking free of it) make up the overarching human movement we call history.[107]

107. Cf. Patočka's own use of the three movements in interpreting the idea of "history" in his *Heretical Essays in the Philosophy of History,* trans. Erazim Kohák (La Salle, Ill.: Open Court, 1996), pp. 27–54. *Ed.*

Nineteenth Lecture:
Phenomenality, Being, and the Reduction

The three basic vital movements in their dialectic interrelation make up one movement, the unity of our vital reality. They are linked one to another, presuppose and negate each other; that is what is dialectical about their interrelation. When one becomes dominant, the others are there, albeit in the mode of absence.

The reality of our life, just as other realities, is a reality in relation to other beings, parts of the totality of what there is. Every reality, as a reality, is individual and *individuated,* it is fully determinate, that is, it includes no essentially indeterminate aspect. For that reason, too, the process which constitutes our reality, which we had sought to describe as a vital movement, is at the same time a process of our individuation. Our vital process, as a fully determinate, a fundamental vital structure, *Dasein in concreto,* is a present activity, here and now, at a specific time, in relation to other natural and historical (social) realities.

What are the specific traits of the individualized being that we are, in contrast with beings like animals, plants, stones? Those, too, are individuated, occupying a quite specific nitch in space and time, relating to other realities within the totality and determinate in that relation. Their determinations are always determinations *in a relation.* Every quality is actualized by relating to an objective correlate, to a definite other reality, manifesting itself with respect to other realities (for instance in specific gravity, in chemical properties). The being of every thing is fully individuated, that is, determinate in relation to any other reality. How is our individuality different from that? Our human relating?

A mineral is something fully individually determinate, not interchangeable with anything else, existing for a definite period in a definite place, coming into being, as by crystallization, and passing out of it, as in decomposition. On what grounds do we designate a particular mineral as an individual reality? To some extent its designation as a single individual reality is conventional. There are certain conditions: it has to constitute a unitary configuration, must be continuous in space and time, have a structure, etc. Yet it is *we* who take note of all these aspects. The reality itself is not aware of this individuation, this determination. In its being, it is wholly indifferent to its individuation.

Human beings, the processes they are, the processes that include their essential determination, the content of their being, are such that in this case we cannot speak of an indifference to being. In presenting Heidegger, we have on several occasions encountered this concept of a nonindifference to being, of caring about being. Now we need somehow to define this characteristic, to specify it. Heidegger defines existence as an existent which in its existing comports itself with respect to its being.[108] How are we to understand that? How are we to understand the claim that this being is not indifferent to its being and so to being as such? Not to be indifferent is something practical, pertaining to what we do. Here the assumption is that there are open to us various possibilities of being. We have demonstrated such various possibilities in the three movements of existence.

In the movements of placing ourselves in the world and of coming to terms with it we relate foremost explicitly to individual realities around us. In the third movement we relate explicitly also to the whole within which realities are located and accessible, where alone we can encounter them. In order to exist in a human way, we need to be encountering individual things. We are not things among others, indifferent to them and to their being but rather we *encounter* them, that is, we understand them, we are not indifferent to them as they are to us. Things appear to us precisely because we are full of interests; we encounter things in the context of our interests. Our individuation takes place in this context. The most profound care is the care for our own being, for

108. See Heidegger, *Being and Time*, §4, especially p. 32. *Ed.*

the mode of this being. In it we relate either to particulars or to the whole which makes encountering particulars possible.

We have spoken of the concept of the horizon in our experience. Individual phases of our experience of a thing are not isolated, they are always in a context. (For instance, the experience of a piece of chalk, of manipulating it, fits the context of my vocation: the chalk is in its place, prepared for my handling it, that means that what confronts me is not the impression of a particular only, the chalk is what it is only within this classroom, in this context of other particulars which point to it, confirming the experience, confirming what it really is.) Every particular becomes meaningful only in a context which first defines the thing, determines it, makes it possible to verify what each thing is; in reality it is a context of references which go beyond the immediate present (a classroom is a classroom in a further spatial context—there is the building, the street, the city, etc.). We might ask what all is needed to define the present object, its meaning, in order to consider this reality as this and no other. That is hard to answer precisely. It is not only the spatial context of an environment. It is, however, certain that before any particular there is a prior whole which determines this reality in its meaning. Even though we might not be able to analyze the structure of this antecedent whole, set it clearly before us, it is present in the functioning references, in the phases of dealing with things. It leads us from moment to moment, it allows us to deal with the same, to have before us an objectival meaning constant in diverse operations. Our individual experience always presupposes a context preceding it. Not just experience of the particular but of all realities presupposes the continuity of all such contexts. Every reality that manifests itself bears with it a range of possibilities of its appearing, of its phenomenalization.

Husserl elaborated this idea in his theory of phenomenological analysis. He believed that we can reach the original kernel of this phenomenalization by phenomenological reduction. We have seen, however, that Husserl's phenomenological reduction, cast as an absolute reflection, will not do as a viable philosophical idea for placing philosophy on a solidly experiential rather than a speculative footing. Husserl lacks a *theory of reflection* itself. We need to conceive of reflection as a vital act, placing it in the context of an existence on the way to itself, seeking itself, understanding itself,

that is, understanding its possibilities. If that is how we approach being human, if we cancel out the concept of reduction as an access to absolute existent or Being—does the principle of phenomenalization and the antecedent range of contexts needed to exhibit a particular object fall away with it?

This much is certain, that in the conception of this context we have before us a real phenomenon, something that is neither the reality of a human being (of our lived experiences on the one hand, of the physical foundation of our situation—body—on the other), nor the reality of the thing that appears before us on this range, always individuated. Here that which is the presupposition of the presence of the particular is not itself a particular reality. What we have in the phenomenon of the context and of the whole of all contexts is no special existent but rather the *being of* what is manifest. Here there is a clear difference between an existent located at a specific place, individuated in time and space, and this context which functions uniformly for any thing of a particular type, in general and apart from individuation. Certainly, there is here a relation to this antecedent context, to the totality of all things. All of our individual experiences, all things appearing before us are in some sense emplaced within the context of a single reality. (For Kant, space and time are a single form, something singular and unified, and all realities are placed within such a singular, internally coherent framework.) This framework is anticipated as a whole. It is just that in this anticipation it is not given as a reality, it does not appear, it is not itself a phenomenon: it is what phenomenalizes. That within which things manifest themselves is not itself another thing, another reality. If we say of that antecedent matrix that it "is," then only with a grain of salt. If what is ready to hand and present at hand is to manifest itself for what it is, it must manifest itself to humans, there must be present a human reality which understands its possibilities. Yet the world, the context of understanding that makes it possible for all things to appear to us in the context of our practice, is neither my reality nor an objective one, but rather an interval, a space of being. This "in between"—being and the world, the light in which things appear,[109] cannot be understood in terms of things themselves.

109. Another Czech pun: world=*svět*, *svět*lo=light. *Trans.*

For, on the contrary, these presuppose the world for their appearing. For their appearing, not for their being. We cannot explain being in terms of existents. To explain being in terms of existents, that inevitably means interpreting being somehow falsely, depriving it of its character of an antecedent condition, integrating it into the world of individuation. Existents—beings—are what they are in the light of being.

For that reason, Heidegger does not claim that the world, that being, is a subjective horizon, something that belongs to *our* reality. That again is a reflection of subjectivistic metaphysics, of the conception according to which the world is to be explained in terms of one level of existents, that of the subject of cognition which represents a privileged type of objectivity, an object par excellence, self-presenting itself in the original. Still, we have seen how Husserl's phenomenology contributed to this conception of being as distinct from existents precisely with the concept of a phenomenalization which follows its own rules, which *nulla re indiget ad existendum.*[110] A reduction which uncovers the region of appearing as a region *sui generis* does to some extent open up an understanding of being. Heidegger annulled the reduction as a reduction, that is, as a transformation into the reality of the subjective region. Heidegger seeks to invert it: that being manifests itself, that there is being as an event, is at the same time the birth of human reality. The opening up of the region of appearing, the illumination of the world, the temporalization of time, this inexplicable yet all-explaining event of being is contemporaneous with the birth of humans. That leads to an answer to the original question of how human being differs from the being of an objective entity. In the case of humans, their own individuation, their time, the process which is their own emplacement in world time and space, always takes place *in relation to being,* not only in relation to existents. Yet if that is so, then the primordial, natural world, the world which is not constructed by our minds, by our explicit cognitive activity, the world as it is given, as it addresses us, is such an encounter between mute entities, enclosed in themselves, "not caring" about their being, nor being as such, nor humans who live in a relation to their being and to being as such and perhaps

110. "Needs no being to exist." See Husserl, *Ideas I*, p. 110. *Ed.*

also to a vaguely sensed existent which transcends all finite existents. All this comes together in the primordial event of being. Its character as event becomes evident when the uncovering of existents is at the same time a concealing of the context of existing as a whole. Reality is never revealed to us as a whole. In understanding the whole we encounter particulars but the understanding of the whole, of being, conceals itself in understanding particulars. Those are always unveiled only from a particular perspective, it is an understanding always for one particular aspect only, in a specific perspective, in a specific situation. Concealment always goes hand in hand with unconcealment. Existents as a whole and the being which unveils beings and conceals itself is in its essence a mystery.

This is a conception more congenial to another thinker, Eugen Fink, who takes the autonomization of being even further than Heidegger.[111] Is there not, in Heidegger's conception, still too much that is anthropological? An excessive emphasis on what is close to humanity? Is not the event of being understood too much from the perspective of human phenomena: unveiling, concealing, meaning, the phenomenon of speech? Is there not, in the conception of the world as an aggregate of potentialities which we can interpret, read, still too great a tendency to ignore the original closure of what is into itself, the primordial dark night of existents more primordial than all individuation? An individual brute existent (a hunk of lava on the moon) is determinate in its relation to other existents. Those, too, are individuated. All existents are within a *universal being.* Can we conceive of that being as an aggregate of particulars? Or does it precede all particulars in the world as something that makes them possible as individual and singular? Is it not an antecedent whole even in a purely objective sense? All our explanations lead us to see the whole from the perspective of the particular. Is, though, the universal spacetime a sum of its individual parts? Or is it a phenomenon *sui generis,* by its very nature an antecedent whole which provides the place for each individual thing? A whole incommensurate with particularities? Something that is wholly in each particular though we

111. For example, see Eugen Fink, *Grundphänomene des menschlichen Daseins,* ed. Egon Schütz and Franz-Anton Schwarz (Freiburg: Verlag Karl Alber, 1987), especially pp. 47–114. *Ed.*

cannot grasp it in itself, in its own nature, except from the perspective of realities contained in it? Do we not have here before us something analogous to the phenomenon of the appearing of entities within the whole of a preliminary understanding of being? Is not the antecedent whole of all that is, an essential presupposition of mute entities as well as of entities such as we, who relate to being? Here, in the universal "content" (containing all else) is the condition of the possibility of (i) the individualization of things and (ii) the appearing of existents in the light of being. It is a condition for the appearance of an existent that it be somewhere, at some time, always within some understanding of time and space. Is there not then within us some understanding—unclear, anticipatory, unobjectifiable—of this antecedent whole? Might we not thus receive into an ontological context that which creates the light for appearing—the whole of all that is, the world in the strong sense of the word? Would we not that way rehabilitate the ancient idea of *physis* as *archē*? The primordial, antecedent whole of which the earliest preserved philosophical fragment says "Whereof all individual existents take their rise, therein also the perishing of all must be"?[112] *Physis* as *archē* which rules in all particulars. Our understanding of reality is always in the light of individuation, in the light of existents already individuated. For that very reason, the problem of the origin of individuation is always already passed over methodologically. For that reason, too, Fink speaks of two modes of appearing—in ancient and in modern philosophy. The appearing of being, being as the condition of the possibility of appearing, is something each philosophy thematizes from a different aspect. Ancient philosophy presents appearing as a real process of individuation in the world. Things appear—that is, emerge and perish—within the whole of *physis*.[113]

We, too, belong to that whole, though in a different mode than other things. We, too, are individuated reality, belonging to a particular place in spacetime, but in such a way that we at the same time understand this localization of ourselves and of things, that is, we explicitly relate to the whole and we understand

112. The reference is to the fragment of Anaximander in Simplicius, *in Phys.* 24, 13 (DK 12A9). *Ed.*

113. E.g., see the first part of Eugen Fink's *Grundfragen der antiken Philosophie,* ed. Franz-Anton Schwarz (Würzburg: Königshausen und Neumann, 1985).

particulars through this relatedness. That is what it means when we say that existence can be understood as a movement. It means that humans by their living single themselves out of the whole in an explicit relation to it and that their most intrinsically human possibility—that of existing in a human way—lies in their understanding this specific trait, that humans are capable of encountering being as things are not. The openness for being, understanding being and, on the basis of that, the possibility of encountering things, with existents as existents. Humans, the universal beings and the beings of the *universum*, are *called* to things, to give them what they lack, to make that encounter possible. There is nothing distinctive about the human ability to seize power over individual existents for a moment, to accumulate power and might; that is only a quantitative difference as against other realities. What humans alone can do is that encounter, that calling to those things which cannot be without humans. In a manner of speaking, humans are *pragmata*, services; human life is a service in a sense different from that in which things serve us. Thinghood means *letting* things *be*, letting them come to themselves, to their being which is external to them and yet is theirs.

Twentieth Lecture:
Personal Spatiality, Husserl, Heidegger

Let us now briefly, schematically glance over the journey we have traveled. We set out from the observation that something like a personal region, personal relations and traits, is something philosophically recent, appearing explicitly only in modern philosophy, though here it comes to appear so fundamental, that, as philosophically relevant, it becomes the center of reflections, what is essential, belonging to the nature of what is simply because it is. Aristotle's philosophy is a philosophy in the third person, that is, though the personal is not wholly absent, is not thematized, it remains concealed. The third person belongs in principle together with the first and second person, that is, a philosophy starting out with the world in the third person is not apersonal at all. For instance: Aristotle describes the world as a living being in the third person, attributing to it traits of our orientation in the world: up-down, right-left, near-far, personal relations. Antiquity obscures the personal dimension inasmuch as the expressions so central to modern philosophy, starting with Descartes and culminating in German classical philosophy, terms like "I," do not appear in ancient philosophy at all. For Plato and Aristotle, a philosopher's interest revolves around the existent in its existing, but it never occurs to them—not even when they arrive at the nature of existence in its most intense form, as spirit—that the *nous* could refer to itself as I. This pure reality, this pure actuality which contains not even a trace of potentiality, of something that has not been realized, something that would not be an act in the strong sense, Aristotle never even thinks of characterizing by expressions taken from the human situation, such as "I."

The word situation has to do with *situs,* emplacement. A situation is the mode of our emplacement among things. At the start we showed, in a historical perspective, how Descartes discovered the personal. That appeared within philosophical reach already in Christian philosophy, in Augustine. There, though, it was distinctively linked to the tradition of antiquity so that the entire thrust of this link led not to a philosophical grounding of our knowledge of ourselves and of the world but rather into a morally and soteriologically theological realm. Philosophically speaking—it was Descartes who first made the concept of the personal the basis of philosophy. We did not go into the way he did so, focusing only on one aspect, precarious for him—our situatedness in the world. A philosophy founded on *ego cogito cogitatum,* on self-knowing consciousness, comes to grief on the question of my situatedness in the world. The personal beginning proved not to be radical enough. Descartes attempted to go directly from the personal starting point to the third person and so generated an apersonal philosophy which surpasses the apersonality of antiquity—a philosophy of an impersonal *res extensa,* of mathematical nature. It is a nature into which humans are integrated in a purely objective manner. There is no room here for situational concepts or for situatedness generally. Our lived experience, as we live it and as we grasp it in reflection, is subjected to a new interpretation from this impersonal perspective. Descartes's start from the I, from something fundamentally personal, remains stillborn.

We need to delve beneath this layer of the impersonal and bring out the originary personal experience. The experience of the way we live situationally, the way we are as personal beings in space. We cannot rest content with the trivial conception which sees our body in a dualistic perspective—contained in the *res extensa* as a thing among things and objective processes, with which subjective processes are coordinated as their reflection. Even those need to be objectified in turn, transformed into impersonal entities which we can impersonally coordinate with them. Impersonal nature, impersonal subjective processes, impersonal coordination—what has become of that original element from which we started, where is the original grasp and analysis of the foundation on which this kind of philosophy is conceivable?

So we asked how it is that we are in space. Are we in it as a thing among things? Is such a conception thinkable? We sought

to show that just the opposite is the case, that knowledge of things that are solely next to each other, in purely objective relations, is possible only if there is a being that is in space differently, not just one of the things, indifferently next to them in space, but is rather in space by *existing* in it, that is, by relating to itself, to its life, through relating to things. That means, a being who can act out its life, comport itself with respect to its life in various ways simply in relating to other things and so finding a place in the world of things. We are not indifferent neighbors of things. Our relations are not external, indifferent. Our nonindifference to our own being, that it matters to us, that we are not indifferent to our being—all that is expressed in the typically human expression, *for the sake of*: we do something *for the sake of* something. Therein lies the nonindifference of our mode of being. That *for the sake of* entails being integrated into the world. *For the sake of* signifies the means to a particular end, means provided for the most part by the things around us. There is a continuity between what is projected *for the sake of* and such means. That means that our being among things is not a mere indifferent being next to, a juxtaposition of things in space.

We then sought to characterize this being from various aspects as an oriented being, aiming at things, ordered to acting among things, acting and in that action *co*-acting with others, oriented not just to things but also to the world of other persons. Our original drive toward things turns back on itself as a relation to others in which we first see ourselves. That is the natural reflective tendency of our drive into things. Given the typical way humans place themselves among things, this emplacement is a part of the structure of their being in the world, external, a mere next to, indifferent to their being; being in space among things is a part of our nonindifference to things and to ourselves.

We asked further about the essential reach of our reflections. Our goal was to reach such a level of description, of grasping of the originary phenomenon, that we would reject all objectifying models of human life, preceding the personal, human integration in a world. That led us to reflect on two phenomenologies, two conceptions of phenomenology. Phenomenological thought which either builds no constructs or does it only as last resort, sticking to what appears, what presents itself of itself. However, such a conception of appearing, of self-presentation, is nothing

obvious. It is not enough to open our eyes and to accept whatever presents itself: the crux of phenomenology lies precisely here, in the quest for a way to that originality.

We have compared Husserl's and Heidegger's conception. In Husserl's conception we sought to show modern Cartesianism in its most extreme and most sophisticated form. Its personal starting point is in the *ego cogito* and it seeks to remain in the personal, that is, in what Husserl calls transcendental intersubjectivity as the ultimate ground to which the phenomenological reduction leads, an intersubjectivity for which the world is the basis of communication. The personal world is not a set of islands amid an impersonal nature, rather, impersonal nature becomes a mere objective pole of unified intentionalities of harmoniously living monads that make contact through this objectivity. The access to it is reflection, self-grasping in pure originality and self-certainty.

Still, this conception is problematic. On the one hand, it is immensely attractive in the perspectives it opens on the subjective streams of lived experience beyond life's banalities, the possibilities of insight, of analysis and depth. There are, however, problems beyond that attractiveness. There is, for instance, the question of the absolute reflection which once more transforms our personal, that is, finite lived experience into an absolute object which is there only for observation, an absolute one, to be sure, grasping in absolute completeness, adequacy, originality but objectifying nonetheless. Reflection transforms a living and lived life into a contemplating and contemplated one.

Husserl avoided many shortcomings of Cartesianism, for instance the ludicrous dualism which makes it impossible to find a substantive relation between *res extensa* and *res cogitans* and does not make it possible to explain that we have a body, the phenomenon of corporeity and our situatedness in the world through corporeity. Why, though, do not these flaws show up in Husserl? Because Husserl's conception is not a dualism but an idealism of transcendental intersubjectivity. An object, nature, is the unitary pole of unitary intentionalities, something sustained as the unitary object of our intentions, but without that living reality which belongs only to a living subject. Thus we can say that Husserl's phenomenology did overcome Cartesian dualism in a sense, though it is not clear that it was not in a direction which

continues to preserve a certain kernel of Cartesianism, a certain Cartesian impersonality.

To be sure, Husserl himself emphasized and sensitively analyzed the phenomenon of the subjective body. Yet in his work the meaning of the corporeal subject is never clearly brought into continuity with absolute reflection. Willy-nilly, we must ask why, ultimately, subjectivity is always an embodied subjectivity. In a sense, the way Husserl sees it is that the embodiment of subjectivity, the subject's corporeity, is a necessary condition of our living together, not in isolation, but as beings in mutual contact. Yet that assumes that the proper significance of our subjectivity, the inmost core of our I, of the personal, is really not what is personal but what we note after the reduction, namely what is given in absolute reflection as a stream of experience. The ultimate foundation is not personal, rather, it is subject*ivity:* something that may constitute both our persons and other things in the world in its acts but that is not itself a person in the world in all its fundamental nature.

What is the ultimate ground of absolute reflection? It stands on itself. There is no further theory, no deeper explanation, no further reason or basis. Absolute reflection is the foundation of all philosophy, there is no theory about it. It is the ground to which all else needs to be reduced. Here it seemed to us that such a theory sunders the Gordian knot of reflection instead of untying it. Is there, need there not be found, a theory of reflection which, without rendering impossible the achievement of truth, of the clarity, of all that Husserl's transcendental phenomenology provided, would yet remain a theory of *finite* reflection, continuous with the finitude of human life?

Here a second conception of phenomenology comes into play, Heidegger's, starting out from existence, from overtly personal being, that is, from one which is not indifferent to its own being, and, since not to its own, neither to being generally. At the basis of Husserl's theory, we could again sense an impersonal foundation, an existent which merely notes itself, which is given to itself purely for observation. There is, though, an alienation in observation, a distance, a mere juxtaposition. In Heidegger, there is a conception of an existent living in its own possibilities and relating to them. We have shown, arising from that, a conception of

the world as a context of references in which our world-dwelling life lives its *for the sake of,* which it itself projects and gives to itself. A world not as an aggregate of entities but as a context belonging to our own intrinsic structure, to the structure of our being.

We have shown that Heidegger was able to stress very sharply the finitude within the basic structure of our living, the finitude of reflection flowing from our original preoccupation with things and with ourselves and from the need to react against it. Reflection is grounded in the innermost finitude of being human and in its relation to truth. Those, ultimately, are the reasons for reflection. What Husserl cleaves with the stroke of a sword, Heidegger only probes with inquiries. The need for truth, the possibility of truth are, for Husserl, rooted in our ability to grasp ourselves in the original in absolute reflection: we have ourselves in the power of absolute vision and, in that sense, we are absolute. Whoever would inquire further will get only one answer: that is how it is and no other—*cogito ergo sum.* That *cogito,* however, holds all the problems within it. Even the *sum* is problematic, it is the *sum* of a finite being. How can a finite being arrive at an absolute truth? In this respect, Heidegger is more human, though at the same time also more objective in seeing an essential fallibility about being human, the entanglement of a truthful being in untruth, in concealment, in deception, in secretiveness, in self-blindness, in deceiving oneself and others. For the *universum* of humans and for its interpretation, Heidegger's philosophical conception offers greater possibilities than the absolute which Husserl finds. Heidegger's inquiry is more profound, it is an inquiry into the ground of existence.

There is one point, though, where we sensed a need to be more honest and specific than Heidegger. That was the phenomenon of our emplacement within things by our corporeity (such emplacement would make no sense for a purely spiritual being). Heidegger does not deny corporeity, he does not deny that we are also objectively among objects, but he does not analyze it further, does not recognize it as the foundation of our life which it is. Following Merleau-Ponty's analysis, we showed that the ongoing self-integration into the world, which makes us spatial and in space, takes place by means of our subjective corporeity which is horizonal, manifesting itself as corporeity in the strongest sense of the word. In this sense we agree with the materialists, or would, if

materialists were at all able to approach the phenomenon of the subjective body, the existing body which is the precondition of all experience of thing, of material nature.

On the basis of this criticism we demonstrated the possibility of interpreting existence as a triple movement. That we did using both an ancient and a modern idea. The modern idea was Heidegger's, that life is a life in possibilities characterized by a relation to our own being; we project that for the sake of which we are, that *for the sake of* is the possibility of our life; in the world a totality of possibilities is always open to us. The ancient idea—Aristotle's definition of movement as a possibility in the process of realization, not motion in Galileo's sense. For Aristotle, to be sure, movement is always the movement of a substance. Only conditionally could generation and perishing be understood, in Aristotle, as qualitative movement. An analysis of these three movements distinguished: (a) the movement of sinking roots, of anchoring in things, by which humans are beings for others, (b) the movement of self-prolongation, of self-reflection, in which humans live to need and be needed—in a world no longer fused by kin but in the harsh turmoil of the reality of labor and conflict, no longer shielded by the community of kin, (c) a movement in which humans do not relate to things in the world by means of the world but rather to the world as such.

This led us to ask for a conception of the world in a sense more radical than that of Heidegger for whom the world is a world of ready-to-hand pragmata present in the context of practical significations. We asked for a conception of a world which is on the one hand what enables us to encounter particulars and, on the other hand, to live in truth. Humans are the only beings which, because they are not indifferent to themselves and to their being, can live in truth, can choose between life in the anxiety of its roles and needs and life in a relation to the world, not to existing entities only. This nonindifferent being (nonindifferent toward things as well as toward being in general) precisely here, in this region of explicit relating to what there is not as mere individual existent or as a sum of such, has its own domain, here it is irreplaceable, here it is at home with itself. Here is also what constitutes the special mystery, adding the depth and perspective which life lacks in contact with particulars, what slips through our fingers like the fool's gold in fairy tales wherever life itself

dissolves into individual contacts. In contrasting Husserl's central conception of the non-*reell* correlate of our lived experience with Heidegger's conception of being which is no thing, we sought to exhibit that relation of humans to something that enables them to transcend all particulars and all sums of particulars while remaining with being, while being within it.

Here phenomenology touched upon something that all modern humanism neglected, what that humanism lacks. Modern humanism thrives on the idea that humans are in some sense the heirs of the absolute, an absolute conceived along the lines of Christianity (from which our humanism grew), that they have a license to subjugate all reality, to appropriate it and to exploit it with no obligation to give anything in return, constraining and disciplining ourselves. Here phenomenology touched upon the fundamental problem of humanism, that humans become truly human only in this nonindifference to being, when being presents itself to them and presents itself as something that is not real and so also is not human, something that challenges them and makes them human.

We arrived at the conclusion that the world in the sense of the antecedent totality which makes comprehending existents possible can be understood in two ways: (a) as that which makes truth possible for us and (b) as that which makes it possible for individual things within the *universum,* and the *universum* as a sum of things, to be. Here again the phenomenon of human corporeity might be pivotal since our elevation out of the world, our individuation within the world, is an individuation of our subjective corporeity; we are individuals in carrying out the movements of our living, our corporeal movements. Individuation—that means movements in a world which is not a mere sum of individuals, a world that has a nonindividual aspect, which is prior to the individual. As Kant glimpsed it in his conception of space and time as forms which need to be understood first if it is to become evident that there are particulars which belong to a unified reality. It is as corporeal that we are individual. In their corporeity, humans stand at the boundary between being, indifferent to itself and to all else, and existence in the sense of a pure relation to the totality of all there is. On the basis of their corporeity humans are not only the beings of distance but also the beings of proximity, rooted beings, not only innerwordly beings but also beings in the world.

Translator's Postscript: The Story of an Author and a Text

Each of Jan Patočka's works presents the translator with problems all its own. This, arguably Patočka's finest contribution to contemporary philosophy, is no exception. *Body, Community, Language, World* is a gem of insight and erudition, summing up in bold yet surgically precise strokes the achievements and problems of continental philosophy at mid-century with both scope and depth. Had I to choose a single work to introduce my erstwhile American colleagues to this arcane world, I should first proclaim the task impossible, then select the present volume.

Still, the book has problems. One of them is that Patočka never actually wrote it. The text we have is not even *scripta*, a lecturer's own notes reproduced for students' convenience. It is, rather, *reportata*, a compilation of students' notes from lectures Jan Patočka gave at the Philosophical Faculty of Prague's Charles University in the academic year 1968–69.

Those were the first lectures he could give since 1949. During the war, the universities had been closed. Though he habilitated in 1937, Patočka was able to lecture only during the three-year respite between the war and the Communist coup. At the time, he started from the beginning, giving courses on the pre-Socratics, Socrates, Plato, and Aristotle. Then came the coup. The new Communist regime soon barred him from teaching. Only during the short-lived liberalization in 1968 was Patočka able to return to the university. The lectures he gave in 1968–69 were rich with the scholarship and reflection of years of enforced silence.

179

Those lectures were also eagerly awaited. Over the years, many students—including those who, like Patočka, had been barred from the university—got to know him through informal contact, in part thanks to the private seminars he held in his apartment, in part from his privately circulated writings. A group of them, consisting of Jiří Polívka, Jaromír Kučera, Jiří Michálek, Ivan Chvatík, Miloslava Volková, Josef Vinař, and Marika Krištofová, took it upon themselves to keep a faithful record of the lectures. None of them knew shorthand, none had a tape recorder compact enough to take to the lecture hall. Instead, they took notes, as students had for generations before Gutenberg, then met to reconstruct the text. Jiří Polívka undertook the compilation of the final version and dictated the results to Miroslav Petříček, who produced a typescript for private circulation. This was the text which, in 1983, still deep in the Communist era, Ivan Chvatík included in the fourth volume of a typescript compilation of Patočkiana known as *Archival Collection of the Works of Jan Patočka*—or, at the Patočka archive at the Institute for Human Sciences in Vienna, as *Prager Abschrift*. It would remain the sole source of Patočka's writings abroad until the fall of the Communist regime in 1989.

It was one of those carbon copies, none too legible, that came into my hands at the institute in 1985. By then, the director of the institute, Krzysztof Michalski, and the head of the institute's Patočka Archive, Klaus Nellen, had managed to assemble an impressive collection of typescript copies of Patočka's works as well as texts Patočka had been able to publish here and there during various periods of liberalization. I had come to Vienna specifically in search of such texts. Eight years earlier, when Jan Patočka died after extended police interrogation, I swore his death would not pass in silence, unnoted by the wider philosophical community. I promised myself then that I would make his work available in English. The result of that oath was a philosophical biography, *Jan Patočka: Philosophy and Selected Writings,* published in 1989; some articles; and numerous typescript translations which I circulated privately among my students at Boston University and deposited in my files.

There they might well have remained when I returned to a new life in Czechoslovakia, soon to become the Czech Republic and the Slovak Republic. There is so much to be done, rebuilding

our ravaged country. Writing in Czech seemed much more urgent than translating into English. When Open Court approached me about an English edition of some of Patočka's major works, I hesitated. The task loomed large and the world of English speakers far away. Fortunately, James Dodd, former student and cherished colleague, agreed to transcribe my translations by computer and provide them with necessary footnotes, leaving me free to prepare an English text. That that text is now appearing in English is due in great part to his scholarship, diligence, and devotion.

Since I first translated the *Body* volume (my favorite) from the *Prager Abschrift* version, two other versions have become available. One is the German translation prepared by the Institute for Human Sciences in Vienna as a part of its comprehensive edition, *Jan Patočka: Ausgewählte Schriften* (Stuttgart, 1991), based on the same typescript I used for my translation. The second is a Czech edition, *Jan Patočka: Tělo, společenství, jazyk, svět* (Prague, 1995), reviewed and revised by two of the original editors, Jiří Polívka and Ivan Chvatík, with the help of Pavel Kouba, all students of Jan Patočka and now my colleagues at Charles University. When in doubt, I have treated their readings as authoritative.

Even their text at times bears the marks of its origin as classroom notes. The lectures bore no titles: Dr. Josef Moural of the Center for Theoretical Studies and Philosophical Faculty of Charles University suggested those, as well as the chapter summaries. Other than that, I refrained from interfering. Patočka has a distinctive philosophical style, powerful, erudite, and suited to his thought. I have sought to produce a faithful rendering of both the thought and the style, even at the cost of having to live with occasional telegraphic compression and incomplete sentences.

Since Patočka's thought is heavily marked by Heidegger's, I have generally followed the conventions established by Heidegger's translators except where Patočka's interpretative translation into Czech calls for a different term. Thus I have left *Dasein* in German but have opted for *disposition* rather than "mood" for Patočka's reading of Heidegger's *Befindlichkeit*. When Patočka speaks of Husserl, I have generally followed Dorion Cairns's helpful *Guide to Translating Husserl*. Throughout, I have sought to make my translation as transparent

as possible, letting Patočka himself speak through my English.

Only in one respect have I consciously departed from the text. Patočka was not sexist, but a literal translation of his text would be. Czech is a highly inflected language; its plethora of endings makes nearly every word gender specific. Few Czech speakers are sensitive to it—and even fewer were in the mid-sixties, when Patočka wrote this text. To avoid giving an erroneous impression, I have followed the American Philosophical Association guidelines on inclusive language even at the cost of minor departures from the text. So I have, for instance, substituted plural nouns for Patočka's singular to avoid gender-specific personal pronouns. Though it is a departure from the letter of the text, I believe it is more faithful to the author's intent.

A different problem arises in the context of Patočka's periodic pronouncements concerning animal psychology. To anyone familiar with the subject, many of those pronouncements, for instance concerning other animals' communication, awareness of death, sense of possibilities, appear embarrassingly anthropocentric, however translated. In part the problem is that the research summed up by authors like Donald Griffin in *Animal Minds* or Masson and McCarthy in *When Elephants Weep* simply was not available at the time. More basically, however, neither Patočka nor Heidegger had any interest in animal psychology. They spoke of nonhuman animals much as the Scholastics were wont to speak of angels, as of hypothetical constructs whose mode of being, posited wholly a priori, could be used as contrast to bring out aspects of being human. So it is useful to take Patočka's claims about nonhuman animals not as problematic assertions about animal psychology but as metaphors designed to make crucial traits of being human stand out in greater clarity.

To a lesser extent, that is a useful approach to some of Patočka's etymologies as well. Like Heidegger, Patočka often uses them to bring out an overlooked aspect of an overused word. Whether or not such etymologies would withstand philological scrutiny, they invariably point out an important aspect of his exposition. As such, they can be most useful, even if not easy to translate.

There is, finally, one task which I have not even sought to undertake. Patočka lived his philosophy and philosophized his living. He lived and wrote as radically situated, in a situation. A full

understanding of his text would require projecting his assertions against the background of his time. It was a turbulent time. The early lectures, in which Patočka speaks movingly of humans as called to things, called to bestow meaning upon them, were written in the euphoria of long-awaited liberalization. Some of the later lectures, echoing motifs of struggle, were written amid the bitter death of hope after the Soviet occupation of our country, one under the direct impact of the self-immolation of Jan Palach, a young philosophy student, to protest the Soviet invasion—and our own cowardice. A text, Patočka insists, cannot be understood apart from its situation. A faithful translation would have supplemented every half page of text with another half page of historical background.

That task, alas, far exceeded my abilities. The best I can do is to refer the reader to my *Jan Patočka: Philosophy and Selected Writings* for some of the badly needed background. My consolation is that, as Patočka points out, meaning is not present as a text but rather appresent *through* it. I hope that, whatever the imperfections of my translation, Patočka's meaning will speak through it.

As for my own situation, I should like to thank all my colleagues at Boston University and at Charles University for providing me with the academic *Umwelt* that made this work possible. More personally, I owe a debt of thanks to Frances Macpherson, to Sheree Conrad, who carried texts through the iron curtain between Vienna and Prague, and to Stephen Capizzano, Jiří Vančura, and Dorothy Mills Koháková for having been my life-world through the years between my first translations of Jan Patočka's human-rights texts in 1977 and this, my final payment on that long-ago promise.

Prague, Easter 1997

Name Index

(compiled by Joseph Moural
Faculty of Philosophy, Charles University)

Subject Index

(compiled by Joseph Moural
Faculty of Philosophy, Charles University)